THE METHODOLOGIES OF ART

Also by Laurie Schneider Adams

Art and Psychoanalysis

A History of Western Art

Art on Trial

Art Cop

Giotto in Perspective (editor)

Psychoanalysis and the Humanities (co-editor)

*Federico da Montefeltro and Sigismondo Malatesta:
The Eagle and the Elephant* (co-author)

THE METHODOLOGIES OF ART

An Introduction

LAURIE SCHNEIDER ADAMS

IconEditions
An Imprint of HarperCollins*Publishers*

HarperCollins books may be purchased for educational, business, or sales promotional use. For information please write: Special Markets Department, HarperCollins Publishers, Inc., 10 East 53rd Street, New York, NY 10022.

Designed by Caitlin Daniels

Library of Congress Cataloging-in-Publication Data

Adams, Laurie.
　The methodologies of art : an introduction / Laurie Schneider Adams.
　　p.　cm.
　Includes bibliographical references and index.
　ISBN 0-06-430312-8 / 0-06-430231-8 (pbk.)
　　1. Art—Historiography. 2. Art—Methodology.　I. Title.
N7480.A32　　1996
701' .18—dc20　　　　　　　　　　　　　　　　　　　　　96-10778

96 97 98 99 00 ❖/RRD 10 9 8 7 6 5 4 3 2 1

Contents

List of Illustrations

COLOR PLATES

(following page 108)

Preface

———◦•◦———

A picture is worth a lot more than a thousand words. No amount of words can describe an image or an object exactly, whether it is a picture, a sculpture, or a work of architecture. This is because words constitute one kind of language and imagery another, thereby creating a need for translation. When the great nineteenth-century art critic John Ruskin described paintings, he approached a unique fusion of language and image by creating what has been called the "poetical equivalent of a painting."[1] But even reading Ruskin does not eliminate the necessity of *seeing* what he describes, however convincingly he describes it.

Ruskin's famous account of Turner's *The Slave Ship*[2] [Plate 1] is a case in point. A comparison of Ruskin's prose with Turner's picture quickly demonstrates the gap between words and images:

> The noblest sea that Turner has ever painted, and, if so, the noblest
> certainly ever painted by man, is that of the *Slave Ship*, the chief
> Academy picture of the Exhibition of 1840. It is a sunset on the
> Atlantic, after prolonged storm; but the storm is partially lulled,
> and the torn and streaming rain-clouds are moving in scarlet lines

to lose themselves in the hollow of the night. The whole surface of
the sea included in the picture is divided into two ridges of enor-
mous swell, not high, nor local, but a low broad heaving of the
whole ocean, like the lifting of its bosom by deep-drawn breath
after the torture of the storm. Between these two ridges the fire of
the sunset falls along the trough of the sea, dyeing it with an awful
but glorious light, the intense and lurid splendour which burns like
gold, and bathes like blood. Along this fiery path and valley, the
tossing waves by which the swell of the sea is restlessly divided, lift
themselves in dark, indefinite, fantastic forms, each casting a faint
and ghastly shadow behind it along the illumined foam. They do
not rise everywhere, but three or four together in wild groups, fit-
fully and furiously, as the under strength of the swell compels or
permits them; leaving between them treacherous spaces of level
and whirling water, now lighted with green and lamp-like fire,
now flashing back the gold of the declining sun, now fearfully
dyed from above with the undistinguishable images of the burning
clouds, which fall upon them in flakes of crimson and scarlet, and
give to the reckless waves the added motion of their own fiery fly-
ing. Purple and blue, the lurid shadows of the hollow breakers are
cast upon the mist of night, which gathers cold and low, advancing
like the shadow of death upon the guilty ship as it labours amidst
the lightning of the sea, its thin masts written upon the sky in lines
of blood, girded with condemnation in that fearful hue which signs
the sky with horror, and mixes its flaming flood with the sunlight,
and, cast far along the desolate heave of the sepulchral waves,
incarnadines the multitudinous sea.

From a description such as this, it is clear that Ruskin's passion
matches Turner's. The lines and colors evoked by Ruskin's pen
are as energetic and intense as those created by Turner's brush.
We feel the fear of destruction at the hands of nature and the guilt
of the slave trade coursing through Ruskin's prose. But we cannot,
without Turner's image, as readily comprehend the picture from
the words as we would comprehend a Russian novel such as *War
and Peace* from a good English translation. Although something is
always lost in translation, even in the same medium, still more is
lost when a work from one medium is translated into another.

The Betrayal of Images [1] by the Belgian artist René Magritte illustrates many things about the nature of pictures, some of which are discussed in subsequent chapters. The point most relevant here is what Magritte has to say about translations and transitions between words and images. Quoting the French philosopher Michel Foucault, the American theorist W. J. T. Mitchell calls the *pipe* "a demonstration that 'the relation of language to painting is an infinite relation.'"[3] The precision of Magritte's forms, and the space between the *pipe* and the written statement, accents the gap separating them. "Magritte," writes Mitchell, "shows everything that can be shown: written words, a visible object. But his real aim is to show what cannot be pictured or made readable, the fissure in representation itself, the bands, layers, and fault-lines of discourse, the blank space between the text and the image."[4]

Works of art have been interpreted, or "read," in increasingly different ways since art history became an established academic discipline in the nineteenth century. The different approaches to describing and interpreting art constitute the so-called methodologies of artistic analysis. Since every work of art is an expression of its culture (time and place) and its maker (the artist) and is also

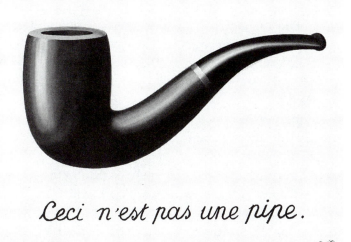

1. René Magritte, *The Betrayal of Images*, 1928, Los Angeles County Museum of Art.

dependent on its medium (what it is *made of*), any single artistic product is immensely complex. The very proliferation of methodologies is a reflection of the convergence of many levels of meaning in a single image. And while writers on art tend to approach works from the bias most congenial to themselves, readers should bear in mind that, by the very nature of imagery, no single approach can be definitive. Many different factors contribute to the creation of an image. Works of art, like dreams, are multiply determined.

In this book I survey some of the methodologies used in reading pictures, sculptures, and architecture, with a view to enriching the viewer's response to works of art. Each chapter is illustrated with examples, primarily of Western art, that appear in the major textbooks used in American colleges and schools. Chapter One offers some general observations on the nature of art, and Chapters Two and Three deal with formalism and iconography. Marxism and feminism—Chapters Four and Five—are contextual methods that both expand on, and take issue with, the formal and iconographic approaches. Chapter Six reviews some of the conventions of artists' biographies and autobiographies, and readings of works in relation to the lives of artists. Chapters Seven and Eight introduce the semiotic methodologies, which are derived from linguistics, philosophy of language, and literary criticism. These include Structuralism, Post-Structuralism, and Deconstruction. Chapters Nine and Ten show how different psychoanalytic theories can be applied to aspects of imagery, and also how they interact with other methodological approaches to art. Chapter Eleven deals briefly with two examples of psychology and aesthetics.

In the interest of brevity, the bibliography includes only the works cited. Readers are referred to the bibliographies in those works for further sources.

Several people have been extremely helpful in the preparation of this text. John Adams, Paul Barolsky, David Carrier, Allison Coudert, and Mary Wiseman read the manuscript through, and offered valuable suggestions and criticism along the way. Chapters Seven and Eight owe their existence largely to the input of Mary Wiseman. David Cohen's insights on Roger Fry and for-

malism improved Chapter Two considerably. Finally, my editor, Cass Canfield, Jr., together with his assistant, Karen Shapiro, was extremely generous in his encouragement of this project.

NOTES

1. Quentin Bell, *Ruskin* (New York, 1978), p. 29.
2. Ibid., pp. 29–30, citing John Ruskin, *Modern Painters*, vol. 1, III, p. 571.
3. W. J. T. Mitchell, *Picture Theory* (Chicago, 1994), p. 68. Cf. also Michel Foucault, *This Is Not a Pipe* (Berkeley and Los Angeles, 1983).
4. Mitchell, p. 69.

THE
METHODOLOGIES
OF ART

1

What Is Art?

———•◦•———

Art is as simple as it is difficult to define. For those who belong to the "I know what I like" school, art, like beauty, is in the eye of the beholder. For others, art is any object or image that is so defined by its maker. Art can also be an object or image not explicitly identified as such, but which strikes the observer as expressive or aesthetically pleasing.

Before there was art history, and the methodologies considered in this book, there was philosophy. Philosophers have had a great deal to say about the nature of art and the aesthetic response. For Plato, visual art was *mimesis*—Greek for "imitation"—and *techne,* or "skill." And beauty was an essential ideal that expressed the truth of things. But beauty and truth, in Plato's view, were of a higher order than art. In fact, he had little interest in works of art, because they were neither useful imitations of essential ideas nor the ideas themselves.

Take the example of Magritte's *The Betrayal of Images* [1]. According to Plato, there would be, in the world of ideas, an essence of perfect "pipeness." A pipe in the real world, on the other hand, might be useful, but it would lack the perfection of the ideal pipe. The painted image of the pipe, however, is neither useful nor ideal—as

is implied by Magritte's written text. For Plato, therefore, the image is the least "true" of the three conditions. Magritte's title—*The Betrayal*—indicates that he, like Plato, believes that pictorial illusion is treacherous. But whether Magritte would agree with Plato's banishment of artists from his *Republic,* or ideal state, is another question.

In contrast to Plato and the Platonic tradition of ideal essences that artists strive to imitate, Aristotle's position allowed for more possibilities. Even though he followed Plato in the basic conception of art as a combination of *mimesis* and *techne,* he did not restrict it to the exact, or "essential," copy. To know a thing, in Aristotle's view, one had to know its matter, its maker, and its purpose, as well as its form. He thought that art could improve on nature by various means, such as idealization and caricature. These achieve an "essence" of a different kind, and accord the work of art some grounding in the artist's perception.

Plato banished the artists because he considered their images to be deviations from the truth (and therefore from the Good and the Beautiful—the *kalos k'agathos*). He also objected to art—and to music and poetry—as capable of inciting destructive passions. Aristotle, on the other hand, believed in the power of art to repair the deficits of nature. These philosophical positions address the origins of art as well as its nature. For Plato, art derives from an ideal, but its distance from that ideal makes it useless at best and possibly dangerous. For Aristotle, art can be a route to knowledge. He believed that we are delighted by a good imitation, because we can learn from it, and that this makes us delight in learning itself. Whereas for Plato the original ideas—and not the art—contain truth and beauty, for Aristotle, truth and beauty are contained in the forms and structures of art.

These and other philosophical issues have addressed the question "What is art?" right up to the present day. In 1927, this question had its day in court. At issue was a sleek bronze sculpture entitled *Bird in Space,* by the Romanian artist Constantin Brancusi [Plate 2]. The American photographer Edward Steichen had purchased the *Bird* in France and, on his return to the United States, he declared it to Customs as an original work of art. In American law, original works are exempt from import duty, but the Customs officer rejected Steichen's claim. The *Bird,* he said, was not ART, and it entered the

country under the category of KITCHEN UTENSILS AND HOSPITAL SUP-PLIES. Steichen had to pay six hundred dollars in tax.

Later, financed by Gertrude Vanderbilt Whitney, the American sculptress and founder of the Whitney Museum, Steichen sued. Testimony revolved around the nature of art. Conservatives championed the Platonic view of art as *mimesis* and *techne,* and wanted to know why the *Bird* had no head, feet, or tail feathers. To the conservatives, the *Bird* was neither an accurate imitation of nature nor the product of a skilled technician. According to the modernists, on the other hand, the *Bird* satisfied the essential criteria of "birdness." For them, Brancusi had captured the very essence of a bird suspended in space. Its graceful form expressed qualities of birdness as perceived by the artist, and its high degree of polish evoked its relation to the sun when in flight. Furthermore, the modernists testified that Brancusi had called his sculpture a bird, which was itself sufficient evidence that it was, indeed, a bird. Their position thus approximated Aristotle's view of art as originating in the perceptions of the artist. On this occasion the modernists prevailed, and the court ruled in Steichen's favor. Brancusi's *Bird* was declared a work of ART.

Aesthetic value judgments of the kind illustrated in Steichen's court case, and disputed by the philosophers, are not the central issue of art history. The latter has traditionally focused on identifying, cataloguing, and characterizing specific works or groups of works. Nevertheless, the art historian has to make certain judgments in the very selection of the work to be considered.

Art history deals with ancient, as well as contemporary, works, which raises new questions about the nature and definition of art. For example, when we see a painting over ten thousand years old on a cave wall—say at Lascaux in the Dordogne region of France, or at Altamira in Spain [2]—we know that the painter did not call it "art" in our sense. Our concept of "art" began to take shape during the eighteenth century. If a cave painting depicts an animal, as most do, we suspect that it functioned as a kind of picture magic and symbolically "captured" the animal necessary for the survival of the Paleolithic (Old Stone Age) hunting society that created the image. Today, the people who make paintings are called artists. But we view cave paintings over a distance in time and are far removed from the original context. When we "suppose" picture magic, we

are trying to reconstruct the context based on what we know, or think we know, of the Old Stone Age, and our reconstruction is influenced by the theory that images of that period were part of wider religious and magical belief systems.

Our assessment of the artist depends partly on our perception of what the notion of "art" represented to a particular society at a particular time. Since the identities of artists from certain societies and time periods are unknown, one function of art history is to determine attribution—that is, to match the names of artists with the works of art from a specific time and place. Whether or not attribution is possible depends on the vicissitudes of historical preservation, or lack of it, on the nature of the culture in question, and on the skill of the person making the attribution. In certain periods of Western art, notably of ancient Greece and Europe from the Renaissance to the present, artists' identities are better known and more easily connected with works of art than, for example, in the Middle Ages. From the nineteenth century, various methodological approaches to works of art have developed, and these provide us with different ways of thinking about images, artists, and even critics. In the best of all possible worlds, these "methods" of artistic analysis do not compete, but reinforce one another, and reveal the multifaceted character of the visual arts.

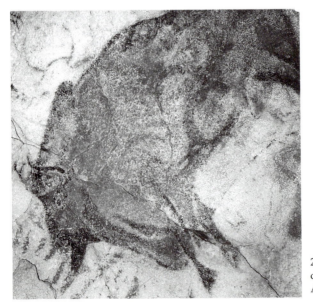

2. Room of the Bisons, c. 15,000–10,000 B.C., Altamira Caves, Spain.

The Artistic Impulse

One thing that can be securely said about "art" is that it derives ultimately from an inborn human impulse to create. Give children crayons, and they draw. Give them blocks, and they build. With clay, they model; with a knife and a piece of wood, they carve. In the absence of such materials, children naturally find an outlet for their artistic energy. Sandcastles, snowmen, mudpies, scribbles, and treehouses are all products of the child's impulse to impose created form on the world of nature. What children create may vary according to their environment and experience, but they invariably create something. This is borne out by biographies and autobiographies of artists, which frequently record a drive to draw, paint, sculpt, or build in early childhood. How such childhood drives are channeled depends on a complex interaction between the nature of the society, the family, and the propensities and experience of the individual.

All the creative arts—including the visual arts—separate the human from the nonhuman. Animals build only in nature, and their buildings are *determined* by nature. These include birds' nests, beehives, anthills, and beaver dams. Mollusks, from the lowliest snail to the complex chambered nautilus, build their houses around their own bodies and carry them wherever they go. Spiders weave webs, and caterpillars spin cocoons. But such constructions are genetically programmed by the species that make them, and do not express individual or cultural ideas.

People, on the other hand, build in contrast to nature, even though buildings can be related to nature. The Neolithic cromlech, or circle of stones, at Stonehenge, for example, is both distinct from, and related to, its natural environment [3]. About 3000 B.C., Neolithic builders chose as their site the broad, flat plain now called Salisbury in the county of Wiltshire in England. Over the next twelve hundred years, Stonehenge developed into the last monumental cromlech of the Neolithic period in Western Europe. By around 1800 B.C., its builders had arranged the monolithic stones into a significant form and placed horizontal lintels on top of vertical posts.

Because of its open spaces and unpolished surfaces, Stonehenge strikes viewers as naturally related to the site. It also creates a visual transition between earth and sky. But it is distinct from nature in being man-made and in expressing cultural ideas. It reflects, for

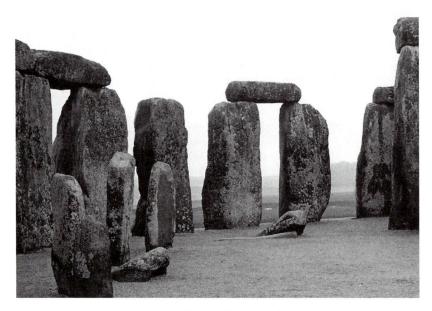

3. Stonehenge, c. 1800 B.C., Salisbury Plain, Wiltshire, England.

example, the belief that stones are imbued with a magic power to fertilize the earth. And, on a broader level, Stonehenge exemplifies the monumental stone architecture that developed when people made the transition from Paleolithic hunting societies to agriculture.

The Gothic cathedral at Chartres, begun in A.D. 1194, differs from Stonehenge in the degree to which it relates to nature [4]. Whereas Stonehenge is constructed on a flat, green expanse of land, Chartres rises from the highest point of a medieval French town. The cathedral builders aimed at height to express the Christian belief that heaven is located in the sky, and the aspiration to achieve it after death. Instead of a flat plain, the Gothic builders chose a naturally elevated site to enhance the soaring movement of the vertical spires. But the cathedral's formal relationship to nature ends there. As a work of architecture, Chartres is more differentiated than Stonehenge; its interior has been enclosed by stone walls, stained-glass windows, and a roof. Its exterior is decorated with hundreds of sculptures and carved architectural details.

Animals come by their "architectural" skills naturally, but in most human societies, one needs some training and formal study to become an artist. Even the so-called naive, or self-taught, artists study art and

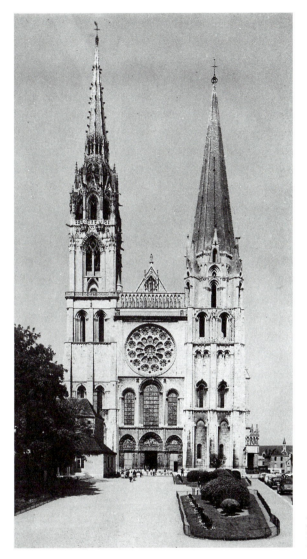

4. Chartres Cathedral, begun 1194, Chartres, France.

master certain techniques. The formal and technical control achieved by human artists is learned over time and with practice. Although the artistic impulse is inborn, someone had to teach Paleolithic children to paint cave walls, and medieval children had to learn various crafts, including engineering, in order to ensure the realization of Gothic cathedrals. Renaissance children studied for years as masters' apprentices before becoming masters themselves. But there are no art schools or apprenticeships in the animal kingdom.

The ancient Greeks created several myths about the nature of art and the artistic impulse. The mythical weaving contest between the mortal girl Arachne and the goddess Athena in Ovid's (46 B.C.–A.D. 17) *Metamorphoses* is a case in point.[1] Arachne was renowned throughout ancient Lydia (in modern Turkey) for her skill in weaving. Athena, the virgin goddess of war and wisdom, as well as of weaving, wanted Arachne to acknowledge that her talent was divinely inspired. Arachne refused and challenged Athena to a contest instead. Each wove tapestries of great beauty, and Athena became angry at her rival's skill. The subjects of Arachne's scenes were calculated to enrage the goddess, for they depicted myths in which the male gods pursue mortal women. Athena, in turn, wove scenes showing the punishments inflicted on mortals when they presume to challenge the gods. Her tapestries were thus an implicit warning to Arachne and, in her anger, the goddess struck her challenger three times with the spindle. The distraught mortal girl tried to hang herself in despair, but Athena rescued her and changed her into a spider, to hang and spin forever.

In this myth, the goddess spares her challenger from death, but casts her down to the level of a spider. As an arachnid rather than a human, Arachne spins genetically determined webs. Without a human brain—and thumb—she is no longer in a position to challenge Athena, for she cannot create art.

Implied in the myth of Arachne's challenge to Athena are some of the many qualities distinguishing animal productions, even when they are expressive and aesthetically pleasing, from works of art. Animals build and organize three-dimensional structures for purposes that are either individual, as in the snail shell, or communal, as in the anthill. But their structures do not express religious or political ideas. Nor do they satisfy the wishes of patrons who commission works of art. Art historians do not write histories of anthills, beehives, or spiderwebs, because such structures do not have a "style" in the art historical sense of the term. Nor are they symbolic. Symbolic thinking, which is a necessary component of human creativity, does not motivate animal building. Human architecture shares a utilitarian purpose with animal building, but it also has symbolic form and meaning.

Unlike human architects and human inhabitants of buildings,

animals have no impulse to decorate their environments either for aesthetic or symbolic purposes. Architectural decoration includes painting, drawing, photography, printmaking, mosaic, stained glass, tapestries, handicrafts, and possibly furniture. The ancient Egyptians, for example, filled the walls of their tombs with paintings, which they believed would be useful in the afterlife. The Greeks decorated their temples with paintings and sculptures detailing the exploits of gods and heroes. Christian churches contain chapels that provide architectural environments for sculptures and painted scenes from the Bible and from the lives of the saints.

Artists also decorate the natural environment. They create gardens, and landscape them with flowers and plants or with rocks and sand. In the twentieth century, the environmental artists alter the natural landscape—and sometimes the urban landscape—in a variety of ways. In 1970, on the Great Salt Lake of Utah, for example, Robert Smithson moved huge amounts of earth and stone to create *Spiral Jetty,* which has since been covered over with water. The Christos' *The Umbrellas Japan–U.S.A.* dotted the California landscape with thousands of yellow umbrellas, each the size of a small studio apartment. When they were opened, in 1991, thousands of corresponding blue umbrellas were opened simultaneously in Japan. In July 1995, Christo and Jeanne-Claude wrapped the Reichstag in Berlin, an international event of political and artistic significance [5]. This, like all of the Christos' environmental projects, was temporary, and had no utilitarian purpose in the way that animal structures have. But, because people have a longer-term memory than animals, and a sense of history, Jeanne-Claude and Christo's work is recorded—in preparatory drawings, models, books, and on film.

Since animals do not decorate their "houses" or the exterior environment, Arachne lost this impulse when she was turned into a spider. She became no longer capable of telling a story in pictorial form. The threads of a spider's web and the designs they make have no narrative and tell no story. They are devoid of what art historians call *iconography,* which is content with specific meanings.

Works of art are not necessarily narratives, and they may not represent recognizable figures and objects. Several terms have been used to designate such works, including *nonobjective, nonfigurative,* and *nonrepresentational.* When we see a picture of a recognizable

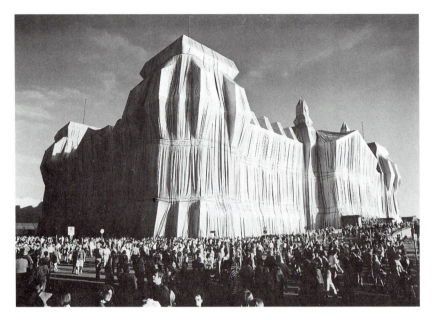

5. Christo and Jeanne-Claude, *WRAPPED REICHSTAG*, Berlin, 1971–95.

subject—for example, Magritte's *pipe*—we are not seeing the actual subject, but rather a two-dimensional representation of it. Even a three-dimensional representation, such as a sculpture, is an "abstraction" from nature or from the artist's environment. What distinguishes the nonfigurative styles of art from the designs of the spider's web are the ideas that inspire the art. Spiders, unlike humans, are not inspired by aesthetic or narrative ideas. They neither observe the environment nor make a conscious choice to create the abstract geometry of their webs. An artist, on the other hand, might observe a spider's web and transform it into a work of art.

The ability to observe nature and turn it into art requires a kind of imaginative metaphorical thinking—a way of describing one thing in terms of another, such as Shakespeare's "All the world's a stage"—that is part and parcel of human creativity. Leonardo da Vinci recognized this ability as a prerequisite for making art. He wrote in *On Painting*,

> I shall not refrain from including among these precepts a new aid to contemplation, which, although seemingly trivial and almost ridiculous, is none the less of great utility in arousing the mind to various

inventions. And this is, if you look at any walls soiled with a variety of stains, or stones with variegated patterns, when you have to invent some location, you will therein be able to see a resemblance to various landscapes graced with mountains, rivers, rocks, trees, plains, great valleys and hills in many combinations. Or again you will be able to see various battles and figures darting about, strange-looking faces and costumes, and an endless number of things which you can distill into finely-rendered forms. And what happens with regard to such walls and variegated stones is just as with the sound of bells in whose peal you will find any name or word you care to imagine.[2]

That Leonardo used his imagination in this visual way is particularly evident in his drawings. For example, the *Old Man Contemplating the Flow of Water Around a Stake* [6], accompanied by Leonardo's text, reveals the artist's penchant for seeing chance forms in nature. Here, he turns them into visual metaphor. As the water flows around the vertical of the stake, it creates a pattern of lines that resembles the configuration of a woman's long, partially braided hair. In this drawing, Leonardo's visual metaphor corre-

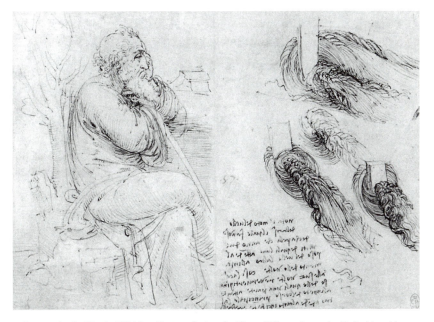

6. Leonardo da Vinci, *Old Man Contemplating the Flow of Water Around a Stake* (*An old man seated in profile; four studies of swirling water*), late fifteenth century, drawing. The Royal Collection, Windsor, England.

sponds to a verbal metaphor. One speaks, for example, of "flowing" hair as well as of the "flow" of water. The word *flow,* which makes the verbal metaphor possible, corresponds to a visual metaphor made possible by the observation of nature. In Leonardo's drawing, these associations, which exemplify a significant aspect of the creative process, become a subject of contemplation by the old man. Perhaps the old man is the artist, Leonardo himself, gazing on the mystery of creation and fascinated by his own metaphor.

Leonardo's account of the artist's ability to see and transform natural shapes provides an insight into the procedures of the Paleolithic cave painters at Altamira, Spain [2]. The natural bumps on the cave ceilings and walls reminded the artist of the mass and bulk of the bison hunted by members of his community. Figure 2 shows how the artist created a visual metaphor based on similarity of form. He outlined the edges of the raised surface in black, added legs, a head, and a mane, and filled in the shape with earth colors.

In the twentieth century, partly as a legacy of the Industrial Revolution, manufactured objects became a subject of art. Marcel Duchamp's ReadyMades and ReadyMades Aided are objects taken from the man-made environment and transformed into "art." His first ReadyMade, of 1915, was a shovel, which he purchased from a hardware store. He gave it the title *In Advance of a Broken Arm.* The connection in this case, unlike Leonardo's, is not by verbal or visual association. Rather, it is by sequential action. The work of shoveling, which is done with the arms "in advance" of the body, temporally precedes the broken arm. There is, in Duchamp's "shovel," an implied narrative, a sequence of events, that takes into account the passage of time. In metaphor, on the other hand, the connection, whether verbal or visual, is simultaneous. What *is* simultaneous in Duchamp's work is the punning. In this case, "in advance" can be read simultaneously as *"in front of* the body" and *"before* the broken arm."

When Picasso made his *Bull's Head* of 1943 out of the seat and handlebars of a bicycle [7], he created a visual metaphor in which parts of a manufactured object are rearranged to evoke a natural image—namely, the head of a bull. Since we know that bullfights were a significant part of Picasso's life and art, we can safely say that the *Bull's Head* is a metaphor with autobiographical meaning. It

also reveals Picasso's sense of play and his genius for synthesizing many different forms and ideas into a single image. The sculpture combines the early-twentieth-century influence of African masks on European art, Picasso's games with bull masks and religious attendance at the bullfights, the ancient history of the bull as a mythological figure of power and male fertility, and a bicycle seat and handlebars detached from their usual context, reattached and cast in bronze.

In an effort to characterize the creative process, H. W. Janson called Picasso's *Bull's Head* a "leap of the imagination."[3] It is that very "leap" that makes the associations contained in the metaphor. That Picasso made such leaps as a child is suggested by his account of the problems he had learning math in school. Whenever he saw the number seven (7), he said later, he read it as an upside-down nose. That particular leap in Picasso's mind was a translation from the abstract number to the concrete picture, reversed like the bicycle seat of the *Bull's Head* and similar in form to the noses of his early Cubist figures.

A comparable process was described by the self-taught American painter Horace Pippin. When learning to read, he reported, he automatically imagined pictures at the end of words. When learning to spell and write, he would turn the end of a word he had written into a picture. His written words thus "metamorphosed" into images.

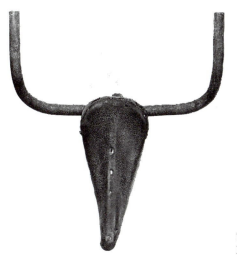

7. Pablo Picasso, *Bull's Head*, 1943, Musée Picasso, Paris.

Picasso used the same term to describe the *Bull's Head:* "A metamorphosis has taken place," he said, "but now I would like another metamorphosis to occur in the opposite direction. Suppose my bull's head was thrown on the rubbish heap and one day a man came along and said to himself: 'There's something I could use as handlebars for my bicycle.' Then a double metamorphosis would have been achieved. . . ."[4]

Such metamorphic "translations," as well as the symbolic and metaphorical capacity of the human mind, are necessary faculties for the creation of art. They can also, as in the case of the *Bull's Head,* have a playful quality, which is housed in the etymology of the word *illusion.* It is derived from the Latin verb *ludere,* meaning "to play," "to mimic," and "to deceive."[5] Play and humor are aspects of the creative arts, and for children play is the work that, among other benefits, forms the basis of future creativity. Etymologically, therefore, "illusion"—like the *Bull's Head* of Picasso—provides a transition between the play of childhood and adult creativity. And just as etymology contains the history of language, so the creative arts house the broader history of art and of the artist within them.

When we consider the creative arts today, we tend to think that culture is a prerequisite for artistic activity. In Greek mythology, however, the order is reversed, and the arts and crafts are credited with having civilized the human race. Athena and Hephaestos, the blacksmith god, were said to have fostered the transition from a wild to a civilized state by bringing the arts and crafts to mankind. One subtext of these myths is thus the equation of artistic creativity with civilization.

The early history of art, as far as we know it, is a combination of the modern and the mythological points of view. No visual arts have been found from the Neanderthal era. It is not until *Homo sapiens* that the earliest traces of art appear. By the Paleolithic period, artists were making sophisticated sculptures and painting cave walls. And with the development of agriculture in the Neolithic period, people began to produce monumental stone architecture. The evident relationship of the creative arts to human evolution resonates with the myth of Arachne's challenge. For it equates artistic creativity with the human condition, in contrast to the spider, which weaves by rote.

NOTES

1. Ovid, *Metamorphoses,* trans. Frank Justus Miller, Loeb ed. (Cambridge, Mass., and London, 1984), bk. IV, pp. 1ff.

2. N. 572 *Codex Urbinus Latinus,* 35v, in *Leonardo on Painting,* ed. Martin Kemp (New Haven and London, 1989), p. 222. For this reference I thank Bradley Collins.

3. H. W. Janson, *History of Art* (Englewood Cliffs, N.J., and New York, 1977), p. 10.

4. Cited in, ed. Edward Lucie-Smith *The Faber Book of Art Anecdotes* (London, 1992), p. 444. For this reference I am grateful to Paul Barolsky.

5. See Paul Barolsky, *Infinite Jest* (Columbia, Mo., and London, 1978), p. 17.

2

Formalism and Style

————•◦•————

Formalism is the approach to art that stresses the significance of form over content as the source of a work's subjective appeal. Roger Fry (1866–1934), the most influential formalist critic in England, took the position that art has little or no meaningful connection with either the artist who makes it or the culture to which it belongs. His approach was thus ahistorical, and focused on the emotional effects created by works of art. In this view, Fry echoed the eighteenth-century German philosopher Immanuel Kant (1724–1804), who discussed the nature of the aesthetic response to beauty and affirmed its significance as a product of the human mind.[1] Like Plato, Kant believed in an essential ideal beauty, which is distinct from both nature and art. Considerations of utility, origin, context, and so forth interfere, in Kant's system, with the experience and judgment of an object's aesthetic qualities. Writing in the tradition of Plato and Kant, Fry cites Plato's opinion that the visual arts are mere imitations, although he notes that the visual arts have persisted, despite their Platonic exile, because they are a basic human expression.[2]

Whereas people and animals share certain instinctual, biological responses, according to Fry, people—and not animals—can recall and imagine. This human ability allows for the possibility of what

Fry calls a "double life; one the actual life, the other the imaginative life."[3] This aspect of the arts, as we have seen, is one subtext of the mythical weaving contest between Athena and Arachne. For it is the "other imaginative life" that drives the imagery of the contestants. Athena and Arachne have one "conversation," which is "actual" and verbal, and another, in which they send pictorial messages to each other. The latter reveals the imaginative character of the competition, and that is what finally determines its outcome.

In the imaginative life, Fry believes, there are different values and perceptions because action is precluded. Art, therefore, is the expressive product of the imagination and not, as Plato would have it, mere imitation. Our response to the artistic product is more emotionally intense, as were the responses of Athena and Arachne, because we have the leisure to experience and observe at the same time. "When we are really moved at the theatre," writes Fry, "we are always both on the stage and in the auditorium."[4]

Art, in Fry's assessment, diverges from biology. Whereas the biological function of the eye is to see, its artistic or aesthetic function is to look. When we "look" at an object, we apprehend its formal relationships. And because the artist's vision is "creative vision," it crystallizes into a harmony of elements that supersedes subject matter.[5] Fry's emphasis on the difference between art and life led him to analyze works "out of context"—as pure form, rather than as expressions of a time and place.

A formalist analysis of a work of art would consider primarily the aesthetic effects created by the component parts of design. These parts, called *formal elements,* constitute the basis of the artist's visual language. They consist of *line, shape, space, color, light,* and *dark,* which artists arrange in many different ways to achieve broader categories of design. These, in turn, consist of *balance, order* and *proportion,* and *pattern* and *rhythm,* which, with the component elements, evoke certain responses in the viewer. The final arrangement made by the artist is the *composition* of the work of art. A formal analysis of the artistic composition considers how each element contributes to the overall impression made by the work.

Works of architecture and sculpture are three-dimensional and have height, width, and depth (the third dimension). Buildings are

generally bigger than sculptures because they organize space—interior and exterior—for utilitarian purposes. People move, work, live, worship, are entertained, and are buried inside architectural structures. Pictures are two-dimensional images, usually on a flat surface, so that whatever depth they appear to have is illusory. The difference between actual and illusionistic depth in pictures, sculpture, and architecture requires consideration of other formal elements. These include *mass* and *volume,* which are real qualities of sculpture and architecture, and illusory qualities in pictures. *Texture* is another component of imagery that can be actual or illusory and depends partly on the nature of the artist's material, or *medium,* and partly on an illusion created by a particular technique. The various kinds of *perspective,* techniques for creating the illusion of depth on a flat surface, must also be part of formal analysis.

The impression created by a work of art is at once the sum of its parts and more than the sum of its parts. In Leonardo's drawing, *Old Man Contemplating the Flow of Water* [6], for example, we can analyze the lines and describe the effects of their arrangement, but the explanation of Leonardo's genius as a draftsman is more elusive. We can say that the stake looks like a three-dimensional rectangle and that its vertical, or upright, plane (direction of space) convinces us that it is immobile in contrast to the flowing curves of the water. From this detail, we can conclude that a vertical evokes a sense of stability in the viewer, whereas a curve suggests motion.

Our responses to these elements of line and plane in an image are partly responses to our own sensory experience in relation to the world. If, for example, we see a tall building tilting in a diagonal plane, we might run for cover, expecting it to fall down. A vertical building, on the other hand, reassures us that it will continue to stand up. When we ourselves occupy a vertical plane, we are standing upright, our feet firmly planted on the ground. When soldiers stand at attention, they are in a vertical plane. Like the stake in Leonardo's drawing, the soldiers exert a physical tension with which we can identify. Even standing at ease requires sufficient muscle control to prevent falling down. If, like Leonardo's stake, we were to stand in a pool of water, we would feel the flow of water around our bodies. We would also see that the lines created by the flow were curves.

When we ourselves begin to move, we break up the vertical plane

of an upright stance, and parts of our body begin to occupy curved and diagonal planes. Soldiers who goose-step move their legs in forward diagonals. Runners' legs occupy zigzag planes, which are composed of two or more diagonals. Graceful dancers, on the other hand, create curves with their torsos and limbs. In an image, diagonals as well as curves create the illusion of motion.

When lying down on a flat surface such as a floor or a bed, we tend to be at rest. Under these conditions, we are generally more relaxed than when we stand, sit, or run, and we are occupying a horizontal plane. In Leonardo's drawing, there is a slight suggestion of a horizon line (note the verbal connection between *horizon* and *horizon*tal) on which a shape resembling a house has been placed. That part of the picture, horizon line and house, is the most restful. The indications of actual movement in the house are the curves at the top right, which represent smoke escaping from the chimney.

The illusion of distance in this drawing, that the house is distant from the old man, is created in two ways. The placement of the house on the picture plane, higher up than the man, makes it seem farther away. It is also smaller than the man, which corresponds to our experience of the world, for when we see two objects that are identical in size, the one that is closer to us appears larger. We also know that a man is smaller than a house, so that if we see the inverse proportion, we conclude that the house must be more distant from us than the man.

This kind of illusion of depth, determined by the difference in the sizes of objects, is created by the technique of *linear perspective*. Another kind of perspective, which is used in Western art but which is more prevalent in Far Eastern art, is *atmospheric perspective*. In atmospheric perspective, the illusion of distance is created by decreasing clarity rather than by decreasing size. For example, in a twelfth-century A.D. Chinese painting of the Sung Dynasty, *Cottages in a Misty Grove in Autumn,* by Li An-chung [8], the distant trees are covered with a horizontal of mist. The landscape mountains behind the trees are virtually obscured by mist, in contrast to the more delineated foreground. Leonardo was also aware of the possibilities of atmospheric perspective. In the *Mona Lisa* [9], the landscape forms are set in a bluish mist. The relatively small size of the distant mountains compared with the woman reflects the use of linear per-

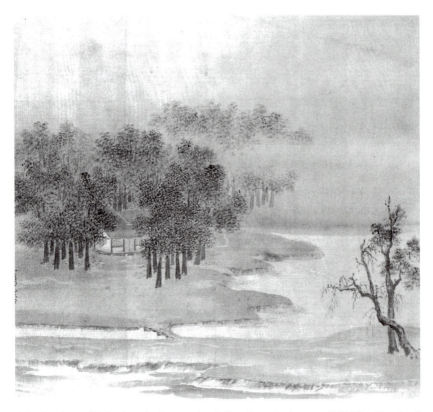

8. Li An-chung (Li Anzhong), *Cottages in a Misty Grove in Autumn*, 1117. The Cleveland Museum of Art.

spective. Their blurred edges and muted surfaces, however, attest to Leonardo's use of atmospheric as well as linear perspective.

In Leonardo's drawing of the old man, the arrangement of lines and shapes defining the figure is complex. All the lines are curved, as they are naturally in any living being, but they create different effects. The top of the old man's head approximates a hemisphere, or half dome. The slight irregularity of its outline enhances the impression that it is the head of a particular person. By virtue of the *hatching* lines—that is, the parallel curved lines at the lower left of the skull—Leonardo adds the illusion of a three-dimensional form. These lines create a sense of darkness, whereas the blank part of the form appears light. This transition from light to dark, called *shading*, is read as light hitting the blank section of the skull, which becomes darker as it curves inward, moving away from the direct light, and

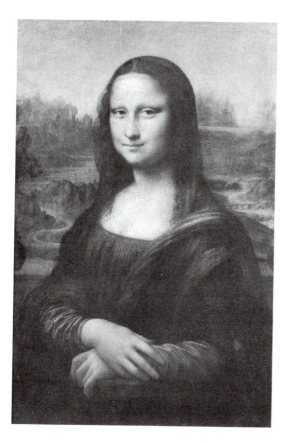

9. Leonardo da Vinci, *Mona Lisa* (*La Gioconda*), c. 1503–6, Louvre, Paris.

approaches the neck. The resulting sense of *volume* informs the viewer that the skull is not flat, or two-dimensional, but that it has *mass,* which denotes actual physical substance.

The neck has darker hatching lines to convey the relative absence of light on that part of the body. Hatching lines also convey the sense of mass on the long oval shapes defining the right upper arm and leg. To create the impression that these limbs are rounded and catch the light above the hatching lines, Leonardo has left the upper sections of the forms relatively blank. He has also drawn the hatched curves with varying degrees of pressure; on the underside of the limbs, the curves are darker, and they become lighter in both pressure and tone as they move upward. The darkest part of the right upper arm is indicated by *cross-hatching,* in which a second set of lines is drawn across the first set. By these techniques, Leonardo's curves seem to conform to the natural mass of arms and legs.

The curve of the torso informs us that the old man is leaning forward. He is, in fact, somewhat curved in on himself. He props up his head with his left hand, resting on an unseen ledge. His right hand grasps a diagonal walking stick, which also functions as a support. The lower part of his right arm, between his elbow and hand, seems to recede in space. This illusion is the result of the technique known as *foreshortening,* or rendering *in perspective,* which makes a form appear to move three-dimensionally from the picture plane to a point behind it, by literally shortening its length and compressing the space it occupies.

The convincing quality of Leonardo's drawing persuades us that we are seeing an old man who is immobilized by his contemplation of something. At the same time, he seems to be looking inward, as if preoccupied with his own thoughts. The condensed space of his foreshortened arms and his hunched pose create a sense of weight in his upper body. This formal impression of heaviness seems to reflect the "weightiness" of the old man's thought, reinforced, in turn, by the weight of his head on his hand. Contained in the sense of weight is the notion of seriousness and depth, both of which are implied in the formal character of Leonardo's drawing. Echoing the formal "weight" of Leonardo's old man are the downward curves of his face. The mouth, in particular, curves sharply downward, as if expressing the gravity of his thought.

The metaphor discussed in the previous chapter, in which the flow of water is compared with flowing hair, is achieved by the arrangement of the curves. Although the water seems to flow around the stake, there is a curiously static quality in the curves, as if they are fixed by the braidlike design. It is this quality that allows us to read that part of the image as a woman's long, flowing hair. The genius of Leonardo's draftsmanship, which has made possible both this visual metaphor and the characterization of the old man, is the ultimate source of the picture's aesthetic effect.

Color is an important and often the most visually striking formal element. The psychological impact made by colors has been tested and found to be meaningful. Our reactions to color are reflected in language when we speak, for example, of a "red-letter day," a "blue Monday," "black humor," or a "brown study." We say that an envious person is in the grip of the "green-eyed monster," that a coward

is "yellow," and that one who is very angry is "purple with rage."

Picasso's Blue Period painting *The Old Guitarist* [Plate 3] exemplifies the depressive effect of the color blue. Because the picture is largely *monochromatic,* or composed mainly of a single color, the blue dominates the image. The aesthetic appeal of Picasso's picture resides partly in the relationship between the mood evoked by the blue color and other formal elements. Unlike Leonardo's old man, Picasso's is thin and bony. He, too, is composed of curves, primarily downward curves, but there is less sense of mass and volume in his body. Instead, Picasso's guitarist is elongated, as if stretched thin by a careworn existence. The silvery light, like the thin proportions and downward pull of line and shape, reinforces the eerie quality of Picasso's work.

Color in Delacroix's *Liberty Leading the People* of 1830 [Plate 4] has a totally different aesthetic character than in *The Old Guitarist.* The blues, like the reds, are distributed in small patches throughout the picture plane and are nearly lost in the formal dynamism of the image. Virtually all of the formal elements in this painting contribute to its sense of oncoming energy. The predominant shape is the large, looming triangle, whose angles are formed by the two lower corners of the painting and the upraised hand of the woman. Its placement, slightly to the right of center, results in an asymmetry that enhances the narrative direction of the crowd. Whether lying dead, kneeling, or advancing, all the figures occupy zigzag planes. They seem to emerge as an endless human force from the mists of gunpowder in the background that separate at the right to reveal a section of the Paris skyline.

The woman carrying the French flag, or *tricolor* (three colors), and the street boy at her left are strongly silhouetted against the most brightly illuminated section of the picture plane. She looks back while striding forward so that her pose links the mob behind her with her future direction. These formal shifts—whether from light to dark, as in the edges of the silhouettes, from plane to plane, or from clarity to mist—reinforce the energetic determination of the figures.

The lofty position of the flag unites the scene chromatically as well as politically. It is the symbol of the people's unified desire for independence. The reds, whites, and blues scattered irregularly across the picture plane are organized into three rectangles in the flag. The mob is similarly a coming together of disparate groups for

a single cause. In being elevated, the tricolor, like the spires of a Gothic cathedral, reflects aspirations to higher things—in the one case to heaven, and in the other to freedom.

Style

The aesthetic differences between works of art, insofar as they are determined by the selection and composition of formal elements, have been ordered into categories of style. Writing in the 1950s, the American art historian Meyer Schapiro defined style as "constant form—and sometimes the constant elements, qualities, and expression—in the art of an individual or a group."[6] But the earliest reference to art history as a history of style occurs in the writings of the eighteenth-century German intellectual Johann Winckelmann (1719–68). His interest in Greek and Roman antiquity, fueled by his attraction to Greek sculpture and the contemporary excitement aroused by the excavations at Herculaneum and Pompeii in southern Italy, led to his publication of *The History of Ancient Art* in 1764.

For Winckelmann, in contrast to Kant and Fry, art was tied to history, and changed as the cultures that produced it changed. In his view, the highest achievement in the arts came about in fifth- and fourth-century B.C. Greece. Winckelmann's compatriot of the later eighteenth and early nineteenth century, the philosopher Georg W. F. Hegel (1770–1831), also connected stylistic change with cultural developments. He divided the history of art into three stages: the Symbolic, by which he meant ancient Egypt; the Classical, embodied by Greek sculpture of the fourth century B.C.; and the Romantic, or post-Classical and primarily Christian. Hegel believed that art is a meaningful expression of those who produce it, and thus can be read as an artifact, or historical record of a culture. Like Winckelmann, Hegel saw in stylistic changes over time a kind of predetermined evolution that could be identified and described.

The late-nineteenth- and early-twentieth-century Swiss author of *Principles of Art History*, Heinrich Wölfflin, addressed the question of artistic development as exemplified by the shift from the High Renaissance, which he termed "Classic" because of its affinities with the Greek Classical style, to the Baroque style of the seventeenth century. His analysis of these two styles is a good illustration

of Schapiro's "constant form ... in the art of an individual or a group." Wölfflin identified five pairs of stylistic concepts, which he applied to the formal organization of Renaissance and Baroque art, respectively. These are *linear* and *painterly, plane* and *recession, closed* and *open form, multiplicity* and *unity,* and *absolute* and *relative clarity.*

If we take three pairs of works—two paintings, two sculptures, and two buildings—and compare the Renaissance example to the Baroque example, we will see that Wölfflin's categories are quite convincing. For example, Andrea Mantegna's *Dead Christ* [10] conforms to Wölfflin's notion of Classic design. It is *linear* in the sense that the edges of the forms and their spatial directions are clearly observable. The lines defining the sides of the platform supporting Christ's body guide the eye to a notional, but identifiable, point above the picture. This so-called *vanishing point* requires that the artist construct the space as if it were a rectangular box. Two sides of the box are parallel to the picture plane, which is the physical sur-

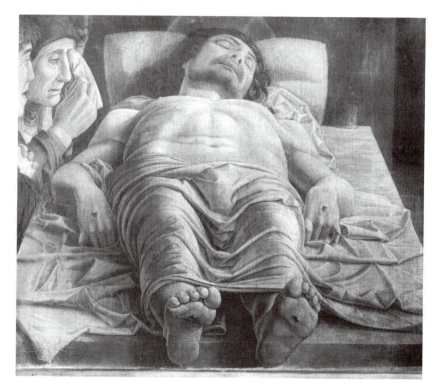

10. Andrea Mantegna, *Dead Christ,* c. 1500, Pinacoteca di Brera, Milan.

face of the work (here the top and bottom horizontals of the platform), and two are perpendicular to it (the sides). The platform itself fits into the constructed space of the painting and defines it.

By *plane*, Wölfflin refers to the Renaissance painters' practice of arranging a spatial sequence identifiably parallel to the picture plane. Thus, in the *Dead Christ*, we can say that Christ's feet are in the foreground and that our eye is carried toward his head by a sequence of planes that includes first his legs and then his torso. In order to create the illusion that Christ does indeed lie in this relation to the picture plane, Mantegna has foreshortened his body, or painted it in perspective, as Leonardo foreshortened the right forearm of the old man in Figure 6.

We are fairly certain that the women in Mantegna's picture stand one behind the other on the floor of the room, and that the floor is parallel to the ceiling and to the platform. We can conclude that the women, and the ointment jar on the right, are upright and occupy vertical planes, whereas Christ lies in a horizontal plane. All the figures and objects, in fact, appear set within the boxlike space that seems to lie behind the picture plane. It is this conviction of identifiable, and finite, space that Wölfflin refers to as *closed form*. Even though the vanishing point of this particular image is outside the picture, its very existence gives the viewer a sense of being in control of the space. Closed form seems to be self-contained, rationally bounded, ordered, and relatively symmetrical.

In Wölfflin's characterization of Classic art, each detail strikes the viewer as an independent element, even though it is also part of a larger formal arrangement. He refers to this phenomenon as *multiplicity*. Thus, for example, Christ's rib cage is composed of a distinct bone structure, musculature, and flesh, but the viewer experiences both the parts of the anatomy and the whole to which they belong.

The qualities of line, plane, closed form, and multiplicity contribute to Wölfflin's last category of Classic art—namely, *absolute clarity*. Here Wölfflin addresses the nature of light and color, which, he says, "have their own life."[7] Light, in a Renaissance painting, typically enters the picture's space from one identifiable direction, independently of natural light. In the *Dead Christ*, light hits the solid forms not from an observed window but from the right. The gradual shading of each form toward the left convinces the viewer of its

three-dimensional volume. The consistency of this construction clarifies the masses as well as the edges of form. In Christ's drapery, for example, we think we know its exact placement in relation to the body and we have the sense that we could reach out and touch it.

Applying Wölfflin's formal categories to Rembrandt's *Anatomy Lesson of Dr. Nicolaes Tulp* of 1632 [11], we can see how they are expressed in the seventeenth-century Baroque style. The term *painterly* refers to the sense of the paint itself, the loose brushwork, and slight blurring of edges. In the *Dead Christ*, by contrast, the medium is subordinated to the image so that we are struck by the solid, sculptural quality of figures and drapery, rather than by paint texture.

Recession—in contrast to *plane*—refers to the construction of painted space. The boxlike space of Mantegna's painting has been disrupted, as if two opposite corners of the box had been pushed inward. The resulting diagonals characterize Baroque spatial construction. In Rembrandt's *Anatomy Lesson*, the platform supporting the cadaver recedes in a diagonal direction from its foreground

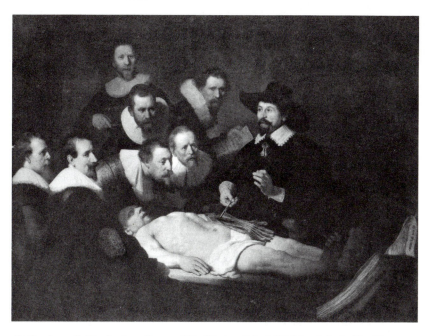

11. Rembrandt, *The Anatomy Lesson of Dr. Nicolaes Tulp*, 1632, Mauritshuis, The Hague.

location at the lower right, back into space at the left. The observer is thus drawn into the picture plane by the receding diagonal.

The placement of Rembrandt's figures, unlike Mantegna's, does not conform to an alignment of horizontal spatial planes parallel to the picture plane. Instead, the doctors observing the dissection occupy an ambiguous space. It is not clear, for example, where the man holding the letter stands in relation to those concentrating on Dr. Tulp's procedure. Because of such ambiguity, it would not be possible, as it is in the *Dead Christ*, to reconstruct the floor plan of Rembrandt's painted room.

Open space—in contrast to *closed space*—is like an open mind; it allows for a sense of flexibility. Open space permits the easy access and flow of figures and objects, just as various ideas and points of view are considered by one with an open mind. Likewise, the diagonal planes of Baroque construction create asymmetry, which *opens* the form. Despite the dark background of the Rembrandt, its space is not bounded except by the frame itself. Inside the picture, figures, objects, and architecture are more fluid than their Renaissance counterparts. The impression of formal movement in the Rembrandt is enhanced by individual diagonals such as the two sides of the book, the hands and hat of Dr. Tulp, the doctors leaning forward, and the cadaver.

The *unity*, rather than the *multiplicity*, of the *Anatomy Lesson*, according to Wölfflin's system, resides in the nature and action of the figures and the system of lighting. The doctors are gathered around the dissecting table and thus convey a group character. The light, which does not enter the picture plane from a single direction, is distributed on the faces, collars, and hands, on the book, and most broadly across the cadaver. The accents of light are just that; they highlight form—like spotlights on a stage—whereas in the *Dead Christ*, the light *defines* form. In Wölfflin's conception of Classic construction, therefore, the light is subordinate to the form, while in Baroque style the domination of light has a unifying effect.

The *relative clarity* of the Rembrandt contrasts with the *absolute clarity* of the Mantegna. Since the light in the *Anatomy Lesson* does not define form, certain areas of the picture plane are highlighted, leaving other areas in darkness. The edges of the figures, the cover of the book, and the outline of the dissecting table are not as clearly identifiable as the edges in the Renaissance picture. Likewise, the painterly quality of

the brushstrokes decreases the clarity of edge, and the ambiguous location of some figures blurs their spatial relationship to one another.

The two marble *Davids* by Michelangelo and Bernini will serve to illustrate Wölfflin's paired categories of style as they apply to sculpture. Michelangelo's *David* [12] stands in a vertical plane on a horizontal base, and its outline conforms to the boxlike space of Classic design. The figure's limits are clearly visible to the observer, and we have the impression that we have a full view of the front of the body. Bernini's *David* [13], on the other hand, turns vigorously, creating a sweeping diagonal of movement and an asymmetrical form. As a result, we cannot have a full front view of the figure and therefore see it less comprehensively than Michelangelo's *David*.

The diagonal plane of the Bernini, like that of Rembrandt's dissecting table, opens the space and creates motion through that space. It also subsumes the parts to the whole, whereas in Michelangelo's

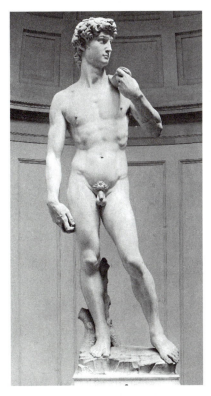

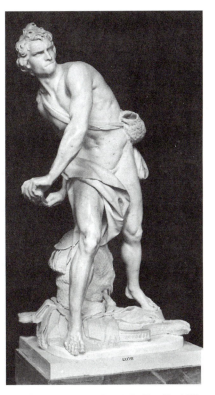

12. Michelangelo, *David*, 1501–4, Accademia, Florence.

13. Gian Lorenzo Bernini, *David*, 1623, Galleria Borghese, Rome.

figure individual parts, such as the rippling muscles, are experienced more distinctly by the observer. The greater variety of open spaces around the exterior of Bernini's *David* and the details of drapery and the pouch add to the formal movement of the statue.

Two examples of church architecture that exemplify the difference between Classic High Renaissance style and Baroque are Giuliano da Sangallo's Santa Maria delle Carceri (1485–91) in Prato [14] and Francesco Borromini's San Carlo alle Quattro Fontane (1665–67) in Rome [15]. Since the plan of Santa Maria delle Carceri is based on the shape of a Greek cross, the building is symmetrical and the four sides are virtually identical. Rising over the center is a drum with twelve round windows and a ribbed dome surmounted by a lantern. The correspondence between inside and outside (shown here) contributes to the clarity of the building structure. Shapes include the basic square, rectangle, circle, and triangle, arranged in a regular rhythm. The horizontals extending from the corners of the pediments are repeated in, and aligned with, those in the corner angles of the building. Also repeated is the relationship of the large and small rectangles on the surface. Each part is thus very much integrated with the design of the whole.

The planes of Santa Maria delle Carceri are vertical and horizontal, like those of Renaissance painting and sculpture, varied only by the sloping pediments and the circles of the dome. They lead our eye inward in a regular progression so that we feel in control of the space. As a result, the space itself strikes us as limited, enclosed, and ordered.

The plan of the Baroque church of San Carlo alle Quattro Fontane is elliptical, and the alternation of convex and concave elements in the facade is enlivened with detail that alters the sense of quiet order. Massive disengaged columns and projecting entablatures cast large shadows that multiply the contrasts of light and dark and obscure parts of the facade. Further increasing motion, and opening up spaces, are the decorative details carved in relief at various points in the surface. The elaboration of decorative elements, sharp contrasts, and the curved walls and entablatures affect the planar impression of the church facade. The sense of shifting elements, whether structural or in the variations of light and dark, tends to merge the forms, much as the painterly quality of Baroque pictures blurs edges and outlines.

Although there are inevitably many exceptions to categories such

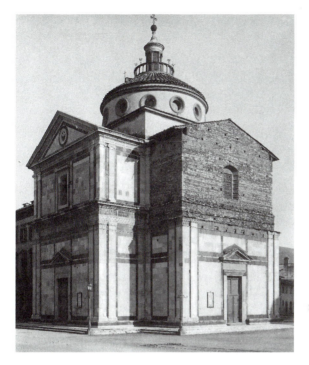

14. Giuliano da Sangallo,
Santa Maria delle Carceri,
1485–92. Prato.

15. Francesco Borromini,
San Carlo alle Quattro
Fontane, 1665–67, Rome.

as Wölfflin's, his system confirms the formal consistency of style. It also helps to distinguish Renaissance (or Classic) from Baroque style. In constructing this system, Wölfflin has essentially shown that it is possible to identify broad categories of style and to situate them within historical and cultural frameworks.

Despite Wölfflin's emphasis on the formal qualities of style and their aesthetic impact on the viewer, he links style to history and culture, and thus departs from the purely formalist approach of Kant and Fry. According to Fry, art has its own history and its own dynamic, which can be understood independently of context. Fry illustrates his view of artistic independence from social and political history by pointing out that a revolution in one cultural area does not necessarily coincide with a revolution in another. For example, he noted that the art of the Roman Empire was largely unaffected by the Christian revolution taking place in its midst.[8] The seventeenth-century artistic transition from the Renaissance to Baroque was not, in Fry's view, reflected in social or political change, although the Renaissance revolution in art *did* correspond to the social, political, and philosophical development of humanism.

The Historically closer to Fry's own time were the Impressionists, who, from the middle of the nineteenth century, began to reject the traditional view of *mimesis* and the notion that the purpose of art was to represent nature figuratively. According to Fry, a new era began with Cézanne, whose revolutionary approach to the picture plane appealed primarily to the viewer's aesthetic sensibility. As for the correspondence of Cézanne's innovations with historical developments, Fry was content to wait and see.

The other major English formalist critic of the early twentieth century, Clive Bell, preceded Roger Fry. But Bell was neither as complex nor as influential as Fry.[9] He, too, recognized a new and revolutionary development in the paintings of Cézanne. Writing about 1911–12, Bell identified Cézanne as the perfect artist[10] because he painted primarily to achieve "significant form." "Thou shalt create form" is Bell's first commandment of art.[11] The importance of significant form, which succeeds in evoking aesthetic emotions based on one's subjective experience of a work of art, was paramount for Bell. The aesthetic response, as for Fry, depended on the

artist's arrangement of formal elements—lines and colors, spaces and shapes, lights and darks—rather than on subject matter.

Bell likened art to religion and endowed it with moral value. He believed in the religious power of art to lead people "from circumstance to ecstasy,"[12] outside of time and place, regardless of historical context. Even more than being independent of time and place, art, according to Bell, carries an inner truth, a "latent reality" that enriches life. For not only does art owe nothing to life, in Bell's view, but life probably owes a great deal to art. And, to reinforce the power of art over life, he recommended reading history in the light of aesthetics rather than reading aesthetics in the light of history.

For Bell, therefore, aesthetic form, rather than context or content, was primary. This was true of his view of the history of the individual as well as of cultural history. He believed that children are born with a natural sense of form,[13] which makes everyone a bit of an artist. "Do not tamper," he wrote, "with that direct emotional reaction to things which is the genius of children."[14] He also thought that society should leave artists alone and provide them with the freedom to work. For the institutions of society, including the art schools, have little to contribute to the arts, but the arts might redeem society.

Bell regarded the history of art as a series of ups and downs within an ongoing stream, and he was quite clear about his own aesthetic response to form. He believed that Europe had produced more good art from A.D. 500 to 900 than from 1450 to 1850, and that Gothic art was the beginning of a decline in quality. He described Gothic architecture as "juggling in stone and glass"[15] and the cathedral as an impressive, melodramatic *tour de force* that was nevertheless not aesthetically thrilling. He preferred the "significant forms" of the Byzantine style to the lifelike character of Giotto's work, which he saw as a high point before the decline.

Bell's objection to the Renaissance, which he called a "new disease" of art-as-imitation, could only have emerged from a formalist perspective. He felt that Renaissance artists sacrificed spiritual quality to science. He called Chardin the only great painter of the eighteenth century and believed that by 1850 art was dead. Then, he asserted, the Impressionists revived art and taught viewers to seek the significance of a work within itself and not in the outside world.

And finally, Cézanne, unlike the artistic dead end of Raphael and the High Renaissance, opened up new formal possibilities.

Bell's aesthetic preferences are consistent with his formalism. He generally disliked what was most naturalistic, such as Renaissance and early-nineteenth-century art. The spiritual art of the early Middle Ages and the Byzantine era, the "moral" tone of Chardin's work ethic, and the Impressionist emphasis on the expressive qualities of the medium appealed to him. His aesthetic conviction that Cézanne introduced a new kind of "significant form" has been borne out by developments of the past hundred years.

Notions of stylistic trends, cycles, ups and downs, and so forth have been around for centuries. Whatever one's view of the historical dynamics of style, one might or might not relate it to a cultural context. By and large, the formalists do not, although they may have strong opinions about a particular style. They also recognize the existence of styles, but their interest lies in the history and the aesthetic effect of style and not in the history of cultural ideas, politics, economics, literature, or science. Nor are they interested in the biographies of the artists or the relevance of those biographies to the works of art. They take art on its own formal terms and experience it according to their personal aesthetic response.

The beginnings of the formalist approach coincide with the development of Impressionism and Post-Impressionism. Fry was an early supporter of Post-Impressionism in England, because that style (particularly the example of Cézanne) seemed to embody his belief in the importance of form over content. Post-Impressionism had structural qualities that Impressionism, with its dissolution of form, lacked. In the twentieth century, the popularity of formalist criticism paralleled, to some degree, the development of abstraction.

The formalist whose views were most clearly derived from those of Fry was the American critic Clement Greenberg. For Greenberg, who wrote from the 1930s through the 1960s, modernism consisted of the renunciation of illusionism (in the Platonic sense of *mimesis*) and of the conception of the picture plane as the fourth wall of a stage. The result was a flattened picture that no longer replicated our experience of three-dimensional space. Rather than drawing viewers into an imagined space through per-

spective (as in the Renaissance) or receding diagonal planes (as in Baroque), the visual elements of modern painting seemed to occur where, in fact, they do occur—directly on the picture plane. "Pictorial space," Greenberg said, "has lost its 'inside' and become all 'outside.'"[16] He noted that abstraction, which he considered the best art of his time, had evolved when artists turned from imitating nature to the forms and processes of art.[17] Like Fry, Greenberg assigned value to works of art insofar as they were experienced deeply and significantly. For both critics, the depth and significance of the subjective experience were a response to the qualities of form, and not to the content.

NOTES

1. See Immanuel Kant, *Critique of Judgment*, trans. J. H. Bernard (New York, 1951).
2. Roger Fry, "An Essay in Aesthetics" (1909, *New Quarterly*), in *Vision and Design* (New York, 1956).
3. Ibid., p. 17.
4. Ibid., p. 27.
5. Roger Fry, "The Artist's Vision" (1919, *Athenaeum*), in *Vision and Design*, pp. 47–54.
6. Meyer Schapiro, "Style," in *Aesthetics Today*, ed. Morris Philipson (New York, 1961), p. 81. Reprinted from *Anthropology Today*, ed. A. L. Kroeber (Chicago, 1953).
7. Heinrich Wölfflin, *Principles of Art History*, trans. M. D. Hottinger (New York, n.d), p. 16.
8. Roger Fry, "Art and Life," lecture to the Fabian Society, in *Vision and Design*, pp. 1–15.
9. Clive Bell, *Art* (New York, 1958).
10. Ibid., p. 135.
11. Ibid., p. 38.
12. Ibid., p. 68.
13. Ibid., p. 186.
14. Ibid.
15. Ibid., p. 102.
16. Clement Greenberg, "Abstract, Representational, and So Forth" (1954), in *Art and Culture* (Boston, 1961), p. 136.
17. For a persuasive rebuttal of Fry, Greenberg, and formalism, see Leo Steinberg, *Other Criteria* (New York, 1972), esp. ch. 3.

3

Iconography

———•◦•———

The iconographic approach to works of art primarily considers the meaning of subject matter. The term comes from two Greek words—*eikon,* meaning "image," and *graphe,* meaning "writing." *Iconography* is thus the way in which an artist "writes" the image, as well as what the image itself "writes"—that is, the story it tells. In an iconographic analysis of a work, it is possible, although not always advisable, to ignore the formal qualities. Nevertheless, as a general rule, iconographic studies focus on content rather than on form.

An important group of scholars who took the iconographic approach to works of art were those associated with the Warburg Institute. Founded in Hamburg, Germany, the Warburg moved to London before World War II to escape Nazi persecution. Erwin Panofsky[1] was a leading member of the Warburg, and a pioneer of the iconographic method. He distinguished three levels of reading works iconographically. He called the first level the "pre-iconographic"—that is, the level of "primary, or natural, subject matter." In Christian art, the figure of a man on a cross described as a man on a cross would be an example of a pre-iconographic reading. Describing the same image on a secondary level, which is the level of convention and precedent, would refer to it as Christ on the

Cross, or the Crucifixion. In this reading, the image is identified with the story of Christ's death as recounted in the New Testament Gospels. At this level, a text underlies the image.

The third level arrives at the intrinsic meaning of the image. It takes into account the time and place in which the image was made, the prevailing cultural style or the style of the particular artist, and the wishes of the patron. This is a synthetic level of interpretation, one which combines data from various sources. It includes cultural themes, available contemporary texts, texts transmitted from past cultures, artistic precedents, and so forth.

The approach related to iconography, called *iconology,* or the "science" (*logos*) of imagery, refers to the study of the larger program (if any) to which a work belongs. The distinction between iconography and iconology was characterized by another Warburg scholar, Sir Ernst Gombrich, in 1972.[2] Iconology, according to Gombrich, involves the reconstruction of an entire program, and therefore encompasses more than a single text. It is contained within a *con-text,* which includes a cultural as well as an artistic setting.

If we review these classifications in regard to the popular cartoon character of Mickey Mouse, they may become clearer. A pre-iconographic consideration of Mickey would read the image as a mouse having a circular face and large round black ears, who wears red shorts with white buttons and yellow shoes. In a second-level reading, we recognize the identity of the mouse as Mickey, because we are familiar with his attributes. That is, we know the conventional representation associated with this particular character. We know his form, what he wears, and also that he stands upright like a human, and behaves and talks like a human. If we are watching a movie, and we see Mickey shaking hands with the conductor Leopold Stokowski or getting into mischief with a sorcerer's magic, we can identify the movie as *Fantasia.*

If we are doing a third-level iconographic study of the intrinsic meaning of Mickey, we research his original comic strips, watch his old movies, read what has been written about him, and look at the way he has been depicted by artists other than his original creator. We would also have to consider the nature of his conception and evolution in the context of the Hollywood movie industry—the fact that his large round ears were derived from the reels of the early

movie projector, and that his face evolved from the elongated form of a rodent to a round shape so that he would appear less sinister and more childlike.[3] Since Mickey Mouse has become something of a cultural icon, he has taken on many meanings. We would have to consider some of these meanings in the context of twentieth-century America, as well as investigate the appeal or lack of appeal of Mickey Mouse in the United States and elsewhere.

An iconological study of Mickey Mouse would include more than a single image or text. Entire "programs," such as a series of movies, comic books, T-shirts, and so forth, would have to be considered. In addition to individual film clips, such as Mickey shaking hands with Stokowski or reading from a sorcerer's book of spells, we would have to analyze the underlying meanings of *Fantasia*. These might include the role of the artist in relation to magic, and even the history of civilization (the prehistoric animals). We would also need to know when the film had been conceived and produced, its connection with contemporary events, its intended audience, and the ways in which it was financed.

In this chapter, we take three works of art from different times and places, and subject them to a brief exercise in iconography. All three works have a common content—namely, the birth of a baby. The earliest example is the Indian relief sculpture of the second to third century A.D., the *Birth of Buddha* [16]. Its pre-iconographic reading would be as follows: A woman, who is larger than the other figures, stands at the center of the relief. She raises her arms to grasp the branches of a tree behind her. At the right (her left) another woman puts her arms around her. A small figure seems to emerge from the right side of the central woman, and is received by the woman at her right (our left). At the far left, a woman with a circle around her head places her hands together, and at the far right, another woman holds a kettle. On either side of the tree, at the upper right and left of the relief, are two figures with their hands together and circles around their heads. All these figures wear long dresses, or robes, with curvilinear folds. The large central woman also wears a necklace and heavy, pendant earrings.

The iconographic key to this relief lies in the small figure emerging from the side of the central woman. If we know the

16. *Birth of Buddha,* second–third century A.D. Ashmolean Museum, Oxford.

story, or "text," of the birth of the Indian prince Siddhartha, we recognize the woman as Queen Maya, the mother of Buddha. Her dress and jewelry are consistent with her royal status. According to the traditional "text" of his birth, Buddha emerged from his mother's side as she stood beneath a tree in her garden. The woman receiving Siddhartha and the woman with the kettle, therefore, are midwives. And the remaining figures are praying, for they recognize the holy nature of the newborn prince. They also have halos (the circles around their heads), which identify them as potential boddhisattvas—holy figures who have temporarily renounced heaven (or, in Buddhist terms, *enlightenment*) in order to help others attain it. When Siddhartha himself attains enlightenment, which he does while meditating under the pipal tree, he becomes the Buddha.

The intrinsic character of this relief and its relationship to a wider context are elusive, because it has been removed from its original

site. Nevertheless, one could consider it as a product of Gandharan art (second–third century A.D.), situate it in time, and compare it with other products of the same time and place. It projects an image of the miraculous birth of India's new religious leader and founder of a major world religion. As such, the iconography of this relief appeals to the universal sense that an unusual beginning, or birth, contains significant implications for the future.

The same sense informs the birth of Christ, which is referred to as the Nativity. But in Christian art, the actual birth is never represented. Instead, artists follow the theological texts in focusing on the miraculous conception of Christ. The first event in which we see Christ's human manifestation is just *after* his birth, when a midwife presents him to his mother.

In Giotto's fresco of about 1305, which depicts the Nativity scene [17], we see a woman (the midwife) handing the swaddled baby to his mother (the Virgin Mary). Other elements in this scene include a shed and a mountain, a seated old man in the foreground, an ox and an ass, five white sheep and one black goat, two standing men at the right, and five winged figures over the shed. The winged figure on the far right seems to be talking to the standing men. This is the pre-iconographic description of Giotto's *Nativity*.

There are many possible texts from which Giotto might have selected his image. Just as the story of Buddha's birth can be found in Buddhist texts, commentaries on Buddhist texts, and in orally transmitted folktales, so the sources for Christ's Nativity are numerous. The basic text, however, is the Gospel of Saint Luke (2:7): "And she brought forth her first born son and wrapped him in swaddling clothes, and laid him in a manger; because there was no room for them in the inn."

Once we have identified the text of the Nativity, we can proceed to the identification of certain motifs in the painted image. We can identify the old man as Joseph, because the Bible tells us that he married the Virgin Mary, who was much younger than he. The shed refers to the stable where Mary gave birth, because there was no room in the inn. The ox and ass are farm animals, and therefore associated with stables. But we have so far left out the right side of the picture and the flying figures over the shed. For these, we must read on in the Gospel of Luke:

17. Giotto, *Nativity*, c. 1305, Arena Chapel, Padua.

And there were in the same country shepherds abiding in the field, keeping watch over their flock by night [2:8]. . . . And the angel said unto them, "Fear not, for, behold, I bring you good tidings of great joy, which shall be to all people." [2:10]

Now it seems that the standing men at the right are shepherds guarding their sheep, of which we see five. The flying figures over the shed are the angels, who bring the news of Christ's birth to the shepherds in their fields at night. Giotto has thus condensed two events, which occur simultaneously but in different places, into a single space. He has also, if we look again, altered parts of the text. For Mary is neither swaddling Christ nor laying him in a manger. Instead, she lies down and turns as a midwife hands Christ to her.

This was a fairly conventional alteration, for it is more seemly to represent Mary at rest, and the infant being handed to her by a midwife, than for Mary to be fussing with the details of infant care right after she has given birth.

So far we have surveyed the most literal features of the textual basis for Giotto's scene, which constitute Panofsky's second level of iconographic reading. Panofsky's third, synthetic level opens up many additional avenues of discussion. For example, why does Joseph rest and his eyelids droop when Mary, who has done all the work, is wide awake? The dozing Joseph is a convention, which we understand through precedent and tradition. Because Christ's true father, according to the Christian texts, is God, and not Joseph, the earthly father symbolically withdraws from the event by going to sleep. In this regard, Giotto's Joseph differs slightly from the precedent, for he is not sound asleep, and his eyes remain slightly opened.

Giotto has not only condensed two events—the Nativity and the Annunciation to the Shepherds—he has also condensed the interior of the stable with exterior landscape. He accomplishes this by the openness of the shed, which, along with the ox and ass, denotes the stable. The ox stares at Mary and Christ, whereas the ass bends its head indifferently. This refers to the role of the ox as an enlightened creature, which recognizes that an important event is taking place. The ass, in contrast, fails to see what is happening, and thus becomes symbolic of ignorance and sin.

Ox and ass stand inside the stable, while the sheep and the goat are outside [17]. The latter are meant to be read with the shepherds, at some distance from the Nativity. But they are not just any old sheep, because they are accompanied by a goat. They are symbolic sheep, and their juxtaposition with the goat refers to the account of the sheep and the goats at the Last Judgment. This is described in the Gospel of Matthew (25:31–33):

> When the Son of Man shall come in his glory, and all the holy angels with him, then shall he sit upon the throne of his glory: And before him shall be gathered all nations: and he shall separate them one from another, as a shepherd divideth his sheep from the goats: And he shall set the sheep on his right hand, but the goats on the left.

The positive and negative connotations of right and left, respectively, are contained in Matthew's text. And in Giotto's image, the negative character of the goat resides in its blackness, in contrast to the whiteness of the sheep. The conventional Christian opposition of left and right, negative and positive, ignorance and knowledge, sin and salvation, dark and light are symbolized by Giotto in the formal opposition of black and white.

In the case of Giotto's *Nativity*, it is possible to undertake an iconological as well as an iconographic study, because it is part of a larger program. The fresco is located on the north wall of the Arena Chapel in Padua, and is one of twenty-five narrative scenes from the life of Christ. The entrance wall depicts a monumental *Last Judgment*. The *Nativity* is located in its chronological sequence between the *Visitation* to the left on the chancel arch and the *Adoration of the Magi* to the right on the nave wall. But the program of the Arena Chapel is more complex than a simple narrative sequence of events.

In a 1947 article, Michel Alpatov[4] analyzed the vertical parallelism of the Arena Chapel's iconological program. The *Nativity*, for example, is above the *Last Supper* [18], and therefore vertically aligned with it. Alpatov describes this parallel as follows:

> . . . the *Nativity* opens the story of Christ's childhood, the *Last Supper* that of his Passion. In the thirteenth century, pictures of the Nativity showing the Child in a manger on an altar alluded to Christ's future sacrifice. Both scenes represent the mystery of incarnation: in the first of them that of the Second Person of the Trinity into human flesh, in the second—the transformation of bread and wine into Christ's flesh and blood. Moreover, Giotto tried to emphasize the visual resemblance of both scenes. Despite the Byzantine tradition, Giotto reestablished in his *Nativity* the shed of Early Christian iconography, with a parallel in the edifice of the *Last Supper*. Giotto placed Christ in the *Last Supper* and the Virgin in the *Nativity* at the left part of the composition and insisted upon their resemblance by emphasizing both the Virgin's and John's tenderness towards Christ.[5]

In addition to vertical parallelism, the iconological programming of the Arena Chapel frescoes includes an entire system of prophecy and fulfillment woven through the scenes. Several aspects of that system converge in the *Nativity*. The metaphor of Christ as both the

18. Giotto, *Last Supper,* c. 1305, Arena Chapel, Padua.

shepherd of a human flock and the sacrificial lamb, for example, is related to the prior story—depicted in the top register of the chapel walls—of Joachim and Anna, Mary's parents. Joachim is represented as a shepherd who, in the opening scene, hugs a lamb. He has offered the lamb at the temple as a prayer for a child. But the priest rejects the offering—on the grounds that Joachim is too old—and shoves him toward a void. The dejected Joachim returns to his flocks and dreams of a child. He goes again to Jerusalem and embraces Anna at the Golden Gate.

In the *Nativity* these motifs recur: the shepherds, the sheep, and the seated, sleeping or dozing, foreshortened figure of the elderly father, whose child has been miraculously conceived. The embrace of Joachim and Anna at the entrance of Jerusalem foreshadows Mary's embrace of Christ in the *Nativity.* The prayer embodied by Joachim's lamb, rejected from the temple as Mary and Joseph were rejected by the innkeeper, is answered with Mary's birth. That she

becomes the mother of Christ fulfills yet another prophecy. Likewise, elements of the Nativity are carried forward in time to later events of Christ's life depicted by Giotto. For example, the unseeing ass is recapitulated in the sleeping soldiers of the *Noli Me Tangere* (*Do Not Touch Me*), in which Mary Magdalen reaches out to the risen Christ. In this scene, sleep stands for ignorance—neither the soldiers nor the ass recognize the significance of what is happening.

The shed and the background rock in the *Nativity* refer back in time to earlier scenes, but they convey additional significance in the future. On a literal level, the shed represents the stable. But on a symbolic level, its wooden material refers to the wood of the Cross, and the rock, although a natural feature of landscape, can refer to the church building. In the Gospel of Matthew 16:18, Christ says:

> And I say unto thee, That thou are Peter, and upon this rock I will build my church; and the gates of hell shall not prevail against it.[6]

Together, the shed and the rock—wood and stone—constitute an architectural metaphor. Christ will lay the foundation of a new religion, the wooden Cross will be its central symbol, and the shape of the Cross will provide the standard outline for western church plans. The stone, on which Christ builds his Church, will last eternally—it will, in the words of the hymn, be "rock of ages." Metaphors of this kind direct our attention forward in time and are conventions of Christian iconography. They are based on the typological system of Christian thought, which created parallels between past, present, and future through paired events and personages. Giotto has incorporated all these parallels into the iconology of the Arena Chapel frescoes.

The late-nineteenth-century painting entitled *Te tamari no atua* (*The Child of God*) [19], by Paul Gauguin, shows a brown-skinned woman with her eyes closed, lying on a bed. She wears a blue cloth around her lower torso, and a cat sleeps at her feet. Seated at the far side of the bed is a woman in lavender holding a baby. Immediately on her right stands a figure with green wings. In the background at the right are several animals under a shed. Two vertical wooden forms seem to rise from the floor to the ceiling of a room. One is decorated with geometric designs, and the other is solid brown, with two diagonals that reach to the top of the picture. Thus the pre-iconographic reading.

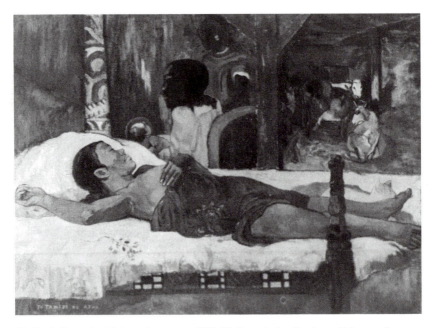

19. Paul Gauguin, *Te tamari no atua*, 1895–96, Bayerische Staatsgemäldesammlungen, Neue Pinakothek, Munich.

Even without the title, there can be no doubt that the iconography of Gauguin's painting is related to the Nativity of Christ. The animals in the shed recall the site of Christ's birth. Both mother and child have golden halos. The winged figure by the seated woman can only be an angel. And the wooden post behind the seated woman evokes Christ's cross by virtue of its shape. All of these motifs more or less conform to the Christian texts. But there is much more to the iconography of this painting.

Gauguin has merged the Holy Land with the islands of the South Seas, where he spent the last years of his life, and Christian motifs with elements of Tahitian myth. For the other sources of *Te tamari no atua*, the iconographer has to turn to previous images and to the "text" of Gauguin's biography. The cat at the foot of the bed, for example, is related to Manet's *Olympia* of 1863 [20]. There, the cat denotes prostitution (a "cat house"), which is not exactly the case here. However, the woman on the bed is Gauguin's mistress, who was described by his art student in Tahiti as "a slovenly, lazy young woman of dubious moral character."[7] Manet's *Olympia* also refers to the Classical tradition of

20. Édouard Manet, *Olympia,* 1863, Musée d'Orsay, Paris.

reclining females, with which Gauguin has merged his Tahitian mistress.

He also merged his mistress with the Virgin Mary, and this may allude to his personal connections to December 25. Significant events had occurred in his life around that time of year.[8] In 1877, his favorite daughter was born on December 24. His close friend Vincent van Gogh, with whom he had a stormy relationship, cut off his earlobe on December 23, 1888. Gauguin had a child by the mistress in this painting who was born within two weeks of Christmas, 1896. He therefore conceived the work around the time of his mistress's pregnancy. His related painting entitled *Be Be (Baby)* [21] has all the motifs of *Te tamari no atua* except for his mistress, her bed, the cat, and the totem pole. In *Be Be,* the angel is more prominent, and the woman holding the infant occupies the foreground. The iconography of these paintings is thus very much about the expected birth. But most of all, on a deeper level, the paintings are about Gauguin, and his identification with Christ.

For Gauguin, Tahiti was Paradise. In the Christian typological system, in which the Old Testament prefigures the New Testament, Mary is the new Eve, and Christ the new Adam, who redeems the

21. Paul Gauguin, *Be Be: Tahitian Nativity (Baby)*, 1896, Hermitage, St. Petersburg.

sins of the original Adam. Gauguin extends conventional iconography to include his own experience and relates it to the parallel between Tahiti and the Paradise that is refound through Christ's birth. Furthermore, the struggle between sin and salvation that runs through Christian history was a facet of Gauguin's personal struggle. He represented himself variously as a saint, as Christ, as a sinner, and as Satan.

In the bed, and the bedpost at the right, Gauguin has merged elements of the two cultures he knew well, Europe and the South Seas. Beds were used in Europe, but not in Tahiti. The painted decoration on the side of this bed is of the type used by Gauguin to depict floors in previous paintings.[9] He thus combines the notion of a floor (where Tahitians slept) with a bed (in which Europeans slept). The bedpost, which is a European feature, is nevertheless carved with "Maori architectural decoration."[10]

Finally, Gauguin juxtaposed the totem pole with the wooden

support that resembles the Cross. In this, he depicted the symbols that stood for the religious beliefs of the two cultures in which he lived. Both have an ancestral content, although they are expressed differently. That is, their "texts" differ, but their thematic content has points of commonality. The totem pole is literally an ancestral object, for the totem, usually in animal form, is the ancestor of a tribe. Gauguin's totem pole is carved in low relief and painted in the red and white geometric shapes typical of the South Seas.

The cross has a formal similarity to the totem pole in that it is thought of, and frequently represented, in conjunction with the image of Christ. In contrast to the totem pole, however, a human figure rather than that of an animal is depicted, or carved, on the cross. But the image of Christ on the Cross is also an ancestral motif, because (insofar as Christ is the Son) it mediates between God (the Father) and humanity (the children of God and Christ). Furthermore, there is a typological parallel between the Cross and the Old Testament Tree of Jesse.

The tree, and its wood, brings us back to Giotto's wooden shed in the *Nativity* and to the Gandharan relief showing the birth of Buddha. For Queen Maya gives birth to Buddha under a tree and, later, Buddha attains enlightenment while meditating under a tree. Trees were as symbolic in Indian religion as they are in the West. Long before Buddhism swept the Eastern world, tree cults had predominated, especially in India. They are found throughout early Mediterranean culture as well, and in both regions were connected with notions of a Cosmic Tree situated at the center of the universe. The tree is also a central symbol in Christianity: it bore the fruit that caused the Fall from Paradise, and it redeemed the Fall through the wood of the Cross. In all these instances, therefore, deeply buried as the implications of the tree and its wood may be, an iconographic interpretation that fulfills Panofsky's requirement of synthesis must take such implications into account.

The iconographic approach can also be applied to pictures and texts illustrating the myth of Arachne and Athena. In the mythical iconography of the tapestries woven by Arachne and Athena, the "text" was the myth itself. At first such texts are orally transmitted, and only later are written down, creating a kind of textual genealogy,

which can become quite complex as it extends through time and space. We can take as an example of this complexity the myth of the Rape of Europa, which Arachne depicted when she challenged Athena to the weaving contest. Europa was the daughter of King Agenor of Tyre. She was abducted by Zeus, who was disguised as a bull, and carried over the sea to Crete. There she gave birth to Minos and Rhadamanthus. Minos became king of Crete and, with Rhadamanthus, was made a judge in the Underworld.

The appearance of the myth in ancient Greece is evident from a scene on a red-figure vase of about 490 B.C. by the Berlin Painter [22]. Here, Europa grabs onto the bull's single horn and seems to rush along beside him. An early Greek source for this myth is Hesiod's *Catalogues of Women and Eoiae*, which is dated to about the late eighth to early seventh century B.C. It reads as follows:

Zeus saw Europa the daughter of Phoenix [the Phoenician] gathering flowers in a meadow with some nymphs and fell in love with her. So

22. Berlin Painter, *Abduction of Europa*, c. 490 B.C., Museo Archeologico, Tarquinia.

he came down and changed himself into a bull and breathed from his mouth a crocus [a sweet-smelling flower to entice Europa]. In this way he deceived Europa, carried her off and crossed the sea to Crete where he had intercourse with her. . . .[11]

Without the written text, it would be more difficult to identify the iconography of the scene on the vase. We would have to read it as a girl grabbing onto the horn of a bull and running alongside him. The myth of Europa was actually well enough known in antiquity to be mentioned and understood in passing references. For example, in the anonymous seventh-century B.C. Greek satire on epic warfare, *The Battle of Frogs and Mice*, Puff-jaw the Frog offers to carry a Mouse across the water on his back. The Mouse leaps willingly onto the Frog, wraps his paws around the Frog's neck, and settles down to enjoy the ride. But when black waves begin to rise up, he panics:

He put out his tail upon the water and worked it like a steering oar, and prayed to heaven that he might get to land. But when the dark waves washed over him he cried aloud and said: "Not in such wise did the bull bear on his back the beloved load, when he brought Europa across the sea to Crete, as this Frog carries me over the water to his house, raising his yellow back in the pale water."[12]

In *The Anacreonta,* which are later than Hesiod, a lyric poet describes a painting of Europa's abduction:

This bull, boy, looks like Zeus to me: he is carrying a Sidonian[?] woman on his back; he is crossing the wide ocean, and he cuts through the waves with his hooves. No other bull would have left the herd and sailed the ocean: he [i.e., Zeus] alone.[13]

The man who observes the ancient painting is in the same position as a modern iconographer. He confronts the unlikely image of a girl riding over the sea on the back of a bull. But, because he knows the "text" of the myth, he can match up the image with the words, and convey its meaning to the boy.

The story of Europa's abduction is most fully told in Ovid's *Metamorphoses*:

Majesty and love do not go well together, nor tarry long in the same dwelling-place. And so the father and ruler of the gods, who wields

in his right hand the three-forked lightning, whose rod shakes the world, laid aside his royal majesty along with his scepter, and took upon him the form of a bull. In this form he mingled with the cattle, lowed like the rest, and wandered around, beautiful to behold, on the young grass. His color was white as the untrodden snow, which has not yet been melted by the rainy south-wind. The muscles stood rounded upon his neck, a long dewlap hung down in front; his horns were twisted, but perfect in shape as if carved by an artist's hand, cleaner and more clear than pearls. His brow and eyes would inspire no fear, and his whole expression was peaceful. Agenor's daughter [Europa] looked at him in wondering admiration, because he was so beautiful and friendly. But, although he seemed so gentle, she was afraid at first to touch him. Presently she drew near, and held out flowers to his snow-white lips. The disguised lover rejoiced and, as a foretaste of future joy, kissed her hands. Hardly any longer could he restrain his passion. And now he jumps sportively about on the grass, now lays his snowy body down on the yellow sands; and, when her fear has little by little been allayed, he yields his breast for her maiden hands to pat and his horns to entwine with garlands of fresh flowers. The princess even dares to sit upon his back, little knowing upon whom she rests. The god little by little edges away from the dry land, and sets his borrowed hoofs in the shallow water; then he goes further out and soon is in full flight with his prize on the open ocean. She trembles with fear and looks back at the receding shore, holding fast a horn with one hand and resting the other on the creature's back. And her fluttering garments stream behind her in the wind.[14]

Ovid's version of the story is more elaborate than the Greek versions, but is essentially the same. They differ, however, in one important detail—in Hesiod it is the god who offers Europa a flower, while in Ovid, Europa offers *him* the flower. Most of the images that illustrate this myth do not depict the seduction, but represent instead the moment when the bull carries Europa over the sea. The iconographer, therefore, focuses on texts or parts of texts that describe Europa and the bull as they race across the sea.

In the *Fasti,* which explains the origins of the Roman calendar, Ovid also includes the story of Europa. This account roughly matches that of the *Metamorphoses,* except that there is more emphasis on the interaction between the girl and the bull while on the sea:

She held the bull's mane in her right hand, her drapery in her left; and her very fear lent her fresh grace. . . . Oft did she withdraw her girlish soles from the sea, and feared the contact of the dashing wave; often the god knowingly plunged his back into the billows, that she might cling the closer to his neck. On reaching the shore, Jupiter stood without any horns, and the bull was turned into a god. . . .[15]

In the *Dialogues of the Sea-Gods,* the second-century A.D. author Lucian elaborated on the activity accompanying the abduction. He relates the events through a dialogue in which the West Wind tells the South Wind what he has witnessed. He says that the sea became calm, that Cupids carrying torches "fluttered alongside just above the sea, occasionally just touching the water with their feet, . . . and singing the marriage hymn. . . ." Half-naked Nereids [sea nymphs] "rode alongside on dolphins. . . ." Tritons and other sea creatures danced around Europa, and the love goddess Aphrodite reclined on a shell. They went all the way from Phoenicia to Crete: "but when he set foot on his island, the bull was no more to be seen, but Zeus took Europa's hand and led her to the cave . . . blushing she was, and looking on the ground, for now she knew why she was being carried off."[16]

The iconography of Europa's abduction remained fairly constant for centuries, although its meaning occasionally varies. In Pompeian paintings and mosaics, there are several examples of Europa on the bull, and one in which Aphrodite and Cupid encourage the seduction beforehand. These are straightforward illustrations of the mythological text. In the Middle Ages, however, Ovid was "moralized," and brought into line with Christian allegory. Illustrations of the *Ovide moralisé* showing Europa on the back of the bull are allegories for Christ carrying off a human soul.[17]

In the Renaissance, with the revival of Classical texts, the story of Europa and the bull was taken up again by poets and painters. They shed the Christian gloss and returned to the mythological intent of the narrative. Ovid continued to be well known among humanist intellectuals, some of whom composed their own versions of his stories. In his long poem the *Giostra,* for example, the humanist Angelo Poliziano revived Ovid's account in two stanzas (1, 105, 106):

You can admire Jupiter transformed into a beautiful bull by the power of love. He dashes away with his sweet, terrified load, her

beautiful golden hair fluttering in the wind which blows back her gown. With one hand she grasps the horn of the bull, while the other clings to his back. She draws up her feet as if she were afraid of the sea, and thus crouching down with pain and fear, she cries for help in vain. For her sweet companions remain on the flowery shore, each of them crying "Europa, come back." The whole seashore resounds with "Europa, come back," and the bull looks round and kisses her feet.[18]

In addition to contemporary texts inspired by Classical mythology, the Renaissance produced new translations of the Classical texts. The Venetian humanist Lodovico Dolce translated the second-century A.D. Greek work of Achilles Tatius in 1546, and this was read by Titian.[19] Titian's *The Rape of Europa* [23] shows that he included the dolphins, Cupids, the distant mountains, Europa's companions on the shore, and Europa's pose from Tatius' text.[20] The painting was

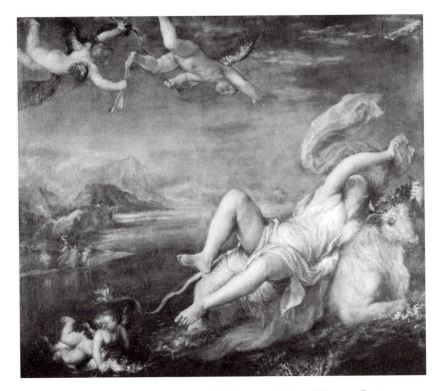

23. Titian, *The Rape of Europa*, 1559–62, Isabella Stewart Gardner Museum, Boston.

one of a series of so-called mythological *poesie* commissioned from Titian by King Philip II of Spain. The overall meaning of the icono- /patron/ logical program of the *poesie* has so far eluded researchers. But the texts that informed the individual works, including the *Europa*, have been fairly well established.

Titian's *The Rape of Europa* became a "text" for Velázquez's painting entitled *The Spinners* [24]. As the court painter for Philip IV of Spain in the seventeenth century, Velázquez had access to the Spanish royal art collection, where he regularly saw Titian's work. In its role as "text," Titian's *Europa* was reinforced by Ovid's account of the weaving contest between Minerva and Arachne. Ovid's text reads as follows:

> Arachne pictures Europa cheated by the disguise of the bull: a real bull and real waves you would think them. The maid [Europa] seems to be looking back upon the land she has left, calling on her companions, and, fearful of the touch of the leaping waves, to be drawing back her timid feet.[21]

24. Diego Velázquez, *The Spinners* (*The Fable of Arachne*), late 1650s, Prado, Madrid.

Here Ovid describes Arachne's picture, and we assume that his account was read by Velázquez as well as by Titian. When Velázquez depicted his own version of this event, however, he followed Titian's iconography more closely than Ovid's text. In *The Spinners*, Velázquez has painted a replica of Titian's *The Rape of Europa* in a complex scene that includes contemporary seventeenth-century women spinning in the foreground, and the mythological contest on a stage in the background. A copy of Titian's picture forms the backdrop of the stage.

Ovid's text, as we have seen in Chapter One, also describes the contest itself, and Minerva's rage at Arachne's skill. On the painted stage of *The Spinners*, Velázquez depicts the moment when Minerva strikes Arachne with the spindle:

> The golden-haired goddess was indignant at her success, and rent the embroidered web with its heavenly crimes; and, as she held a shuttle of Cytorian boxwood, thrice and again she struck Idmonian Arachne's head.[22]

In *The Spinners*, therefore, Velázquez juxtaposes Ovid's text with Titian's image. This, in turn, illustrates the point made in the Preface—namely, that a translation from one medium into another loses something of the original. In the case of Titian's painting, the image is "translated" from a sixteenth- to a seventeenth-century canvas: it is copied, and inserted into a new context. But the image itself is replicated. In the case of Hesiod, Ovid, Lucian, Achilles Tatius, and Poliziano, elements of text are changed or omitted. Since the translation from a written text to a picture is only more or less approximate, reading the image in the light of the text is never entirely complete. It invites further methodological approaches, which we consider in subsequent chapters.

NOTES

1. Erwin Panofsky, *Studies in Iconology* (New York, 1962), ch. 1.
2. Ernst Gombrich, *Symbolic Images* (London, 1972), ch. 1.
3. Stephen Jay Gould, "Mickey Mouse Meets Konrad Lorenz," *Natural History*, May 1979, pp. 30–36.
4. Michel Alpatov, "The Parallelism of Giotto's Paduan Frescoes," *Art Bulletin* 29, no. 3 (1947): 149–54. Reprinted in *Giotto in Perspective*, ed. Laurie Schneider (Englewood Cliffs, N.J., 1974); see pp. 111–12.
5. Ibid.

6. Note that "Peter," *petra* in Greek, means "rock."

7. Richard Brettell, "The Final Years: Tahiti and Hivaoa," in *Gauguin* (National Gallery of Art, Washington, D.C., 1988), p. 410.

8. Ibid.

9. Ibid.

10. Ibid.

11. *Catalogues of Women and Eoiae* in Hesiod, *The Homeric Hymns and Homerica,* trans. Hugh G. Evelyn-White, Loeb ed. (Cambridge, Mass., and London, 1982), p. 171; and p. 155: "Eoiae" refers to heroines who were introduced with the words ē oiē, "or like her."

12. *The Battle of Frogs and Mice,* in Hesiod, lines 70–80, p. 547.

13. *The Anacreonta,* in *Greek Lyric, II,* trans. David A. Campbell, Loeb ed. (Cambridge, Mass., and London, 1988), p. 231.

14. Ovid, *Metamorphoses,* II, 844–75, trans. Frank Justus Miller, Loeb ed. (Cambridge, Mass., and London, 1984), pp. 119–21.

15. Ovid, *Fasti,* V, 608–17, trans. Sir James George Frazer, Loeb ed. (Cambridge, Mass., and London, 1976), pp. 305–7.

16. Lucian, *Dialogues of the Sea-Gods,* trans. M. D. Macleon, Loeb ed., vol. VII (Cambridge, Mass., and London, 1969), pp. 235–37.

17. Panofsky, fig. 15.

18. Ibid., pp. 29–30.

19. Harold E. Wethey, *The Paintings of Titian,* vol. III (London, 1975), p. 173.

20. Ibid. and p. 78.

21. Ovid, *Metamorphoses,* VI, 103–7, p. 295.

22. Ibid., VI, 130–34, p. 297.

4

Contextual Approaches I: Marxism

The two most recent art historical methodologies that consider the economic and social context of art are those which have been influenced by Marxism and feminism. To a certain extent, these methods can be seen as reactions against formalism, and as expanding iconography to include aspects of the cultural context. Because the Marxist method predated, and influenced, the feminist method in its present form, we begin with Marxism.

Art historians influenced by Marxism read works of art mainly in relation to their political and economic role in society. For example, Turner's *The Slave Ship* [Plate 1], which Ruskin described so vividly in *Modern Painters,* was inspired by revulsion against the slave trade. A Marxist reading of Turner's painting could not ignore the political and economic impetus behind slavery, and its effect on the artist. In 1839, Thomas Folwell Buxton, a member of Parliament and a Quaker who led a crusade against slavery, published *The African Slave Trade and Its Remedy.* His argument detailed the abuse of human beings for economic gain. It included the report of an English captain who had 132 slaves thrown overboard in 1783 in order to claim insurance on the loss: "The master of the ship," Buxton wrote, "called together a few of the officers, and stated to

them that, if the sick slaves died a natural death, the loss would fall on the owners of the ship; but, if they were thrown alive into the sea, on any sufficient pretext of necessity for the safety of the ship, it would be the loss of the underwriters. . . ."[1]

To a considerable degree, art history that has been influenced by Marxism derives from certain views of Marxist politicians, critics, and philosophers. As early as 1857–59, in his *Introduction to the Critique of Political Economy*, Karl Marx argued for tying art to the culture that produced it. On the assumption that past cultural conditions cannot be exactly replicated, Marx believed that the production of art necessarily depended on its immediate context. Greek art, for example, required Greek mythology, and would be impossible in the context of nineteenth-century industrialization. "What chance," he wrote, "has Vulcan against Roberts and Co., Jupiter against the lightning-rod and Hermes against the Crédit Mobilier?"[2]

These sentiments reflect Marx's opposition to the prevailing nineteenth-century aesthetic of "art for art's sake." He also objected to a purely formal approach on the grounds that it failed to account for moral, social, and economic factors in the making and selling of art. For Marx, art did not belong in an ivory tower inhabited by aestheticians, but rather in the larger context of society and the economic historical process. He focused on the production of art, its relationship to the working class (the proletariat), and its exploitation by the ruling class. Marx viewed nineteenth-century capitalism as having accentuated the social division between an economic base dependent on the productive energy of the proletariat and a bourgeois superstructure largely consisting of the ownership class. Works of art, in this view, are made by "workers," but are commissioned, owned, and used for the advantage of the bourgeoisie. As a result, the artist—like the rest of the working class—is alienated from his own production, which has become a commodity. He has, in a sense, lost contact with a part of himself, and with the totality of his time and place.

Marx's approach to art influenced politicians, philosophers, critics, and art historians. Each of these disciplines has incorporated the Marxist point of view according to its own intellectual—and practical—bias. Many Marxist writers take a polemical stance, and most seem to agree with Marx that the end of medieval feudalism marked the beginning of the dichotomy between proletariat and bourgeoisie.

This historical development roughly coincides with the Renaissance.

In 1925, Leon Trotsky wrote that the Renaissance began when a new ownership class emerged from Gothic oppression. This new class, according to Trotsky, gained control of the means of production, the educational system, and the media. Trotsky took issue with Kant and the formalists, who analyzed the *elements* of art rather than its context. The Gothic cathedral, he said, could not be understood apart from the medieval town, the system of guilds, and the hierarchy of the Church. Attempts to do so signaled "intellectual decline." "The Formalist school," he declared, "represents an abortive idealism applied to the questions of art. . . . They [the formalists] are followers of St. John. They believe that 'in the beginning was the Word.' But we [the Marxists] believe that in the beginning was the deed. The word followed as its phonetic shadow. . . ."[3]

Trotsky was among the Marxists who believed that art—particularly "socialist art"—would serve political ends. In his view, the bourgeoisie was morally bankrupt, and socialist art would assist in reconnecting man to his spiritual self. "Socialist art," he said, "will revive tragedy."[4] For G. A. Nedozchiwin, a member of the Soviet Academy of Sciences, aesthetics played a part in economics, culture, psychology, and ethics, as well as in the history of art. He championed Soviet aesthetics as a force for Socialist Realism in opposition to bourgeois "Formalism and Naturalism."[5]

This political, rather than formalist, position was, to some extent, echoed by the avant-garde German playwright Bertolt Brecht in his *Notebooks* of 1935–39. Brecht focused on nonfigurative painting, of which he thoroughly disapproved. He was especially bothered by the fact that some nonfigurative painters allied themselves with Communism. Imagery, he felt, had a moral obligation to convey a social message. And he was dissatisfied with artistic displays of mere form. "You would do better," he admonished the nonfigurative painters, "to show in your paintings how man in our times has been a wolf to other men, and to say then: 'this will not be bought in our time.' Because only the wolves have money to buy paintings in our times. But it will not always be this way; and our paintings will contribute to seeing that it will not be."[6]

Some thirty years later, during the cultural revolution in China, Mao Tse-tung expressed the related view that art should advance the

political and social aims of the Communist state. Artists, like writers, should renounce bourgeois elitism and join the proletariat. Only in that way could artists create images of real life, which would assist the masses in achieving historical progress. Mao's political notion of art was reflected in his assertion that the bourgeoisie always excludes proletarian art, whatever its merit. Rather than allowing the perpetuation of artistic exploitation by the elite, Mao insisted on a "unity of politics and art" and a "unity of content and form."[7]

Seen in the light of Marxist ideology, the myth of Arachne and Athena takes on socio-political significance. Arachne becomes a kind of proto-revolutionary who challenges the goddess-as-superstructure, and tries to overturn her "divine" right. Arachne's alienation is not in the assessment of her talents, since she was renowned throughout Lydia for her skill. Rather, she misjudged the power of the goddess and the consequences of her own role as a worker and member of the proletariat.

Marxist Readings of History

The Austrian philosopher Ernst Fischer projected Marxist ideology into a mythic reconstruction of the economic history of art. He tied it to the history of human development from the era before tools to the twentieth century. For Fischer, art was the work of transforming nature, first by imitation and later by abstraction. Just as children repeat words and name objects in order to gain control of their world, so, according to Fischer, man gains control of nature by his power to repeat the making of tools. This leads to collective activity and permits social organization. "A subject-object relationship," he wrote, "occurs only through work."[8] The emphasis is clearly on work, defined as that which impels cultural and historical progress. Art is unequivocally tied to labor when Fischer writes that the "first toolmaker, when he gave new form to a stone so that it might serve man, was the first artist."[9]

Fischer's Marxist "myth" of the origins of art offers an instructive contrast to the fantasy of the "first artist" described by the American Impressionist painter James McNeill Whistler. Whistler championed the nineteenth-century formalist "art for art's sake" aesthetic, and in 1878 he went to court against the art critic John Ruskin, to

defend it. On February 20, 1885, Whistler delivered his "Ten O'Clock" lecture at Princes Hall in London. He identified the "first artist" as one who "stayed by the tents with the women, and traced strange devices with a burnt stick upon a gourd. . . . [He] perceived in Nature about him curious curvings, as faces are seen in the fire— this dreamer apart, was the first artist."[10] For Whistler, art served no practical, social, or political cause. "She [Art] is, withal, selfishly occupied with her own perfection only—having no desire to teach. . . . Beauty is confounded with virtue, and, before a work of Art, it is asked: 'What good shall it do?'. . . False again, the fabled link between the grandeur of Art and the glories and virtues of the State, for Art feeds not upon nations, and peoples may be wiped from the face of the earth, but Art *is*."[11]

In contrast to Whistler's "first artist," Fischer's was the inventor of tools. On this basis, Fischer constructs a mythical economic history of art. For example, he reads art in ancient Greece as an instance of class distinction embodied by the gods Apollo and Dionysos. Apollo stood for the status quo of the superstructure, especially for the aristocratic class and for royalty. Surging from below was the Dionysiac revolt—primal, collective, and opposed to alienation. It was driven by a nostalgia for social unity, which had been lost in divisions of labor brought about by the fragmented complexity of civilization. The forces embodied by Dionysos were arrayed against the "*hubris* of private property and the wickedness of class rule. . . ."[12]

Just as Aristotle believed that art could repair certain deficits of nature, so Fischer had faith in the power of art to elevate humanity. It could, he believed, repair fragmentation and alienation, and restore wholeness. Great periods of art did just this. They occurred when the interests of both the ruling and the revolutionary classes coincided with the forces of production and the needs of society. But, "In a decaying society," Fischer wrote, "art, if it is truthful, must also reflect decay. And unless it wants to break faith with its social function, art must show the world as changeable. And help to change it."[13] This is a far cry from Whistler's "Art *is*."

Walter Benjamin, writing in 1936 on art in the age of mechanical reproduction, took up the question of the effects of technology on the *value* of art.[14] Whistler's aesthetic of "art for art's sake" would

enhance the value of a work insofar as it is the product of a specific creative artist. But for Benjamin, nineteenth-century advances in technology eliminated authenticity—that is, the certainty that a work was made by a particular artist—as a criterion of value. In his view, the original cultural intent of art—for example, in the Paleolithic cave paintings—had given way to political intent. As early beliefs in image magic began to wane, Benjamin argued, the political value of imagery increased. As it became more feasible to reproduce works of art (by mechanical means) and to arrange for exhibits (through improved communication and more efficient travel), art lost its ritual aura and became a political commodity.

Even further removed from Whistler's formalism are the views of the Marxist literary and film critic Umberto Barbaro, who attributed the "birth" of art to economic necessity rather than to the visual free associations described by Whistler. Barbaro minimized the notion of artistic genius, as well as the value of creativity, by giving preference to collective social needs over the talents of the individual artist. Had one artist not been born to create a specific work, Barbaro wrote in the 1950s, "the work would probably have been accomplished by another artist. . . ."[15]

Such Marxist assessments of the history and role of art in society have influenced art historians who focus on social and economic readings of art. One of the most significant, and seminal, of these is Frederick Antal. Writing in the 1930s and 1940s, Antal combined a Marxist methodology with a history of ideas and attention to subject matter and themes. By this approach, he expanded the iconography of Panofsky and other Warburg scholars.

Marxist Influence in the History of Art

Frederick Antal. Antal opposed the philosophy of "art for art's sake" and pure formalism in favor of social context. His classic study *Florentine Painting and Its Social Background* exemplifies this approach. It deals with painting from Giotto to Masaccio—from the early fourteenth century to about 1430—and sets it within its social, religious, political, and economic context. The issue of patronage, which elucidates the influence of the buyer on the artist and his product, is also considered in some depth.

Antal locates the foundations of European capitalism in Florence from the twelfth through the fourteenth centuries. During that time, the textile industry (especially wool), international trade, and banking were transferred from the control of "master-craftsmen" to the "capitalist *entrepreneur*."[16] The gold florin—the Florentine monetary unit—was first coined in 1252, and became the "international currency of the world market."[17] The large profits made by the Calimala (the guild that finished imported textiles) depended on low wages for the workers.[18] In addition to controlling the means of production, the Florentine "capitalists" also ran the leading banks, and with them the finances of the pope. Such concentration of financial and mercantile power in the upper middle class of Florence was unprecedented and, according to Antal, resulted in the subjugation of the workers.[19] This social configuration was reinforced both by the Church and by the humanists interested in reviving Roman republicanism. Antal relates these social and economic developments to a change in artistic styles. He attributes a new rationalist outlook to the Florentine bourgeoisie, which led to humanist rather than to spiritual trends in art.

The artist who most embodied the new upper-middle-class outlook, according to Antal, was Giotto. He decorated chapels for the wealthy Bardi and Peruzzi banking families in the Florentine Church of Santa Croce, for the Franciscans in Assisi, and for the pope in Rome. For four years (1328–32), he was the official court painter in Naples. In his private life, too, Giotto conducted himself in capitalist style. He rented looms to weavers at high profits and, when debtors were unable to pay off their loans, hired lawyers to collect their remaining assets.

Giotto undertook his best known and best preserved work—frescoes illustrating the lives of Mary, her parents, and Christ—in the Arena Chapel in Padua, at the behest of Enrico Scrovegni. Enrico was the town's wealthiest citizen, and his father had been consigned by Dante to the Inferno for usury, which Giotto also practiced. Enrico's efforts to atone for his father's sins and ensure his own salvation took the form of an artistic commission.

In the iconography of the huge *Last Judgment* [25], filling the entrance wall of the chapel, Enrico kneels—on the side of the saved—and presents a model of the chapel to three angels [26]. His

25. Giotto, *Last Judgment*, c. 1305, Arena Chapel, Padua.

right hand holds onto the steps leading to the entrance. A monk supports the bulk of the model on his right shoulder, which frees Enrico's left hand. Its gesture, combined with the open palm of the central angel, implies that by means of Enrico's gift—made possible by his money—he will be welcomed into heaven.

Antal reads Giotto's narrative frescoes in the Arena Chapel as a

26. Giotto, detail of *Last Judgment*, showing Enrico Scrovegni donating a model of the Arena Chapel.

reflection of the rational humanism of his time. He notes the omission of the more spiritual Passion scenes—for example, "the Agony in the Garden, the Temptation, the Journey to Emmaus."[20] Instead of portraying inner spiritual conflicts, Giotto typically externalizes tension for dramatic purposes. Formally, too, his style emphasizes

the rational, the human, and the psychological. His figures are solid, bulky, and they obey the laws of gravity. Antal describes this as "an ever-increasing tendency . . . to create organic structure, compositional clarity and compactness, and spatial unity."[21]

Giotto painted allegories of the Virtues and Vices on the right and left walls of the Arena Chapel, respectively. Justice is represented as a queen set in a Gothic niche [27]. Like Phidias' statue of Athena in

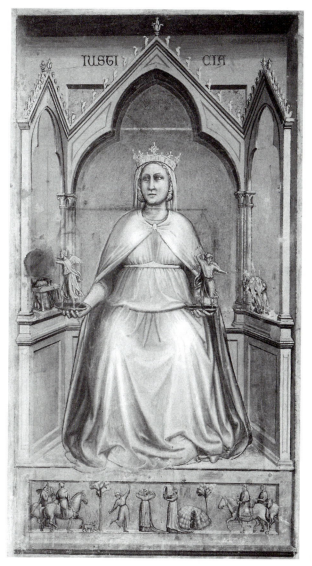

27. Giotto, *Justice,* c. 1305, Arena Chapel, Padua.

the *naos* of the Parthenon, she holds a Nike, or Winged Victory, in her right hand. Below are depictions of the effects of good government, which include dancing and commerce (implied by the riders). This conception, in Antal's view, exemplifies the bourgeois middle-class outlook of the time, and is a secular reinterpretation of a traditional religious allegory.[22]

Antal's study takes us through the fourteenth century into the early decades of the fifteenth. After the bubonic plague of 1348 (known as the Black Death) and the ruin of the Bardi and Peruzzi banks, Antal notes, more spiritual—and democratic—types of painting were produced. He attributes this partly to economic causes, and partly to the influence of a religious trend from Siena. But the basis of his interpretive methodology remains social, for he refers to this period as that "of lower-middle-class influence. . . ."[23]

In fourteenth-century Italy, Giotto was unique among artists in his rise to the status of a bourgeois property owner, and even in the early fifteenth century only a small number of artists achieved similar status. Among these were the sculptors Ghiberti and Donatello, who were patronized by Cosimo de' Medici. Ghiberti's *I Commentarii* is the earliest surviving autobiography of an artist describing his own works, and contains the first translations of Pliny on ancient artists. Likewise, the architecture of Brunelleschi expresses the "rational," secular outlook promoted by Leonardo Bruni and the humanist movement. In Antal's view, Brunelleschi's humanism was embodied in the dome of Florence Cathedral and the Hospital of the Innocents, which was specifically designed to house foundlings in Florence.

Until 1434, when Cosimo dominated Florentine politics, power was concentrated in the hands of a few wealthy families. Antal describes the development of a new upper-middle-class palace architecture at that time, and a proliferation of *cassoni* panels decorated with secular and mythological subjects, and birth plates *(deschi da parto)*.[24] These, he felt, were the result of luxurious tastes engendered by commercial success. Likewise indicating bourgeois patronage, in Antal's view, were commissions for portraiture in which the representation of the donor was gradually enlarged to the proportions of the sacred figures. Furthermore, in the course of the fifteenth century, patrons commissioned individual portraits and also required the inclusion of their images in sacred events.[25]

For Antal, the new fifteenth-century bourgeois style that was centered in Florence culminated in Masaccio, and is exemplified by the iconography of *The Tribute Money,* in which Christ is asked to pay a tax [28]. The painting is divided into three parts: in the center, Christ, who has no money, tells Saint Peter that he will find it in the mouth of a fish at the edge of the Sea of Galilee. Peter retrieves a coin from the fish at the left and pays the tax collector at the right.

Antal argues that the patron, Felice Brancacci, commissioned the work from economic and political motives.[26] Felice was a member of the Board of Maritime Consuls "and in 1422 had been sent to the Sultan of Egypt in Cairo on a mission ... to procure for them the trade with the Orient, based on the recently acquired seaport of Pisa."[27] He thus wished to demonstrate the economic importance of the sea through this rarely represented event from the Gospel of Matthew. The fact that the miracle is relegated to the distance suggested to Antal that the new rationalism had determined Masaccio's arrangement of the scenes. Likewise the new style, which included both aerial and linear perspective, the figures of the apostles inspired by Roman portrait busts, and the humanist influence evident in their dignified, monumental stature, exemplified the upper-middle-class aesthetic.

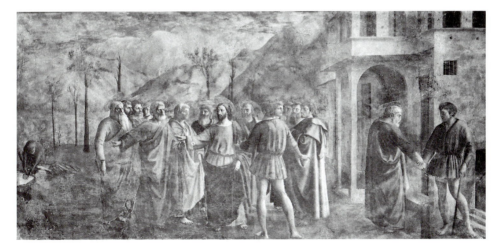

28. Masaccio, *The Tribute Money,* c. 1425, Brancacci Chapel, Santa Maria del Carmine, Florence.

Michael Baxandall. Like Antal, Baxandall was trained at the Warburg Institute in London, and interprets paintings as products of specific social and economic contexts. In *Painting and Experience in Fifteenth-Century Italy*, he addresses some of the ways in which painters participated in contemporary financial systems and styles of reasoning. He focuses on the financial transactions involved in the production of paintings, which he calls the "fossils of economic life."[28] This is particularly apt for the Quattrocento, when paintings were made according to contracts drawn up between artists and their patrons. Baxandall discusses the mathematical systems used in Italy—for example, the economic practice of "gauging." This practice is described by the painter Piero della Francesca in *De abaco*, which was a "handbook for merchants."[29] Since painters were also businessmen, their calculations of the dimensions of their pictures and of the mass and volume of their painted figures and objects corresponded to those currently used in commerce. "When a painter like Piero used a pavilion in his painting," writes Baxandall, "he was inviting his public to gauge."[30] He was also analyzing his visual perception in commercial terms of weight, mass, and volume, which his viewers would sense automatically. Artists as well as merchants, therefore, participated in a mathematical perception shared by the literate fifteenth-century public.[31]

Arnold Hauser. Writing on the sociology of art, Hauser exemplifies a Marxist approach. He identified the sixteenth century as the beginning of the mechanical age.[32] But he set that period within a historical continuum of growing class distinctions, and consequent alienation of workers from their products. In his reconstruction of the history of art, the first tools used by primitive hunters were endowed with a magic aura that conferred power on those who controlled them. Art was used for the political purpose of magnifying images of gods and kings, which made artists the spokesmen of the ruling classes.[33] Arguing against the aesthetic of significant form, Hauser wrote that "form is insignificant apart from the message it communicates."[34]

Hauser's view of Mannerism is a particularly appropriate example of his Marxist readings of art. He sees in the Mannerist style a disunity of form and content, which he relates to contemporary political and religious turmoil. Mannerism coincided with the

Protestant Reformation and the abuses of the Inquisition. Both developments had powerful and conflicting effects on society, its institutions, and the arts. The new intolerance exhibited by both the Catholic and the Protestant church authorities, according to Hauser, alienated many people from them. In the arts, the institution of the Academy was established, which admitted only the most successful and approved artists. This, in turn, encouraged class divisions among artists, and inevitably created new tensions.

Hauser relates contemporary political conflicts to the apparent contradictions of the Mannerist style. He discerns a disconnection between form and content in Mannerism, which is similar to the more general alienation between workers and their production. Mannerist paintings, according to Hauser, express these conflicts. For example, he describes Bronzino's *Eleonora of Toledo* [29] as follows: ". . . The cool, rigid, glassy expression, the lifeless, 'armor-like' masks . . ." show a lack of interest in the person and an excessive

29. Agnolo Bronzino, *Eleonora of Toledo and Her Son Giovanni de' Medici,* c. 1550. Uffizi, Florence.

degree of attention to lavish costume. The character of the sitter, he wrote, is "concealed behind a mask of indifference."[35] In this portrait, therefore, Hauser sees a disjunction between the figure and the splendor of her materialistic dress that reveals both a personal and a social alienation.

A work such as Parmigianino's *Madonna of the Long Neck* reflects the other quality attributed by Hauser to Mannerism [30]. The non-Classical proportions of the figures, the apparently irrational discrepancies between elongation and constriction of human form, and odd spatial juxtapositions also reflect, in Hauser's view, the prevalent social disunity of the age. He considers these formal arrange-

30. Parmigianino,
Madonna of the Long Neck,
c. 1535, Uffizi, Florence.

ments as "soulless, extroverted, and shallow, as an expression of unrest, anxiety, and bewilderment generated by the process of alienation of the individual from society and the reification of the whole cultural process."[36]

Svetlana Alpers. Reflecting an awareness of the relevance of economic factors to the production of art, Alpers has shed light on Rembrandt's relationship to the marketplace.[37] In so doing, she has been able to illuminate qualities of the artist's personality, style, and iconography in a new way. Rembrandt worked in seventeenth-century Protestant Holland, which had a flourishing art market based on the patron/artist relationship. It also had a number of professional artist organizations and "academies" of the kind that Hauser would consider alienating, and through which, according to Alpers, "the patron/buyer encouraged the professional to identify with him and hence serve him socially. . . ."[38]

Rembrandt, however, preferred not to conform to the prevailing system. Instead, he "commodified" his paintings—and himself with them. He turned his work into a kind of "coin" or currency, and issued "IOUs" promising work to offset his debts. Or, viewed in another light, he painted ("printed") his own money. This, according to Alpers, "involved the same speculative spirit which the Dutch exhibited in . . . tulips or the Amsterdam bourse."[39] It was also consistent with Rembrandt's wish to produce work for his creditors rather than for patrons. In that way, Rembrandt dealt in the impersonal market value of his work, the value of *"a Rembrandt"*—the capitalist approach to art—and not in the patron/artist relationship.

There is some irony in the degree to which Rembrandt's economic style represented a revolt against the establishment. He opposed the contemporary system of patronage by applying to art the same capitalist system that his patrons followed in business. In thus revolutionizing the art market, Rembrandt has affinities with the Arachne of Greek myth—when it is read from a Marxist perspective. The difference, of course, is that Rembrandt succeeded, and Arachne failed. For Rembrandt manipulated the social and financial context of his time, whereas Arachne, driven by impulse rather than intelligence, refused to take account of her class position. She was, in the Marxist sense, blinded by alienation from her own social reality.

* * *

Alpers shows that in the very making of a picture, Rembrandt trans-
formed paint into gold. She cites the *Artistotle with the Bust of Homer*
[31], in which the texture of the gold chain merges with that of the
paint. Form thus becomes content and, by the requirements of
Hauser, achieves "significance." In general, Alpers notes, Rembrandt
depicts money in a "decisively public context: *Judas Returning the
Pieces of Silver, Christ Driving the Money-Changers Out of the Temple, . . .
The Parable of the Laborers in the Vineyard, . . .* and, by implication,
perhaps, the group portrait of the Syndics."[40]

Alpers reads the figure in Rembrandt's *The Money-Changer* [32],
who holds up a coin and peers at it by candlelight, as an expression
of the artist's "fascination with hoarding."[41] In the picture, he
emphasizes this fascination by illuminating the stacks of books,
papers, and bags of money in a circle of light. Rejecting the
Christian reading of Rembrandt's figure as the biblical Rich Man,
Alpers takes him as a reflection of Rembrandt's pleasure in "capi-
talist" hoarding. She quotes from Marx's *Capital* a statement appli-

31. Rembrandt,
*Aristotle with the
Bust of Homer,*
1653, The
Metropolitan
Museum of Art,
New York.

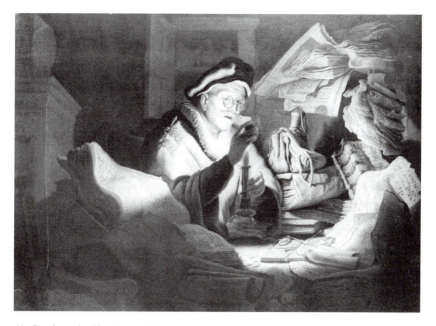

32. Rembrandt, *The Money-Changer* (*The Rich Man?*), 1627, Gemäldegalerie, Staatliche Museen, Berlin.

cable to *The Money-Changer:* "Only as a personification of capital is the capitalist respectable. As such, he shares with the miser an absolute drive for self-enrichment."[42]

In her approach to Rembrandt, Alpers's insistence on the importance of social and economic context enhances the understanding of the work. It also provides insights into the artist's personality, which is revealed by the way in which he turned contemporary business practice to his own financial advantage.

T. J. Clark. Clark's discussions of the nineteenth century add another lens to the social and economic view of art. They reflect the enormous impact of the Industrial Revolution, and of the writings of Karl Marx on Western thought. As Clark wrote, in the middle of the nineteenth century art and politics "could not escape each other."[43] The philosophy of "art for art's sake," on the other hand, was in part a withdrawal from such connections, and therefore a consciously contrived alienation from the disdained world of bourgeois capitalism. The self-conscious character of this withdrawal led to the French aesthetic of dandyism, which was taken up by Whistler and

some of his contemporaries in London. From this perspective, one could read formalism as alienation from content and context.

In two studies, Clark takes Delacroix's *Liberty Leading the People* of 1830 [Plate 4] as an example of how "experience becomes a form" and "an event becomes an image."[44] Delacroix depicts the French uprising of July 1830 against Charles X, the Bourbon king. Charles abdicated as a result of it, and was succeeded by the Citizen King, Louis-Philippe. For Clark, Delacroix's *Liberty*, which was exhibited in the Salon of 1831, was a seminal portrayal of the revolution as evidenced in the numerous visual quotations from it by engravers. Workers and members of the bourgeoisie join in the uprising, and each figure is identified according to class and occupation.[45]

The iconographic origins of the figure of Liberty are allegorical. Clark compares her depiction by Delacroix with profiles represented on antique medals, which he believes detracts from her femininity. She is, according to Clark, "a woman of the people . . . more like a peasant girl than a countess."[46] In the mob, too, Clark points out, of the five figures nearest the picture plane, four are "rabble."[47] His description of the painting thus focuses on social class and political context rather than on form or iconography.

In *The Painting of Modern Life*, Clark characterizes the entire modernist movement in social terms. The emergence of the lower middle class, he wrote, is "one of the main circumstances of modernist art."[48] He situates the development of modernism in Haussmann's renovated Paris of the grand boulevards and department stores, where fashion, recreation, and tourism came into their own. Distinctions were drawn between the city—with its factories on the one hand and places of entertainment on the other. The countryside was for leisure, while the suburbs evoked a sense of melancholy.[49]

The artist most associated with modernism, in Clark's view, was Manet.[50] When Manet's *Olympia* [20] was first exhibited, its critical reception betrayed a focus on the figure's place "in the world of the *faubourgs* and the working class."[51] For Clark, "class was the essence of Olympia's modernity and lay behind the great scandal she provoked."[52] Her iconographic derivation from Titian's *Venus of Urbino* [33] was barely noticed at the time. Instead, Manet's nude struck viewers as flagrantly naked, a slap in the face of the tired academic nudes currently in fashion, and obviously a paid prostitute. She was

33. Titian, *Venus of Urbino,* c. 1538, Uffizi, Florence.

not even a courtesan, or high-class prostitute, which might have passed as an acceptable category of representation.[53] As a common prostitute, Olympia aroused contemporary fears of the consequences of exchanging money for sex. These included venereal disease, which the mid-nineteenth-century authorities were having difficulty containing. The spectacle of sexual capitalism confronted viewers with an aspect of themselves that they would have preferred to suppress.

The impact of defiant visual confrontation also figures in the mythical conflict between Athena and Arachne. If we read superstructure for gods and proletariat for mortals, then Arachne has challenged Athena to *look* at inadmissible social and sexual interchange by depicting the male gods in pursuit of mortal women. Athena, in turn, weaves—and makes visible—the punishments for these transgressions against a social order in which gods and mortals do not mix. As the patron goddess of Athens, Athena stood for civic order and the status quo. The message of her scenes is that those who would be revolutionaries are destroyed.

NOTES

1. In Linnea H. Wren, ed., *Perspectives on Western Art,* vol. 2 (New York, 1994), p. 235.
2. Cited by Margaret A. Rose, *Marx's Lost Aesthetic* (Cambridge, 1984), p. 87.
3. In Berel Lang and Forrest Williams, eds., *Marxism and Art* (New York, 1972), p. 78.
4. Ibid.
5. Ibid., p. 134.
6. Ibid., p. 425.
7. Ibid., p. 117.
8. Ibid., p. 147.
9. Ibid., p. 148.
10. James McNeill Whistler, "The Ten O'Clock" (1885), in *Whistler: A Retrospective,* ed. Robin Spencer (New York, 1989), p. 221.
11. Ibid., pp. 212, 226.
12. Lang and Williams, p. 154.
13. Ibid., p. 160.
14. Ibid., ch. 23.
15. Ibid., p. 172.
16. Frederick Antal, *Florentine Painting and Its Social Background* (Boston, 1948), p. 11.
17. Ibid., p. 13.
18. Ibid.
19. Ibid., pp. 21ff.
20. Ibid., pp. 162ff.
21. Ibid., p. 162. See also Howard McP. Davis, "Gravity in the Paintings of Giotto" (1971), in *Giotto in Perspective,* ed. Laurie Schneider (Englewood Cliffs, N.J., 1974), pp. 142–59.
22. Antal, pp. 238–39.
23. Ibid., p. 199.
24. Ibid., p. 297.
25. Ibid.
26. Ibid., pp. 307ff.
27. Ibid., p. 308.
28. Michael Baxandall, *Painting and Experience in Fifteenth-Century Italy* (Oxford, 1974), p. 2.
29. Ibid., p. 87.
30. Ibid.
31. Ibid., p. 87.
32. Lang and Williams, p. 398.
33. Ibid., pp. 271–72.
34. Ibid., p. 271.
35. Ibid., p. 413.
36. Ibid., p. 410.
37. Svetlana Alpers, *Rembrandt's Enterprise* (Chicago, 1988), esp. ch. 4.
38. Ibid., p. 89.
39. Ibid., p. 96.
40. Ibid., p. 112.
41. Ibid., p. 113.
42. Ibid. and note 57.
43. T. J. Clark, *Image of the People* (London, 1973), ch. 1.
44. Ibid., p. 13; and T. J. Clark, *The Absolute Bourgeois* (London, 1973).
45. Clark, *Image . . . ,* pp. 48–49.
46. Clark, *Absolute Bourgeois,* p. 18.
47. Ibid., p. 19.
48. T. J. Clark, *The Painting of Modern Life* (New York, 1985), p. 202.
49. Ibid., p. 26.
50. Ibid., ch. 2.
51. Ibid., p. 88.
52. Ibid.
53. Ibid., pp. 109ff.

5

Contextual Approaches II: Feminism

———•◦•———

The feminist approach to art history is predicated on the idea that gender is an essential element in understanding the creation, content, and evaluation of art. Like the art historians who have been influenced by Marxism, feminist art historians object to formalism on the grounds that works of art, as well as artists, reflect their cultural context. Neither art nor artists, according to the feminist view, can be understood apart from that context. Questioning Clive Bell's eulogy of "significant form," one feminist critic asks, "To whom must the form be significant to count as art?"[1] This question challenges certain assumptions of traditional art history about the nature of art and the criteria by which it has been judged.

The feminist challenge is twofold. On the one hand, it considers ways in which women have been discriminated against as artists and as subjects of art. On the other hand, feminist art historians have been instrumental in recovering information about the contributions of women—both as artists and patrons. Feminists point out that men traditionally had more access to training in the arts than women, and that it was considered inappropriate for women to draw from nude models. Furthermore, apart from a very few exceptions, women were excluded from the academies that had been

established in Europe beginning in the sixteenth century. Childbearing and the demands of family life are also cited as impediments to artistic careers for women.

Feminists argue that women have consistently been depicted in a passive or negative light, which is emphasized by the selection of certain literary and iconographic themes. These run the gamut from objectifying the woman, as in Titian's *Venus of Urbino* [33], to rendering her as the root of all evil. In the latter role she appears as *Frau Welt*—Madame World—on the exterior of Mainz Cathedral in Germany. Frau Welt is an image of female deception, for seen from the front she is beautiful. But her back is covered with ulcerating sores, from which toads and snakes emerge.

In addition to highlighting these negative aspects of the depiction of women, feminist art historians have been able to provide a fuller picture of women as patrons, as well as artists. European queens such as Jeanne d'Evreux of France[2] and noblewomen such as Isabella d'Este (see pages 92–94) have been studied in increasing depth. Conferences on "matronage" have been held, and their proceedings published.[3] The role of women as artists has received greater recognition—from the medieval nuns who worked as copyists and illuminators, Renaissance and Baroque painters and sculptors, Dutch still life and portrait painters, to the work of nineteenth- and twentieth-century women artists.[4]

Another aspect of feminist methodology has been to show the iconographic effects of assumptions that both the artists and the viewing public are male. As a result, feminists argue, the depicted woman becomes the object of a man's (the active subject) gaze. This facet of feminist reading supports T. J. Clark's interpretation of Manet's *Olympia*. He notes, for example, that in contrast to Titian's *Venus of Urbino*, Olympia does not offer herself to the male viewer. She disrupts conventional expectations and, instead of reclining, sits upright and stares out of the picture plane, assertively returning the male gaze. She is neither self-absorbed nor idealized. Furthermore, according to Clark, her gesture, unlike that of Titian's nude, is calculated to antagonize. In Titian's *Venus*, the hand conforms easily to the curvilinear, languid character of the female body. But Olympia's hand aggressively calls attention to her genitals.[5] Manet thus challenges his audience, forcing the nineteenth-century

male viewer to confront Olympia's status as a prostitute, "to imag-
ine a whole fabric of sociality in which this look might make sense
and include him—a fabric of offers, places, payments, particular
powers, and status which is still open to negotiation."[6]

Gauguin's flight from such "civilized" implications of the female
body as in the *Olympia* to the "primitive" sexual freedom available
in Tahiti has been discussed by Solomon-Godeau.[7] She links
Gauguin's desire for the "Tahitian body" and the woman's submis-
siveness to nineteenth-century relations between colonizer and
colonized, and between the controlling gaze of the male and the
"subjugated," passive female. This view, according to Solomon-
Godeau, resides in the perception of woman as an alien "Other."[8]

The feminist focus on gender issues led to a questioning of the tra-
ditional canons and assumptions of Western art history. The canon is
considered a patriarchal construct, which values the notion of genius
and confers it exclusively on men. Feminists point out, for example,
that prior to the 1970s women artists were excluded from the major ✓
art history survey books. This is consistent with the fact that works
by women were typically considered inferior to those by men, and
were priced accordingly. A striking example of this tendency is illus-
trated by the fate of the *Portrait of Mlle. Charlotte du Val d'Ognes* [34].
The work was bequeathed to New York's Metropolitan Museum of
Art as a work of Jacques-Louis David and hailed by critics as a
remarkable portrait. When it was reattributed to Constance Marie
Charpentier (1767–1849), it "suddenly acquired feminine attributes:
'Its poetry, literary rather than plastic, its very evident charms, and
its cleverly concealed weakness, its ensemble made up from a thou-
sand subtle attitudes, all seem to reveal the feminine spirit.'"[19]

Feminists have also raised questions about the traditional cate-
gories of arts versus crafts. Historically, crafts have been a female
pursuit, while the so-called monumental arts—painting, sculpture,
and architecture—have been dominated by men. The feminist
objection to the lower status of crafts within a hierarchy of the arts
recalls sixteenth- and seventeenth-century "quarrels" over the sta-
tus of painting. Painting's medieval status as a "handicraft"
(because artists worked with their hands) was challenged as the
social status of artists improved. During the Renaissance in Italy—
earlier in Florence than in Venice—painting achieved the status of a

34. Constance Marie Charpentier, *Portrait of Mlle. Charlotte du Val d'Ognes*, c. 1800, The Metropolitan Museum of Art, New York.

Liberal Art. In Spain, however, Velázquez was still fighting for the elevation of painting in the seventeenth century. Feminists believe that crafts have been denigrated because of their association with women. Furthermore, they think that gender influences both the expression and interpretation of history—but for social and cultural rather than for biological reasons.

Women artists in Western Europe have traditionally received the

most attention from Classical and humanist authors. The Roman historian Pliny the Elder cited names of famous women painters in ancient Greece, although their works had been lost. In the sixteenth century, Giorgio Vasari, the biographer of Renaissance artists, deplored discrimination against the achievements of women. Vasari begins his *Life of Madonna Properzia de' Rossi* (c. 1490–1530), the sculptor from Bologna, with a list of famous women of antiquity and the sources from which they are known. Vasari notes that even in his own time women had succeeded in many fields, including the arts, and he is eloquent about Properzia's skill in carving and drawing.[10]

Vasari also cites the example of the nun Sister Plautilla, who lived in a Florentine convent on the Piazza San Marco. Her work was displayed in churches and in private houses. "The best works from her hand," according to Vasari, "are those that she has copied from others, wherein she shows that she would have done marvellous things if she had enjoyed, *as men do* [emphasis mine], advantages for studying, devoting herself to drawing, and copying living and natural objects."[11] In this assertion, Vasari prefigures certain modern feminist views,[12] associating the dearth of great women artists with discriminatory practices.

Sofonisba Anguissola of Cremona (1532/35–1625), a woman painter whom Vasari praises highly, worked for King Philip II of Spain. Although married twice, her career was not hampered by children. The art historian Mary Garrard has shown that Sofonisba's portrait of her teacher, *Bernardo Campi Painting Sofonisba Anguissola* [35], deals with some of the very problems that have traditionally confronted women artists.[13] At first glance, according to Garrard, one could read the painting in terms of the myth of Pygmalion and Galatea. For not only is Campi portrayed as the active painter and Sofonisba as the painted object, but as her teacher Campi actually did contribute to her "creation." Within the cultural context of Renaissance Italy, writes Garrard, men were cast as "subject agents with creative powers and females as passive vessels, objects acted upon by men, a construct that the Pygmalion myth itself reflects."[14]

This being said, Garrard proposes reading the painting in a more subtle light. In her view, Sofonisba planned the work as a disguise, to expose the prevailing "masculinist ideology" rather than to succumb to it.[15] Garrard notes that although Campi is apparently "active" and in the foreground, the portrait of Sofonisba is more

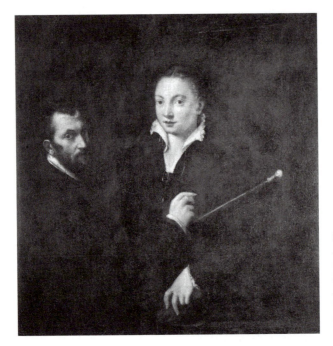

35. Sofonisba
Anguissola,
*Bernardo Campi
Painting Sofonisba
Anguissola,* second
half of sixteenth
century, Pinacoteca
Nazionale, Siena.

central, larger, placed higher up in the picture plane, and more illu-minated than the figure of her teacher.[16] Both Campi and the viewer are in the position of literally "looking up to" Sofonisba's portrait. Since the portrait within the painting resembles some of the artist's individual self-portraits, Garrard suggests that in fact it reproduces an earlier self-portrait. In this case, Campi becomes "unneces-sary"—"not Pygmalion but pseudo-Pygmalion, presenting himself as the creator of an artistic persona that is actually the creation of the artist herself."[17] Furthermore, Campi looks over his shoulder, link-ing the portrait with both the viewer and Sofonisba-as-painter. "With this stroke," according to Garrard, "Anguissola thematizes the subject of the male artist/active agent combined with his sub-ject/passive product while enframing it within a larger dis-course. . . . The invisible artist is therefore a witness to the deception which she records in her larger image."[18]

It is likely that, if Sofonisba had been a man, she would have had a greater range of subject matter at her disposal—and probably of patrons as well. Garrard therefore proposes the hypothesis that, as an educated woman in a "gender-conscious and gender-critical age,"

Sofonisba recognized her disadvantage. She felt that her role as an active woman working in the male-dominated world of art was negated by the very culture in which she lived. A woman in the sixteenth century was far more apt to have been the subject of a painting than its creator. The complexity and paradox of Sofonisba's image suggests that she consciously constructed a message detaching herself from the prevailing conventions of woman-as-object and man-as-subject. Her intention, in Garrard's view, "may have been designed to problematize the topos of the woman artist, to prevent the viewer from conflating the artist-agent with her image as a symbol of beauty."[19]

Although Vasari shared the modern feminist view about the difficulties of training for women artists, he differed with them in his belief that great artists are born, as well as made. Feminists, like Marxists, tend to object to the notion of inborn artistic genius as a nineteenth-century "romantic" construct. To support the idea that artistic accomplishment is primarily a result of training, rather than inheritance, Nochlin cites the fact that many women artists came from artistic families or had artist fathers who trained them.[20]

One such woman was Tintoretto's daughter Marietta, who was trained by her father, but died at the age of thirty. In the seventeenth century, Carlo Ridolfi wrote a biography of Tintoretto and his children, and although he admired Marietta's work, he noted by implication the problems facing a woman artist. He says, for example, that she dressed like a boy and accompanied her father everywhere. She painted works independently, according to Ridolfi, but some were "derived from her father."[21] Others were portraits of her husband's friends. Most revealing of implied comparisons based on gender is Ridolfi's statement that "she painted such works that *men* [italics mine] were amazed by her lively talent."[22] Nevertheless, professional women had an ally in Ridolfi, for he opens Marietta's biography as follows: "Slanderous tongues shoot their darts as they please. They concoct satires and invectives against the female sex, singling out as their greatest accomplishments the use of the needle, distaff, and spindle, and in painting their faces, entwining their hair with ribbons, gems, and flowers, and learning from the mirror how to be charming, how to smile, and how to be angry with their lover."[23]

That such attitudes persisted into the nineteenth century is revealed in the journals of Marie Bashkirtseff, who lived in Paris

and hoped to become an artist. Berthe Morisot and Mary Cassatt notwithstanding, Bashkirtseff laments the restrictions placed on women's access to artistic development:

> What I long for is the freedom of going about alone, of coming and going, of sitting in the seats of the Tuileries, and especially in the Luxembourg, of stopping and looking at the artistic shops, of entering churches or museums, of walking about old streets at night; that's what I long for; and that's the freedom without which one cannot become a real artist. Do you imagine that I get much good from what I see, chaperoned as I am, and when, in order to go to the Louvre, I must wait for my carriage, my lady companion, my family?[24]

Despite such acknowledgments of the problems faced by women artists, it was not until the 1970s that feminism became a significant movement in the art world. In what follows, I take as a framework for a discussion of feminism and art history Judy Chicago's installation sculpture of 1979 entitled *The Dinner Party*. This work has become an icon of feminist concerns [36].[25] It consists of a triangular

36. Judy Chicago, *The Dinner Party*, 1979.

table, each side of which is forty-six feet in length. The table stands on a triangular, porcelain-tiled floor decorated with the names of 999 women written in gold filaments. Thirty-nine place settings, thirteen on each side, stand for historically significant women. Each is celebrated with an image on a porcelain plate, a gilded wineglass, a knife, fork, and spoon, and a large embroidered place cloth. Both the embroidery and the painted china refer to the woman's traditional role in crafts. Similarly, the very iconography of a dinner party evokes the woman's place in the home, preparing and serving food. And finally, the triangular form is both a female sign (of the genital area) and a symbol of the Trinity, while the meal refers to Christ's Last Supper. Women, according to Chicago's message, have been sacrificed to the patriarchal domination of Western society.

One of the intentions of *The Dinner Party* was to write women back into history. The thirty-nine women symbolically "seated" at the table include goddesses, rulers, authors, saints, patrons, a biblical heroine, doctor, scientist, composer, and reformers. "Seated" first at Chicago's table is the Primordial Goddess, followed by Ishtar (an ancient Near Eastern goddess of love and fertility) and the Mediterranean Snake Goddess. The presence of these three figures implies that a matriarchal phase of history had preceded patriarchy.

The first historical figure at *The Dinner Party* is Queen Hatshepsut, who reigned in ancient Egypt during the Middle Kingdom. After the death of her husband and half brother, Thutmose II, she became regent for his son, Thutmose III, by a minor wife. By taking advantage of the co-regency system in ancient Egypt, she "was crowned king with a full royal titulary without having to oust Thutmose III from the throne."[26] Hatshepsut appointed the architect Senmut to renovate the mortuary temple begun by her father at Deir-el-Bahri and presided over a vast artistic revival. Senmut also acted as her steward and as the tutor of her daughter Neferura. Hatshepsut's political security depended largely on her image as a man, which she carefully manipulated in her titles and iconography.[27] Texts were created to assert that her father had personally appointed her his successor before the court and the pantheon of gods. Although at first called the "god's wife," Hatshepsut transferred that title to her daughter, and adopted for herself titles and imagery reserved for pharaohs. Artists represented

her as a king [37] who performed religious ceremonies in a manner reserved for kings. Her divine birth as pharaoh is represented in a relief at Thebes in which her mother, Queen Ahmose, appears with the chief god Amun-Ra.[28]

Hatshepsut's ability to rule Egypt against overwhelming odds makes her an appropriate choice for *The Dinner Party*'s first historical figure. The lengths to which she had to go to establish a male image, and the necessity of doing so, reinforce feminist views of Western history. An interesting footnote to Hatshepsut's reign concerns her daughter. Once Hatshepsut was crowned king, Neferura's image in art became widespread, and her name was repeatedly inscribed on monuments and written in texts. She often appears together with Senmut in statues of the period. It has been suggested[29] that she fulfilled an important ceremonial role usually reserved for queens, for the king's mother, or more rarely for the king's daughter. This would naturally create a problem for

37. *Hatshepsut as Pharaoh*, c. 1490–80 B.C., The Metropolitan Museum of Art, New York.

Hatshepsut, whose mother was dead, and who "could not have a king's principal wife."[30] But Neferura could accompany her mother as the king's daughter. The eventual fate of Neferura is unknown, but she neither succeeded Hatshepsut as pharaoh nor married Thutmose III, who ruled subsequently. Her most important title was "god's wife," which Hatshepsut had transferred to her.

Another patroness of immense political power appears on the second side of the table. This is Empress Theodora, who joined her husband, Justinian, in ruling the Byzantine Empire in the sixth century A.D. She had been a courtesan, but, on becoming empress, she instituted extensive moral reforms and advised Justinian on political and religious policy. She is represented opposite him in the pair of mosaics located on the side walls of the San Vitale apse, in Ravenna [38] [39].

Read from a feminist perspective, these mosaics reveal both Theodora's determination to be seen as the equal of Justinian and the ways in which the artist portrayed her as slightly below him in the hierarchical structure of Byzantine society. A comparison of the two mosaics shows that Justinian and his followers—the army with Constantine's CHI-RHO on a shield, the Archbishop Maximian, and assorted churchmen—are larger and stand more in the foreground than Theodora and her followers. Justinian's men are closer to the picture plane, which placement, with their taller and wider proportions, makes them more imposing. In Theodora's mosaic, the figures are set back from the picture plane, leaving room for the baptismal fountain supported by a truncated Corinthian column. The space that is filled only with figures in Justinian's mosaic is decorated in that of his wife with swags over the women, a symbolic apse, and a doorway and curtain behind the fountain. Furthermore, the abundance of elegantly detailed patterns in the women's dress "feminizes" the image. Even though Theodora is identified with the three Magi—embroidered on her robe—and is framed by the apse, she does not have the monumental presence of Justinian.

Finally, there is an even more subtle distinction between emperor and empress. Their mosaics are on either side of the central apse mosaic, in which Christ is seated on a globe. Like Justinian and Theodora, Christ is represented frontally, facing the viewer. But Justinian is to the right of Christ and Theodora to his left. Given the theological significance of right and left in Christian iconography, it

is evident that Justinian was intentionally located at "the right hand of God." Therefore, although actually at the same height as Theodora on the wall, Justinian is in a preferred position vis-à-vis Christ. This is consistent with his role as Holy Roman Emperor— Christ's earthly representative—and as Constantine's imperial heir made visible through the presence of the CHI-RHO. In contrast to Justinian, Theodora achieved her position by marriage, rather than in her own right.

Chronologically, Chicago's last prominent female patron of the arts is Isabella d'Este, Marchesa of Mantua (1474–1539), who sits at the third side of the table. The design of her plate is reminiscent of majolica glazes, because she promoted that industry in early-sixteenth-century Mantua.[31] She commissioned several leading Italian Renaissance artists to paint pictures for her *grotta,* or den, and her *studiolo,* or private study, in Mantua's Ducal Palace. Isabella's marriage to Francesco II Gonzaga connected Mantua with the Estes of Ferrara. Because of her status, Isabella could either negotiate with artists on her own behalf or hire others to do so,

38. *The Empress Theodora and Her Court,* A.D. 547, San Vitale, Ravenna.

although her plan to commission work from the leading painters of her time only partially succeeded. She failed to persuade Giovanni Bellini and Leonardo to work according to her specifications, but she did commission pictures from Mantegna, Perugino, Costa, and Correggio.

The significance of Isabella d'Este from a feminist point of view lies not only in the fact of her patronage but also in her iconographic choices. She selected the literary sources for the paintings she commissioned, and with her adviser she determined many of their motifs. She also insisted on emphasizing her role as patron by replacing the old Gonzaga insignia on the ceiling with her own personal symbols, and by inscribing her name at the center.

In Costa's *Coronation of a Lady* [40], Isabella herself occupies a central role as the lady crowned.[32] In this, she assumes a position of visual and iconographic importance that was rare for women of her time. Her image is neither an individual portrait nor one among many family members integrated into a larger narrative scene, which would have been more usual in the Renaissance.

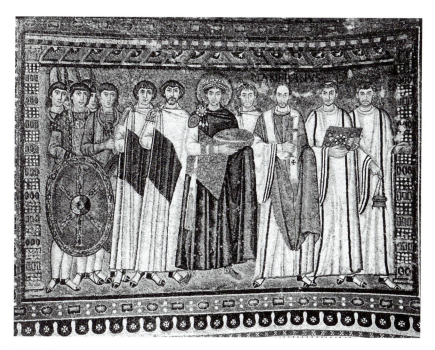

39. *The Emperor Justinian and His Court*, A.D. 547, San Vitale, Ravenna.

40. Lorenzo Costa, *Coronation of a Lady* (*The Realm of the Muses*), c. 1510, Louvre, Paris.

The iconography of the *Coronation* is somewhat elusive, but certain elements have been identified. Most of the foreground figures are mythological, while a battle between soldiers on horseback rages by the shore. A boat has arrived, and its crew strikes the sails.[33] The coronation itself takes place on a smooth, circular knoll, enclosed as a Garden of Chastity and set off against a dark clump of trees. The figures of Diana, with her bow and arrow, at the right, and Cadmus—the legendary founder of Thebes—fully clothed at the left guard the entrance to the garden. They, in turn, direct our gaze toward the seated females holding wreathed animals. These figures narrow the space through which we look up into the knoll framed by poets and musicians.

The focus of attention is the crowning of Isabella. A figure who is probably Venus[34] holds Anteros—the god of virtuous love—on her lap. He places a wreath on Isabella's head, thereby rewarding her "for the conduct of her life and her virtue. . . ."[35] Here, as in the other paintings commissioned by Isabella, themes of Chastity and Virtue

abound. That, in itself, is significant by contrast with the paintings commissioned by her son, Federigo II Gonzaga, for the Palazzo del Tè in Mantua. Both patrons chose Ovid's *Metamorphoses* as their literary source—in particular "the adventures of the gods as woven into Arachne's tapestry."[36] In Perugino's painting for Isabella—the *Battle Between Chastity and Love*—"the gods are denounced as enemies of chastity (*nemici di castità*) who, like Venus herself, must be defeated."[37] Correggio's paintings in the Palazzo del Tè, on the other hand, show Zeus standing for Federigo II. But rather than suggesting that the god is engaged "in an illicit enterprise," Correggio depicts Zeus acting "to accept the desire of the women who long for union with him."[38]

These opposing renditions of Ovid's text certainly reflect personal differences between Isabella and her son. Read from a feminist viewpoint, however, they can also be taken as representing male and female responses to Arachne's scenes. It seems that Federigo II identified with Zeus as the supreme patriarchal god, before whom all women are mere adoring mortals. Furthermore, the iconography reveals Federigo's notion that women would naturally pursue him, thus relieving him of any moral responsibility for his own illicit passions. Correggio shifts the meaning of Arachne's scenes from an emphasis on the active lust of Zeus, and makes the god an object of female desire. Isabella, on the other hand, takes the position of the virgin goddess Athena in Ovid's text. She stands for Chastity, and opposes the illicit behavior of the male gods and their pursuit of mortal women. She also opposes Venus—a traditional rival of Athena—as an advocate of passions that break down moral restraints. In their respective patronage, therefore, Federigo II turns the intentions and behavior of Zeus into the opposite of Ovid's portrayal, while Isabella identifies with the high-minded character of Athena.

Chicago includes two women artists in her *Dinner Party*—the Baroque painter Artemisia Gentileschi, who is "seated" at the second side of the table, and Georgia O'Keeffe. Artemisia has been studied from a feminist viewpoint by Mary Garrard, who has considered her iconography in relation to her role as a woman in seventeenth-century Italy.[39] It is no coincidence that one of Artemisia's most persistent heroines is Judith, who single-handedly saved her people, and that Chicago sets a place for her at *The Dinner Party*. Judith's story is told in the Old Testament apocryphal Book of

Judith. She was a Jewish widow of Bethulia, a town threatened by the Assyrian army. Together with her maidservant, Judith took a food basket and set out for the Assyrian camp. After several days at the camp, the general Holofernes succumbed to Judith's charms and invited her to dine with him. In a drunken stupor, he fell asleep in his tent, whereupon Judith decapitated him with his own scimitar. She placed his head in the food basket and returned with her servant to Bethulia. There she suspended Holofernes' head from the wall of the town, and the Assyrians retreated in disarray.

Garrard places Artemisia's treatment of the Judith theme in the context of her family and the prevailing culture. Artemisia's father, Orazio Gentileschi, was himself a painter, an example of Nochlin's observation that many women artists came from artistic families. But in Artemisia's case, her father hired Agostino Tassi to teach his daughter perspective. Tassi raped Artemisia, and then refused to marry her. The case went to court, where Artemisia—not Tassi— was tortured in order to test her truthfulness. Tassi was convicted but given a light sentence.

According to Garrard, Artemisia participated in the artistic lineage of Michelangelo and Caravaggio, and, like them, placed her own image in significant figures.[40] Judith thus represented a "model of psychic liberation" for a serious female artist.[41] Garrard enriches the interpretations of Artemisia's Judiths as revenge against Tassi by pointing to their social implications: "to justify rebellious, antisocial instincts—which she understandably may have held—through the celebration of the *legitimate* aggressive deeds of the famous biblical character, heroic avenger of the Jewish people."[42]

Taking the example of the Uffizi *Judith* of 1614–20 [41], Garrard discusses the effect on the viewer of a woman in the act of murdering a man. She locates its shock value in the identification of Holofernes as the patriarchal Everyman and the male fear of a woman in control.[43] "In metaphoric terms," writes Garrard, ". . . she [Judith] symbolizes female defiance of male power."[44] And whereas male violence to women is "traditionally perceived as normal or heroic . . . female violence, even when iconographically legitimate, is always questionable."[45]

Garrard compares the iconographic tradition of Judith with that of David, who also decapitates his adversary. Donatello's *Judith and*

41. Artemisia
Gentileschi, *Judith
and Holofernes*,
1614–20, Uffizi,
Florence.

Holofernes, for example, was probably commissioned as a companion piece to his bronze *David*, and both heroine and hero were seen as symbols of Florentine liberty. According to Garrard, however, in the work of male artists David continued as a positive, thoughtful hero, while Judith evolved "from a paragon of chastity, strength, and courage to a dangerous and deceitful *femme fatale*" in the course of the sixteenth and seventeenth centuries.[46] Artemisia's Judith is an individual—an active participant rather than a contemplative type. "In this construction of Judith," according to Garrard, "the artist suggests to us that the very dimension of female character that was inaccessible to male artists—more accurately, undesirable for them to contemplate—the realm of autonomous, independent action, was in fact the effective counterpart of a meditative David."[47]

Having begun with Hatshepsut as the first historical figure "seated" at her table, Judy Chicago concludes with Georgia O'Keeffe, the only member of her *Dinner Party* alive in 1979. To feminist artists,

O'Keeffe seemed a natural role model. Her talent and success had placed her in the forefront of early American abstraction. In 1916, the dealer and photographer Alfred Stieglitz—later O'Keeffe's husband—exhibited ten of her charcoal drawings in a group show at 291, his avant-garde gallery in New York City. Discussions of her work by Stieglitz and others appeared in his periodical *Camera Work,* which was published in October of the same year. Viewers were struck by the sensual monumentality of the drawings, and their dynamic expression of female sexuality. In Stieglitz, O'Keeffe had found her most important patron. Not only did Stieglitz appreciate her work on its own terms, he could also relate to its use of certain photographic techniques—such as the close-up (used in O'Keeffe's flower paintings), oblique views (her skyscrapers), and sharp contrasts of black and white (the *Lake George Window*).

O'Keeffe's *Black Iris III* of 1926 [42] epitomizes the kind of image that promoted her reputation as a painter of female sexuality. In being a close-up, it invites the viewer to focus on the soft interior textures of the petals. These are enhanced by the gradual shading and languid quality of the curves that seem to contract and expand. The layering of the lighter forms suggests a depth into which viewers can never penetrate, while the black center draws one into an unknown darkness. Framing the central and most solid black are two curvilinear "arches," whose diminishing size creates an inward perspectival thrust without the use of orthogonals. At the same time, a more shaded black petal flows from the center toward the picture plane—like a protruding tongue. The conflation of mouth and vagina, tongue and clitoris, lips and labia seems an obvious reading of *Black Iris III.* Such a reading is consistent with the image itself, for the flower is the reproductive organ of the plant. The remarkable synthesis of form and content in this painting is monumentalized by its close-up view. Hence its history as an icon of the feminine.

But all is not so simple. Barbara Buhler Lynes has discussed the ambivalent positions of both O'Keeffe herself and Stieglitz toward the feminine impact of her work.[48] For Stieglitz, O'Keeffe was very definitely a "woman artist"—"I'd know she was a woman—Look at that line," he declared in January 1916.[49] Comparing her to previous women painters, Stieglitz found her "bigger" than they, and this, he

42. Georgia O'Keeffe, *Black Iris III*, 1926, The Metropolitan Museum of Art, New York.

said, enabled her to "throw off her Male Shackles."[50] At the same time, however, Stieglitz emphasized that gender determined art, because it determined perception and experience. He agreed "with the widely held belief that men's and women's elemental feelings (which he called 'one of the chief generating forces crystallizing into art') were 'differentiated through the difference in sex make-up.' He stated that 'Woman *feels* the World *differently* than Man feels it . . . The Woman receives the World through her Womb. . . .'"[51] In the

view of Lynes, Stieglitz was indulging in "inconsistent" thinking, which "neutralized the strength of his position."[52]

With regard to O'Keeffe, Lynes attempts to resolve the apparent inconsistencies through a feminist reading of the artist's attitudes. Lynes shows that although there is ample evidence from O'Keeffe's own statements that she recognized the feminine aspects of her paintings, she objected to being categorized and exhibited as a "woman artist." In 1930, for example, O'Keeffe wrote that she was "trying with all my skill to do a painting that is all of a woman, as well as all of me."[53] And five years earlier she had indicated a preference that women, rather than men, write about her work—"I feel there is something about a woman that only a woman can express."[54]

Politically, as well as artistically, O'Keeffe had stated affinities with women's issues and, in the 1920s, was a member of the radical National Women's Party. In 1926, she spoke at an ERA (Equal Rights Amendment) dinner in Washington, D.C., and in 1942 wrote to Eleanor Roosevelt deploring her refusal to support the ERA.[55] On the other side of the coin, however, throughout the 1920s O'Keeffe fought against contemporary associations of her paintings and drawings with then fashionable psychoanalytic attention to sexuality. She even tried switching subject matter—to buildings instead of nature and sexually suggestive abstraction—in order to change her image. Her refusal in 1943 to participate in Peggy Guggenheim's exhibition of women's art at the Art of This Century Gallery was reiterated in 1977, when she declined another women's art exhibition at the Brooklyn Museum. Nor was she interested in Nochlin's feminist readings of her flower paintings.[56] "The only people who ever helped me," she said in 1973, "were men."[57]

Lynes's method of evaluating the ambivalence of both Stieglitz and O'Keeffe has a twofold feminist character. On the one hand, Stieglitz emerges as unregeneratingly divided: his admiration for O'Keeffe and the high esteem in which he held her work conflict with his opinion of her imagery as biologically determined—as work that only a woman could have created. He reinforced this view through his own work when he photographed O'Keeffe posing before her paintings. In so doing, according to Lynes, "he presented her as a femme fatale and explored her body in a personal tribute to female sexuality. . . . And by having her gesture sugges-

tively in front of her work in several images, he confirmed that in his view her expression was intricately related to her body and, therefore, a revelation of female sexual experience."[58]

For O'Keeffe, on the other hand, Lynes has an explanation that accounts for her shifting position. As a woman artist, O'Keeffe confronted discrimination based on her gender. She was also "working within a male-structured profession," her art was judged by "male-conceived ideas," and her career "inhibited by male-conceived ideas of what it should be."[59] By feminist accounts, the Western art world has always been—and to a large extent still is—"constructed" by men. Within that structure, men are allowed the freedom to be inconsistent—or, one might say, to be themselves—whereas women are held to a higher standard. They are expected to chart a steady course through conflicting political, social, sexual, and artistic waters.

NOTES

1. Estella Lauter, "Re-enfranchising Art," in *Aesthetics in Feminist Perspective*, ed. Hilde Hein and Carolyn Korsmeyer (Bloomington, Ind., 1993), p. 24.

2. Cf. Carla Lord, "Jeanne d'Evreux as a Founder of Chapels: Patronage and Public Piety," in *Patrons, Collectors, and Connoisseurs: Women and Art, 1350–1750*, ed. Cynthia Lawrence (University Park and London, in press).

3. Ibid., proceedings of the conference on "matronage" held at Temple University, Philadelphia, in the early 1990s.

4. Cf. J. J. Wilson and Karen Peterson, *Women Artists* (New York, 1976), pp. 1ff.

5. T. J. Clark, *The Painting of Modern Art* (New York, 1985), pp. 135–36.

6. Ibid., p. 133.

7. Abigail Solomon-Godeau, "Going Native," in *The Expanding Discourse*, ed. Norma Broude and Mary D. Garrard (New York, 1992), ch. 17.

8. For a different perspective on Gauguin's relation to the Tahitian nude, see Peter Brooks, "Gauguin's Tahitian Body," in ibid., ch. 18. For the women as Other in Athenian vase painting of c. 510 to 400 B.C., see Ellen D. Reeder, "Woman as Other," *Source: Notes in the History of Art* XV, no. 1 (Fall 1995): 25–31.

9. Elsa Honig Fine, *Women and Art* (Montclair, N.J., and London, 1978), p. 54, n. 45.

10. Giorgio Vasari, *Lives of the Most Eminent Painters, Sculptors, and Architects*, II, trans. Gaston Du C. de Vere (New York, 1979), pp. 1,043–48.

11. Ibid., p. 1,047.

12. Linda Nochlin, "Why Have There Been No Great Women Artists?" in *Women, Art, and Power and Other Essays* (New York, 1988), ch. 7.

13. Mary D. Garrard, "Here's Looking at Me: Sofonisba Anguissola and the Problem of the Woman Artist," *Renaissance Quarterly* XLVII, no. 3 (Autumn 1994): 556–622.

14. Ibid., p. 560.

15. Ibid., p. 561.

16. Ibid., p. 562.

17. Ibid., p. 565.

18. Ibid.

19. Ibid., p. 579.

20. Nochlin, ch. 7, 1988.

21. Carlo Ridolfi, *The Life of Tintoretto and of his children Domenico and Marietta*, trans. Catherine Enggass and Robert Enggass (University Park and London, 1984), p. 98.

22. Ibid.

23. Ibid., p. 97.

24. Marie Bashkirtseff, *Journals* (2 vols.), trans. Matilda Blind (London, 1890), entry for January 2, 1879. For this reference I am grateful to Allison Coudert.

25. The following discussion of *The Dinner Party* is from Josephine Withers, "Judy Chicago's *Dinner Party*," in *The Expanding Discourse*, ed. Norman Broude and Mary D. Garrard (New York, 1992), ch. 26.

26. Gay Robins, *Women in Ancient Egypt* (Cambridge, Mass., 1993), p. 47. Co-regency provided a means of allowing two kings to rule together, especially if one was elderly, as a way of ensuring "a smooth transfer of power from one ruler to the next."

27. For a fuller discussion of Hatshepsut's political image, see ibid., pp. 47ff.

28. Ibid.

29. Ibid., pp. 48–49.

30. Ibid., p. 49.

31. Ibid., p. 454.

32. Egon Verheyen, *The Paintings in the Studiolo of Isabella d'Este* (New York, 1971), p. 45, n. 93.

33. Ibid., p. 45.

34. Ibid.

35. Ibid., p. 46.

36. Ibid., p. 5.

37. Ibid.

38. Ibid.

39. Mary D. Garrard, *Artemisia Gentileschi* (Princeton, 1989).

40. Ibid., p. 279.

41. Ibid.

42. Ibid.

43. Ibid.

44. Ibid., p. 80.

45. Ibid., p. 295.

46. Ibid., pp. 301ff.

47. Ibid., p. 305.

48. Barbara Buhler Lynes, "Georgia O'Keeffe and Feminism: A Problem of Position," in Broude and Garrard, pp. 436–49.

49. Ibid., p. 439, n. 13.

50. Ibid., pp. 439–40 and n. 14.

51. Ibid., p. 440 and n. 15.

52. Ibid., p. 440.

53. Ibid., p. 442 and n. 24.

54. Ibid., p. 442, n. 23.

55. Ibid., pp. 442, n. 37.

56. Linda Nochlin, "The Twentieth Century: Issues, Problems, Controversies," in *Women Artists: 1550–1950*, ed. Ann Sutherland and Linda Nochlin (New York, 1977), p. 59.

57. Lynes, p. 438, n. 6.

58. Ibid., p. 440.

59. Ibid., p. 442.

6

Biography and Autobiography

The biographical method of art history approaches works of art in relation to the artist's life and personality. It assumes a direct connection between artists and their art, and it takes seriously the notion of authorship. The meaning of a work, its conception and execution, is seen as ultimately determined by the artist, with social and economic factors playing a secondary role. Nor are the formal elements of style thought to exist independently of iconography, which, however conventional, reflects the artist's individual choices in some way. The biographical method relies on texts concerning the artist's life, and also requires that one know which artist made which work. In the absence of such data, a traditional biographical method cannot be applied. The first sections of this chapter discuss biographical conventions about art and artists. The remainder takes up specific works, and shows the presence of the artist in them. It is the nature of that presence which reveals aspects of the artist's identification with the work.

Artists and Gods

In the history of Western art, the earliest written references that name specific artists have a mythical character. They associate

artists with gods, the former making lifelike figures and the latter, creating life itself. God's role as the supreme artist is illustrated in a thirteenth-century manuscript illumination [43], where he is shown drawing the universe with a compass. This image reflects the biographical convention that art is divinely inspired and that the artist has a divine or noble origin. Patrons of art, as well, could be inspired by divine intervention. In ancient Mesopotamia, for example, King Gudea of Lagash dreamed that the goddess Ninhursag instructed him to build a temple. In Egypt, Imhotep was credited as the originator of monumental stone architecture. His greatest surviving work is King Zoser's step pyramid at Saqqara, which dates to about 2700 B.C. [44]. Imhotep was later deified—made into a god—and worshiped at Heliopolis, literally the "city of the sun."

In ancient Greece, *mimesis* and the ability to create the illusion of nature became another conventional aspect of artists' biographies. We have seen (Chapter One) that this is a feature of the Platonic view of art, but it, too, has its origins in the mythic past. The architect and sculptor Daedalus was reputed to have made figures so lifelike that they seemed able to walk and talk. Prometheus stole fire from the gods in order to make his sculptures come alive. Although they were remarkably lifelike, they lacked breath, or spirit, which the Greeks identified with fire. But Prometheus, in the view of the Greek gods, went too far. They condemned him to eternal torture— he was chained to a rock and a vulture devoured his liver, which continually grew back. In this case, the gods objected because Prometheus went beyond artistic creation and refused to be satisfied with the illusions of art. He attempted to achieve the real thing, and, in so doing, challenged the supremacy of the gods.

In the myth of Pygmalion, by contrast, the artist does succeed in effecting the transformation from art to reality. But rather than achieve this by theft, he does so by praying to a goddess. In remaining subservient to the gods, Pygmalion gained favor with Venus, who answered his prayer and turned art into life.

Despite the association of gods with artists, the distinction between them is carefully guarded by the gods. In the biblical story of the Tower of Babel, God became alarmed that the building was reaching into his territory. As a result, he rendered the builders unable to communicate by confounding their language, and they

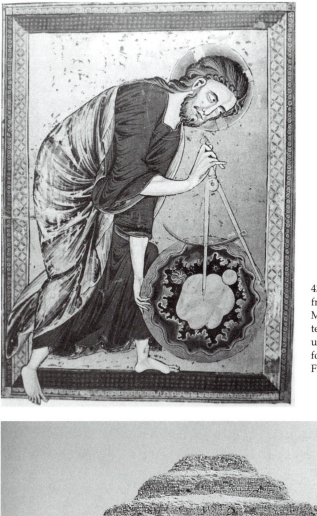

43. *God as Architect*, from the Bible Moralisée, thirteenth-century manuscript illumination, fol. 1v, Reims, France.

44. Imhotep, Step Pyramid, c. 2750 B.C. Saqqara, Egypt.

stopped working. When human creators such as Prometheus and the tower builders challenge the gods, they, like Arachne, are punished. But when artists are respectful of the gods and acknowledge them as the source of artistic inspiration—as Athena wanted Arachne to do—they are allowed to pursue their creativity.

Many ancient accounts of artists and patrons are assembled in texts such as Ovid's *Metamorphoses* and Pliny's *Natural History*.[1] Ovid describes the exploits of the mythic artists, and Pliny tends to deal with historical figures. Gudea's building activity is recorded on Mesopotamian cuneiform tablets. In all cases, the biographical approach to art depends on the written word, even if it is only the artist's signature. And even if one undertook a biographical study of an artist based solely on his work, one would need to have identified a body of work. Such an identification would usually rely on written evidence. The most basic biographical "text," therefore, is the name of the artist.

Biography as Literary Portraiture

Pliny's accounts of the Greek and Roman artists emphasize names. Even when he knows nothing of an artist's work, which is the case with several women, if he knows the name of an artist, he records it. His descriptions are, in effect, literary portraits of the lives, personalities, and works of ancient artists.

Pliny is also a rich source for many of the basic conventions that characterize the genre of artists' biography. His discussion of the fifth-century B.C. Greek painter Zeuxis reflects several such conventions, notably that the artist surpassed his predecessors in skill, wealth, and fame. Pliny cites an epigram of Apollodorus that states, "Zeuxis robbed his masters of their art and carried it off with him."[2] The image is one of theft (compare Prometheus), which evokes the convention of the artist as a trickster and a master of artifice. That Zeuxis carries off his masters' art also suggests the spoils of war, and hence the convention of fierce competition among generations of artists as well as between contemporaries.

Thanks to his skill in painting, according to Pliny, Zeuxis amassed a fortune and spent it advertising his own fame. At Olympia, he had his "*name* embroidered in gold lettering on the

checked pattern of his robes" [italics mine].[3] Zeuxis' pride in his abilities also led him to give away his pictures, on the grounds that their high value was beyond what buyers could afford to pay.[4] The relationship of an artist's sense of his own talents to the value of his work is a fairly constant biographical theme.

Echoes of Pliny-on-Zeuxis reverberate throughout Western biography. In the sixteenth century, for example, Raphael was so determined in his pursuit of wealth that he wrote to his uncle, pointing out that, had he agreed to marry, he would not have saved up three thousand gold scudi.[5] Rembrandt, as we have seen (Chapter Four), marketed his paintings with the aim of amassing wealth. And Rembrandt's biographer Arnold Houbraken wrote that his love of money prompted his students to paint gold coins on the floor, which the artist tried to pick up.[6] Parmigianino took his passion for wealth to unhealthy extremes; he renounced painting and devoted himself to making gold by alchemical means. Zeuxis turned the tables in giving away his work because of its high value. This reveals an arrogance that both asserts his genius and deprives him of money. In a sense, he cuts off his nose to spite his face, which avoids the dangers of *hubris* and turns the artist into a philanthropist.

Pliny says that, when Zeuxis was going to paint a *Helen* for the temple of Hera, "he held an inspection of maidens of the place paraded naked and chose five, for the purpose of reproducing in the picture the most admirable points in the form of each."[7] This corresponds to a convention derived from Plato's notion of the essential ideal. It assumes a prior conception of Truth and Beauty that the artist strives to capture. Zeuxis selects the most "truthful" forms from different women (whose individual imperfection prevents a single one from fulfilling the ideal). He then reassembles the forms to arrive at a totality that is more beautiful than the sum of its parts. In the sixteenth century, Raphael described a similar procedure when seeking a model for his painting of Galatea. He wrote his friend Castiglione, author of *The Courtier*, that no single woman fulfilled his "idea" of beauty. As a result, in order to paint a beautiful woman, he had to extract forms from several women and combine them.[8]

Zeuxis' rivalry with contemporary artists is exemplified by his competition with Parrhasius of Ephesus.[9] In this case, they were vying for excellence in *mimesis*, and each wanted to outdo the other by

creating the most convincing illusion of reality. Zeuxis painted such a realistic picture of grapes, which he hung on the front of a theater stage, that birds flew up and tried to eat them. In response, Parrhasius painted a curtain, and Zeuxis asked that it be opened to reveal the picture behind it. When he realized his mistake, he acknowledged defeat, for he had fooled only the birds, but Parrhasius had fooled him.

On still another occasion, Zeuxis reprimanded himself for imperfect illusionism. Pliny recounts that he "painted a Child Carrying Grapes, and when birds flew to the fruit with the same frankness as before he strode up to the picture in anger with it and said, 'I have painted the grapes better than the child, as if I had made a success of that as well, the birds would inevitably have been afraid of it.'"[10] In the first instance, Zeuxis fools birds but is himself fooled, and in the second, his grapes rather than his child prove to be convincingly illusionistic.

Parrhasius' victory turned out to be prophetic, for he was able to paint human figures that could be taken for real. And Pliny tells us which skills made this possible: he gave "vivacity to the expression of the countenance," drew outlines that conveyed a sense of three-dimensional volume, and contours that suggested "the presence of other parts."[11] Pliny cites Parrhasius' painting *The People of Athens,* in which he depicts their character as "fickle, choleric, unjust and variable, but also placable and merciful and compassionate, boastful, . . . lofty and humble, fierce and timid—and all these at the same time."[12] In other words, Parrhasius was able to convey the contradictory nature of the Greeks and show psychological conflict as well as the anatomical structure of human form.

Two particularly famous examples of Parrhasius' illusionism, in Pliny's view, depict men in the throes of physical exertion. One, *Runner in the Race in Full Armor,* "seems to sweat with his efforts."[13] The other, *Runner in Full Armor Taking Off His Arms,* is "so lifelike that he can be perceived to be panting for breath."[14] Because of his skill, Parrhasius is described by Pliny as arrogant to the point of coining his own epithets (modifiers of his *name*), including "Prince of Painters." He also claimed descent from Apollo, the Greek sun god, thereby conforming to the biographical convention of divine lineage.

According to Pliny, the greatest of all painters before or after his own era was the fourth-century B.C. Apelles of Cos. His competition

with Protogenes of Rhodes to determine who could draw the finest line is well known. Apelles won, and his victory is the source of the ancient maxim "No day without a line." He was also something of a trickster, and liked to hide when his work was exhibited in order to hear spontaneous criticism from observers. On one occasion, a shoemaker remarked that in a painting of shoes, Apelles had left out one of the loops. When Apelles corrected his mistake, the shoemaker fell prey to his own *hubris* and, at a later exhibition, criticized a leg. At this, Apelles appeared from behind the painting and said "that a shoemaker in his criticism must not go beyond the sandal"—an incident that gave rise to the proverb "Let a shoemaker stick to his last."[15]

Pliny makes much of Apelles' illusionistic genius. He notes, for example, that the artist concealed the blind eye of King Antigonus by depicting him in three-quarter view. His *Alexander the Great Holding a Thunderbolt*—which means Alexander with the attributes of Zeus—showed the fingers in three dimensions so that they appeared "to stand out from the picture."[16] His *Nude Hero* "challenged Nature herself."[17] So lifelike were his portraits that the physiognomists—people who foretell the future by reading foreheads—could work as well from the pictures as from the real people. And when he showed his picture of a horse to living horses, the living horses were fooled and neighed at the picture.[18]

In addition to his artistic skill, according to Pliny, Apelles had a gracious and courteous manner. This endeared him to Alexander, who liked to visit the artist's studio and, in fact, had officially decreed that only Apelles be allowed to paint his portrait. Alexander conferred on Apelles the even greater honor of painting his mistress, Pancaspe, in the nude. When Apelles fell in love with his model, Alexander gave her to him. In this way, Pliny says, Alexander gave both his lover and his affections to the artist, and Pancaspe, once the "mistress of a monarch, . . . now belonged to a painter."[19] Apelles is thus associated with the king, who rules by divine right, and therefore implicitly claims descent from the gods.

Hagiography Replaces Biography

From the Early Christian period (fourth century A.D.) to the fourteenth century, the biographical approach to art history is hampered

by a dearth of names. Exceptions such as the name GISLEBERTUS carved on the Romanesque tympanum of Autun Cathedral in Burgundy [45] highlight the relative anonymity of medieval artists. During that time, hagiography—the lives and miracles of the saints—largely supplanted the brief, but memorable, biographical accounts of artists in antiquity.

Nevertheless, certain conventions persist. In the New Testament apocryphal Infancy Gospel of Saint Thomas, for example, Christ is described as a child sculptor who makes birds out of clay. At his command, they come to life and fly.[20] This instance is consistent with the biographical—and autobiographical—convention attributing signs of early promise to artists. It also incorporates conventions in which artists are seen as masters of illusion, and hence as magicians, as well as alluding to their divine origins. In Christian art, the iconography of the baby king, which shows Christ as a miniature

45. GISLEBERTUS signature, c. 1130. Autun Cathedral, France.

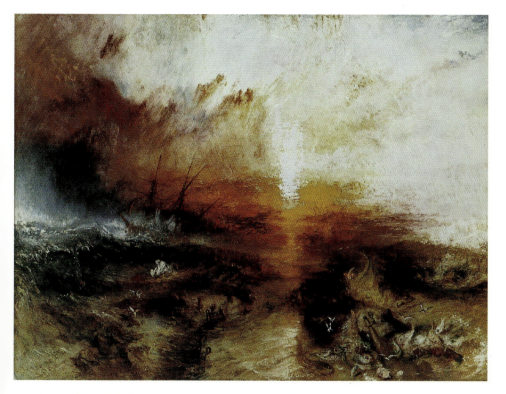

Plate 1. Joseph Mallord William Turner, *The Slave Ship*, 1840. The Museum of Fine Arts, Boston.

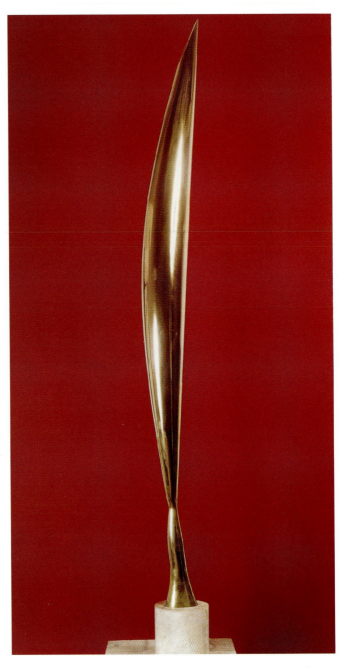

Plate 2. Constantin Brancusi, *Bird in Space*, 1940. Musée National díArt Moderne, Paris.

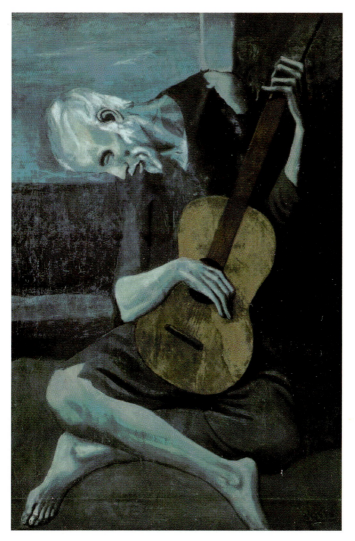

Plate 3. Pablo Picasso, *The Old Guitarist*, 1903. The Art Institute of Chicago.

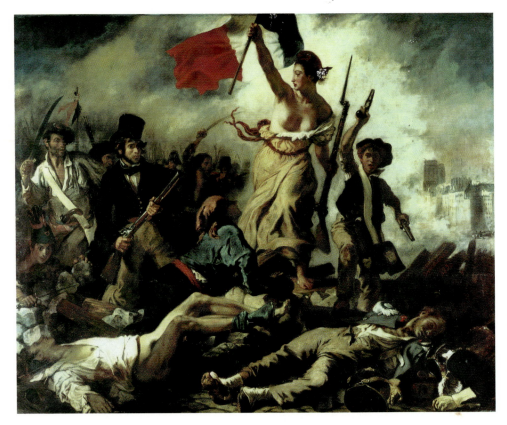

Plate 4. Eugène Delacroix, *Liberty Leading the People*, 1830. Louvre, Paris.

adult sitting upright and blessing the world, combines the promise of childhood with adult greatness into a single image. At the age of ten, Christ disputes with the Doctors in the temple, which also shows a precocious intellectual development.[21]

Christ became an example that the saints and martyrs tried to follow. Saint Francis of Assisi, in particular, set out to lead his life "in imitation of" Christ's life. The intensity of the saint's identification with Christ is shown when he renounces his father's wealth to assume a life of poverty, and when he receives the stigmata, or wounds suffered by Christ on the Cross. Saint Francis did not make art, but the tradition of his ability to speak with birds reveals the depth of his community with nature and with the sense of God's presence in it. Instead of producing illusionistic statues, Francis and other saints—like Christ—perform miraculous resuscitations. They do not actually create life, but they do, on occasion, restore the dead to life.

Vasari's Lives

With the beginning of the Renaissance, especially in Italy from the early fourteenth century, biographies of artists begin to reappear. A new emphasis on individual achievement and personal fame entered the contemporary literature—for example, Boccaccio's (1313–75) lives of famous men and women, and Petrarch's (1304–74) *Triumph of Fame.* By the middle of the fifteenth century, artists such as Ghiberti and Alberti had written autobiographies. Humanist authors writing on the dignity of man and the revival of Classical texts further contributed to the artist's emergence from the relative anonymity of the Middle Ages.

The text that is generally considered a landmark in the transition from anonymity to fame is from Dante's (1265–1321) *Divine Comedy.* His lines in Canto XI of *Purgatory* proclaim Giotto's triumph in obscuring the fame of Cimabue:

Once, Cimabue thought to hold the field
In Painting; Giotto's all the rage today;
The other's fame lies in the dust concealed. [Dorothy Sayers][22]

But the work that epitomizes the biographical approach to art history more than any other is Giorgio Vasari's (1511–74) *Lives of the*

Artists of 1550 (revised in 1568). It begins with the life of Cimabue (c. 1240–1302) and ends with Vasari's autobiography. The author's intention, as stated in the preface, is to preserve the *names* of artists and to link them with their works. The "ravening maw of time," he writes, ". . . has . . . blotted out and destroyed the names of all those who have been kept alive by any other means than by the right vivacious and pious pens of writers."[23] For Vasari, therefore, there is a necessary link between the preservation of names and the written word.

Vasari's purposes in writing the *Lives* have certain affinities with the miracles of the saints. In recording names, he hopes to ensure that they are remembered: "to defend them . . . from this second death [i.e., being forgotten], and to preserve them as long as may be possible in the memory of the living."[24] He also describes resuscitating artists from the dead by recovering their biographies. It was only through the greatest diligence, he asserts, that he was able to "draw them from the tales of old men and from various records and writings, left by their heirs a prey to dust and food for worms."[25]

Vasari revives the biographical conventions of antiquity in his Renaissance *Lives*. He begins by comparing God to a sculptor, calling man the "first statue."[26] He cites Pliny's account of Apelles, and then names his own "greatest artist"—Michelangelo. God, he says, created Michelangelo, who excelled in painting and in sculpture, the "king of sculptors, the prince of painters, and the most excellent of architects," and who, "after the manner of God, . . . can give us infinite delight."[27] Vasari "deifies" Michelangelo in metaphor as *il divino*. He says that he was born under a star—like Christ—and was descended from the noble counts of Canossa. The conventional rather than actual nature of these claims is evident, for the "star" is possible, and can have an astrological meaning, but the counts of Canossa are a fiction.

In addition to the "deification" of Michelangelo, Vasari notes that some artists were sent by heaven, as if God had lent them temporarily to the world. This notion is related to the conviction that artistic genius is inborn, a given of nature—a view rejected by the Marxists and some feminists.

In the "Life of Cimabue," Vasari cites Dante's verse (opposite), but it is his "Life of Giotto" that best embodies the conventions of

artists' biographies. Vasari describes Giotto's early childhood promise, according to which he was ten years old when Cimabue happened upon him drawing a sheep on a rock. The older artist instantly recognized the boy's talent, obtained his father's permission to train him as a painter, and then was surpassed by his pupil.[28] In tending sheep, Giotto is implicitly compared with Christ, who is traditionally portrayed as a shepherd, and with the shepherd boy David, who is one of the Old Testament types for Christ.

As with Michelangelo's fictive genealogy,[29] however, the conventional nature of Giotto's reputed genius in drawing sheep is readily evident from his *Nativity* in the Arena Chapel [17]. In that painting, the sheep are not particularly striking for the accuracy or brilliance of their execution. But other aspects of the painting are. For example, Giotto was the first artist since antiquity to render figures—here, the shepherds—in back view. To do so requires the construction of a three-dimensional picture space, which he also pioneered. His depiction of the intense gaze exchanged between Mary and Christ shows a new, and insightful, awareness of the mother-child relationship, and his dozing Joseph is a masterpiece of volumetric form.

Why, then, does Vasari repeat the anecdote about the sheep, when there is more than enough to account for Giotto's fame in his new way of representing space, weight, form, and dramatic portrayal of character? It would seem that Vasari uses the sheep to satisfy the requirements of biographical convention, specifically the convention associating artists with gods.

Having been "recognized" by the reigning artist of the older generation, Giotto, in Vasari's biography, proceeds according to convention. Years later, the pope's messenger arrives at Giotto's studio, seeking an artist for Saint Peter's, in Rome. Giotto draws a circle with such precision that the pope recognizes his genius, and hires him. This increased Giotto's fame and wealth considerably, for the pope paid him six hundred gold ducats.

Like Apelles, Giotto was known for his humor and wit.[30] This is manifest throughout the Arena Chapel scenes—for example, the detail of Enrico Scrovegni's cloak that illusionistically overlaps the edge of the entrance arch [26]. Sometimes, like certain of the ancient artists described by Pliny, Giotto used illusionism to play tricks on people. "It is said," Vasari wrote, "that Giotto, while working in his

boyhood under Cimabue, once painted a fly on the nose of a figure that Cimabue himself had made."[31] Cimabue believed that the fly was real, and tried to brush it off.

Just as Apelles had admonished the shoemaker for *hubris* in criticizing more than the sandal, so Giotto was intolerant of pretension. When a low-class fellow brought Giotto a buckler, and asked him to paint a coat of arms on it, the artist took offense. Instead of a coat of arms, Giotto painted "a helmet, a gorget, a pair of arm-pieces, a pair of iron gauntlets, a cuirass and a back-piece, a pair of thigh-pieces, a pair of leg-pieces, a sword, a dagger, and a lance."[32] When his client returned and became angry at the work, Giotto replied that he had painted him an entire suit of armor.

These and other conventions of artists' biography fill the pages of Vasari's *Lives*. Because of the mythic tradition relating artists to gods, there is a theme in artists' biography that establishes a genealogy of art and artists, in which both are descended from gods. Pliny describes this in terms of the material of art—for example, types of stone or metal, and the development of colors—and Vasari in family terms. He makes a point of mentioning both the biological and the artistic "fathers" of the artists. Giotto's father agreed to have Cimabue train him; Castagno's father died, but he was discovered by one of the Medici, who took him to Florence; Mantegna's birth was lowly, but he was adopted by an artist who worked for the Carrara lords in Padua; Raphael's father arranged for his apprenticeship to Perugino, and Leonardo was apprenticed by *his* father to Verrocchio. Michelangelo's father opposed his wish to be a sculptor, but eventually apprenticed him to the painter Ghirlandaio. Like Castagno, Michelangelo was discovered by the Medici, the leading patrons in fifteenth-century Florence.

This constructed kinship system among the artists also assumes a spiritual cast in Vasari. He records as popular wisdom that "the spirit of Masaccio had entered the body of Fra Filippo [Lippi]"[33] and that Raphael's spirit "passed into the body of" Parmigianino.[34] Vasari cites Greek epigrams linking Donatello with Michelangelo: "Either the spirit of Donato works in Buonarroto, or that of Buonarroto began by working in Donato."[35] This is consistent with the fact that Donatello and Michelangelo are the sculptural giants of the fifteenth and sixteenth centuries, respectively, and that both

were patronized by the Medici. They were also adherents of attempts by Neoplatonic philosophers to integrate Christianity with Platonism and made works illustrating mythological as well as Christian subjects.

To the degree that artists become a "family," the convention of competitive rivalry among them has a sibling quality. In 1401, in Florence, artistic competition became a civic event. Artists submitted reliefs illustrating the Sacrifice of Isaac for the commission to create a new set of doors for the Baptistery. One of the two leading contestants was Ghiberti, the goldsmith and author of the *Commentarii*, in which he discussed art and artists and included his own autobiography. The other main contestant was Brunelleschi, an architect, engineer, and sculptor. Vasari notes that all the competing artists, with the exception of Ghiberti, worked in secret to prevent their ideas from being copied. Ghiberti preferred to have people in and, like Apelles, to hear their comments so that *he* could learn from *them*. When Ghiberti won the commission, Brunelleschi went to Rome and renounced sculpture.

Renunciation in the face of either defeat or superior talent is another biographical convention for artists. Thus Verrocchio is said to have renounced painting when he saw what the young Leonardo could do. In Flanders, Hugo van der Goes reportedly fell into a depression and attempted suicide in 1481, when he realized that he would never produce a work as great as van Eyck's *Ghent Altarpiece*. But Brunelleschi did not renounce architecture, and came up against his earlier competitor when he was working on the dome of Florence Cathedral.

Ghiberti and Brunelleschi had received the commission jointly, and Brunelleschi objected. He felt that Ghiberti owed his job to political influence and attempted to have him removed. Eventually Brunelleschi resorted to trickery to achieve his ends. He stayed home, saying he was ill, and referred all questions on engineering techniques to Ghiberti. It soon became clear that Brunelleschi, and not Ghiberti, had the knowledge and skill to construct the dome, and Ghiberti was laid off. To Brunelleschi's irritation, however, Ghiberti continued to be paid a stipend for the work.

The resort to trickery, as we have seen in the account of Apelles, is an ongoing convention of artists' biographies. It is related to artifice, *mimesis*, and, in Vasari, to the theme of counterfeiting nature.

He says of Masaccio that his interest in fame led to his recognition "that painting is nothing but the counterfeiting of all things of nature. . . ."[36] Ghiberti, according to Vasari, who had read his autobiography in the *Commentarii*, "delighted in counterfeiting the dies of ancient medals."[37] And Parmigianino amused himself "by counterfeiting everything" once he had noticed the effects of distortion in a convex mirror at the barber shop.[38]

In the case of Parmigianino, counterfeiting took a perverse turn when the artist became obsessed with alchemy. But with Castagno, it became personal and assisted him in covering up the murder of Domenico Veneziano. Castagno's envy of the artist from Venice, particularly of his talent for color, drove him to waylay his rival and violently kill him. He feigned grief, according to Vasari, and confessed only on his deathbed.[39] The conventional character of this story is proved by its inaccuracy, for it has since been shown that Domenico Veneziano outlived Castagno.

Another convention that appears in Vasari is the notion that art can save the artist from danger. As the biblical Joseph was rescued from prison because of his ability to interpret dreams, so Vasari recounts the rescue of Fra Filippo Lippi. The artist had been captured and imprisoned on a ship by the Moors. When he drew a likeness of the master in his elaborate turban, he was freed, and was asked for more portraits. Eventually, because his talent was recognized, he was taken to Naples, where, like Joseph, he worked at court for the king.

A convention that applies mainly to male artists is the role played by women in their lives and art. The woman as a muse who inspires the artist has been a biographical convention since antiquity. In the myth of Pygmalion, it was the imperfection of mortal women that inspired the artist to create the ideal, marble Galatea, whom he treated as a real woman. He thus conflated the image with the person it represented. And just as Apelles fell in love with Pancaspe, Fra Filippo Lippi liked to paint women who aroused his passion. On one occasion, according to Vasari,[40] he had been commissioned to produce a panel painting for a convent. He caught sight of a beautiful novice, and persuaded the nuns to let her pose for his image of the Virgin. The result: he fell in love with his model, and they eloped. Their son, Filippino Lippi, also became a painter.

For Vasari, even more than for the Classical authors, the artist's personality was reflected in his style. In antiquity, the artists who painted illusions were themselves tricksters. But Vasari makes the connection even more explicit. He relates the rough and rugged quality of Castagno's style to his reputation for violence and revenge. He also compares his artistic talent to the ability to deceive in the real world: "Andrea was no less crafty in dissimulation than he was excellent in painting."[41]

Vasari's "Life of Uccello" exemplifies the convention of identifying artists with their art. Endowed by nature with a great talent for painting, Uccello disappointed his biographer by having spent too much time investigating mathematics and perspective. This preoccupation, which made even his wife jealous, resulted in the artist's painting "dry and angular" figures. Furthermore, according to Vasari, Uccello defied the convention in which artists strive to become rich, and made less money than others born with equal talent. He "remained throughout his whole life more poor than famous."[42]

Vasari concludes the *Lives* with his autobiography. Although it is not the earliest example of this genre, it reflects the relationship of biographers to their subjects. Vasari himself was an artist, although less talented than many of those whose lives he translated into written texts.

Developments Since the Renaissance

Since the dawn of the Renaissance, which provided Vasari's starting point for the *Lives*, there has been a proliferation of biographical genres. These range from brief anecdotal comments to autobiographies (Ghiberti and Cellini), notebooks (Leonardo da Vinci), poetry (Michelangelo), memoirs (Vigée-Lebrun), journals (Delacroix), letters (van Gogh), fictional biography (*The Moon and Sixpence*), and occasionally even the artist's signature. Biographical and autobiographical sources are now extensive, and the available material is vast. From Ghiberti's *Commentarii* to the present, artists have written about themselves. For example, Leonardo's notebooks cover a wide range of topics that justifies his reputation as a universal, Renaissance man. He advised artists on how to draw and paint, created architectural plans and maps, and described flowers, rock

formations, the properties of wind, rain, floods, and the physics of flight; he designed flying machines and war machines, composed riddles, and recorded one early childhood memory.

Michelangelo's sonnets are primarily expressions of his inner life. At the same time, however, they can be connected to features of his iconography and to his relationships with people. The memoirs of Vigée-Lebrun reveal herself as well as her time. They include facets of her artistic development, and also portray different aristocratic societies of eighteenth-century Europe. Delacroix's journals can be read as a biography of the artist's art. That they were closely studied by van Gogh is apparent from his letters to his brother Theo, who was an art dealer in Paris. The letters of van Gogh, in turn, chronicle his own life and art, and the influence that other artists had on him.

Today, videos of artists at work record their techniques. Simulated studio visits, taped interviews, and film biographies have been made possible by new visual media. Biographical films on Michelangelo (*The Agony and the Ecstasy*), van Gogh (*Lust for Life*), and Toulouse-Lautrec (*Moulin Rouge*) have become classics of their genre. As we saw in Chapter One, some environmental projects (by Smithson and Christo, for example) are largely dependent on the new media for their continued presence in the historical record.

With all these technological developments, we seem to have come a long way from the mythic association of artists with gods. But the biographical approach to artists remains imbued with traditional conventions about the nature of genius. The term *genius,* in fact, originally referred to a divinity, and the conventions associated with it still inform biographies and autobiographies of artists. It is no accident, therefore, that the genius of Picasso, and his domination of twentieth-century Western art, has led to a proliferation of biographical material on him. The very abundance of publications on Picasso, in effect, amounts to a kind of deification. He has been photographed and filmed, taped and interviewed; many people, from casual acquaintances to dealers, critics, intimate friends, and mistresses, have published memoirs describing their relationship with him. The works by his longtime friend and secretary, Jaime Sabartès, have proved to be valuable sources for the artist's life. In 1948, Sabartès published *Picasso: An Intimate Portrait,* which he calls "a narrative and no more . . . of events lived with Picasso, as I remember them."[43]

The account by Sabartès makes no secret of his admiration for Picasso's genius and the satisfaction he felt in sharing Picasso's life. It exemplifies the intimacy that many biographers feel with their subjects, although, in this case, the connection was *lived* and not only researched. The biography combines Picasso's memories as told to Sabartès with Sabartès's recollections of the artist. Its very inception was inspired by an interchange between Picasso and his biographer, for the artist recommended work as an antidote to the negative effects of idleness. His suggestion that Sabartès *work* at *writing* is a corollary to his own prodigious creative energy. It is consistent with what Gertrude Stein, the American expatriate living in Paris and a collector of Picasso's pictures, wrote in her own rather distinctive *Prose Portrait* of the artist: "One whom some were certainly following was one working and certain was one bringing something out of himself then and one who had been all his living had been one having something coming out of them. . . . This one was one who was working."[44]

Taking Picasso's suggestion, Sabartès knew at once that his subject would be Picasso, but he needed a point of view. When he found it, he turned the tables on conventional biography, and used Picasso's portraits of *him* as markers in *his* "portrait" of Picasso. Sabartès recalled that Picasso did portraits of him whenever they spent time together. He "decided, therefore, to take those portraits as texts, to try to imbue with warmth Picasso's pictures of me, to make them live anew, to enrich them with fragments from the life of their creator and shreds from my own."[45] Sabartès's "portrait" of Picasso is also a self-portrait and an autobiography. His assertion that he is taking Picasso's portraits as "texts" to reveal aspects of himself as well as of the artist is significant. For it is, in fact, possible to read imagery as an autobiographical "text."

Visual Biography and Autobiography

The image as a text that reveals the artist is perhaps most obvious in self-portraiture, where the artist consciously depicts his own image. When we see the artist's physiognomy, we naturally have the impression that we know something about him.

Sometimes one artist will make a portrait of another artist, or will comment on a past work that illuminates both of them. For exam-

ple, Duchamp's famous ReadyMade Aided *L.H.O.O.Q.* [46], in which a reproduction of Leonardo's *Mona Lisa* is given a mustache and beard, combines biography with autobiography. In that iconography, Duchamp makes a visual pun on Leonardo's bisexual identity and reveals his delight in playing with his own male-female identifications.

More indirect instances of visual autobiography include the artist's

46. Marcel
Duchamp,
L.H.O.O.Q., 1919.
Philadelphia
Museum of Art.

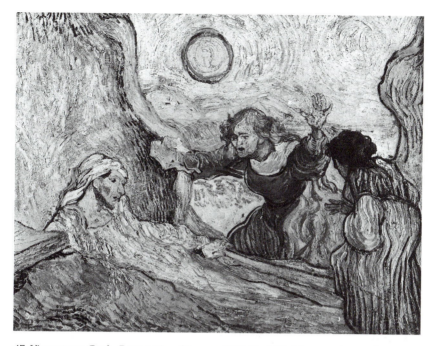

47. Vincent van Gogh, *Resurrection of Lazarus*, 1890, Stedelijk Museum, Amsterdam.

identification with a written text that his work illustrates. When van Gogh depicts himself as the barely resurrected Lazarus [47], he refers to his personal sense of having tentatively returned to sanity after a psychotic episode and a stay in a mental hospital. Gauguin represented Christ with his own features in *Christ in the Garden* [48], thereby identifying with the Temptation of Christ, and portraying his inner conflict between good and evil. This conflict is confirmed by Gauguin's *Self-Portrait with Halo* [49], which shows the artist simultaneously as an angel and a devil. The background division of the picture plane into red and yellow can be read as a formal, Symbolist device to reinforce the artist's struggle between two sides of himself.

Bernini was reputed to have represented himself as the biblical David,[46] which linked his own sculptural "heroics" to the slaying of Goliath [13]. In effect, he associates the power of his artistic innovations with the intellectual superiority of the unarmed shepherd boy. He implies that he, as a young artist, is up against the "giant" of tradition, which he has to topple in order to achieve his own stylistic "voice." (This is, in effect, what Duchamp does in

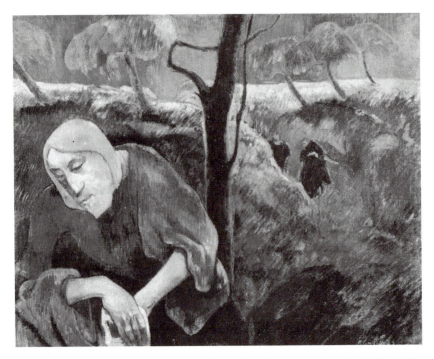

48. Paul Gauguin, *Christ in the Garden of Olives*, 1889, Norton Museum of Art, West Palm Beach, Florida.

L.H.O.O.Q., when he *de*faces—or *re*faces—what has become an icon of western art.) When Caravaggio represents himself as the beheaded Goliath [69], he identifies with the physical superiority and greater age of the giant. But he also reveals his private sense of psychological defeat at the hands of his young lover, who is represented as David.

Velázquez's self-portrait in *Las Meninas* [50] is a declaration of his position as the court painter to Philip IV of Spain. He hides the subject of the painting he is working on by turning the back of the canvas to the picture plane. He, on the other hand, *faces* both the picture plane and the viewer. On the "face" of it, therefore, he has chosen to reveal himself rather than his painted painting. He shows us the royal environment with the servants, dog, and dwarf who attend the five-year-old infanta Margarita. He shows us the king and queen reflected in the mirror, and the tapestry master standing in the back doorway. And he fills the walls with mythological pictures, now barely visible, which are about the Greek gods and their creative pursuits.

49. Paul Gauguin, *Self-Portrait with Halo*, 1889, National Gallery of Art, Washington, D.C.

50. Diego Velázquez, *Las Meninas,* 1656, Prado, Madrid.

One of these pictures illustrates the weaving contest between Athena and Arachne. Its presence links the fierce competition among artists at the Spanish court with the Greek myth. The latter serves as an exemplary warning against the *hubris* of Arachne, presumably aimed at the viewer but also at the artist himself. For Velázquez was a winner in Philip's court; he had once been accused of not being able to paint full-length figures, but had proved otherwise. On another occasion he was deemed the best painter by a panel of

judges. In the same painting in which Velázquez proclaims his intimacy with the royal family, and in which he stands before a huge canvas, he also uses the device of the picture-within-the-picture to project a psychological message as much to himself as to observers.

Another autobiographical element in *Las Meninas* concerns Velázquez's self-image as an aristocrat. Much of this is documented by Velázquez's biography, which was written in the eighteenth century by Palomino, Charles II's court painter. It was Velázquez's ambition to have painting in Spain elevated from a handicraft to a Liberal Art, as it had been in Italy during the Renaissance. This artistic ambition paralleled the artist's social ambition to become a member of the nobility. When he painted *Las Meninas* in 1656, Velázquez had not yet been accorded noble status. Nonetheless, he represents himself as a nobleman, at once assertive and at ease in the company of royalty, for the red cross of the noble Order of Santiago is prominently displayed on his black costume. The only explanation of this is that, three years after completing the picture, in 1659, when he was finally made a member of the Order, Velázquez revised *Las Meninas* by adding the red cross. He thus "signed" the picture twice, once with his self-portrait, and later with the red cross. In so doing, he condensed time—the time before and after his acceptance into the nobility.

"Signatures," as we have seen, can take many forms. Giotto's *O*, for example, has been discussed as "an abbreviated signature, playing on the double sound of the *O* in his name."[47] He literally made himself into a compass in order to draw the perfect circle. In so doing, he echoed the creative powers of God drawing the universe with a compass. Similarly, Michelangelo identified with God's hands as the tool of creative transformation from the idea to the work of art. This is apparent in his Sistine ceiling creation scenes, where God's hands are given special prominence. In the marble *David* [12], the right hand holding the stone is notably large in relation to the statue as a whole. On a preliminary drawing of the *David*'s arm, Michelangelo wrote, "David with the sling, and I with the bow"—the bow referred to a part of his tool for drilling marble. In the metaphoric association of the sling with the drill, Michelangelo relates David's manual skill as a fighter to his own as a sculptor.[48]

Signatures as Autobiography

When artists sign their works, they claim them as theirs. Most of the time, they sign with a name, monogram, or stamp, or they carve their name if they are sculptors. In the earliest recorded epic of the ancient Near East, the hero Gilgamesh is said to have "cut his works into a stone tablet."[49] By this the poet meant that Gilgamesh carved his exploits—which included the construction of the walls of Uruk—in stone. In some cases, the nature, location, or frequency of a signature has a specific autobiographical meaning that can be difficult to decipher. Michelangelo signed only one sculpture, the *Pietà* in Rome, which raises the question, why this one?[50] Even more curious, Titian signed his *Rape of Lucrezia* inside Lucrezia's shoe. (For more on shoes, see Chapter Eight.)

In 1889, at the age of twenty, Matisse was at his parents' house recovering from appendicitis. He entertained himself with *chromos,* an early "and less mechanical version of painting by number."[51] He signed two of these *Essitam,* which is *Matisse* spelled backward. "A picture," he is quoted as having said later, "is something that is signed, isn't it?"[52] In 1890, he signed "his first original painting [a still life of law books and a candle on a newspaper] . . . in reverse: *Essitam, H.*"[53] He also used *Essitam* as his cable address in Nice in the 1930s.[54]

When the relevant biographical information is available, or can be understood, it is possible to uncover the meaning of a signature. For example, on more than one occasion, the fifteenth-century Flemish artist Jan van Eyck signed his pictures with a statement as well as with his name. His *Man in a Red Turban* [51] of 1433, which is assumed to be a self-portrait, is inscribed "All I can" on the frame. This informs viewers that he poured his "all" into the work, that the *tour de force* of painted folds in the turban and of the minute physiognomic details required determination as well as ambition and talent. It also reflects the characteristic Renaissance wish to be remembered and immortalized through one's work. In the *Arnolfini Wedding Portrait* [52], van Eyck's famous prominent signature above the mirror on the back wall reads *"Johannes de eyck fuit hic,"* meaning "Jan van Eyck was here." The many interpretations of this painting notwithstanding, it seems clear that, as with the self-portrait, the artist is emphasizing his presence both *in* the picture and as the "author" *of* the picture.

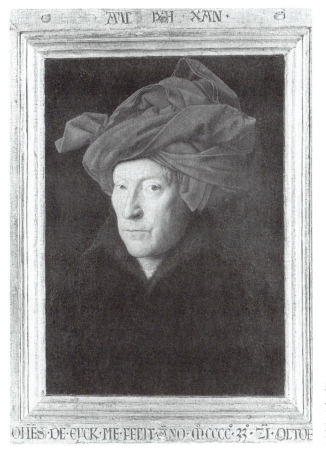

51. Jan van Eyck, *Man in a Red Turban,* 1433, The National Gallery, London.

Raphael was an enormously prolific artist, but he rarely signed his paintings. When he did, he was marking a significant point in his life. The earliest signature is on the *Crucifixion* (National Gallery, London), which he painted about the age of seventeen, at the end of his apprenticeship to Perugino. Since the style of that painting is so close to Perugino's style, one can conjecture that Raphael wished to identify himself as an artist distinct from, and superior to, his master. In so doing, he conformed to the biographical convention in which the young genius outstrips his teacher.

In 1504, at the age of twenty-one, Raphael signed and dated the *Marriage of the Virgin* [53]. The location of the date and signature, over the arch in front of the central doorway, marks his architectural ambitions and his future in Rome. Ten years later, in 1514, he

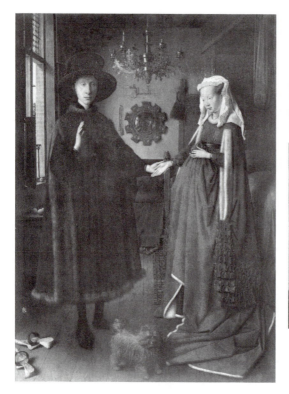

52. Jan van Eyck, *Arnolfini
Wedding Portrait*, 1434, The
National Gallery, London.
(Detail showing signature.)

would succeed his mentor, the architect Bramante, as chief architect
of Saint Peter's. Bramante thus became another teacher superseded
by Raphael's genius.[55]

The date of Raphael's *La Fornarina* [54] is not known. Nor is the
identity of the woman, but the signature on her armband is surely
an indication of the artist's special relationship with her. The gesture
of the left hand—the traditional *Venus pudica* ("modest Venus")
pose—has undeniable erotic connotations. It is the same gesture
that we have seen in Titian's *Venus of Urbino* [33] and Manet's
Olympia [20]. With her right hand, the Fornarina proffers her breast
as if referring to maternal nourishment. She thus combines the sex-
ual with the maternal qualities of a woman, and, as such, can be
read as Raphael's muse. His signature on her armband claims her as
his. He depicts his "ownership" of the Fornarina as certainly as if,
like Pancaspe, she had been granted to him by a reigning monarch.

In contrast to Raphael, who was known for his easy manner in
social and political situations, van Gogh revealed his lonely isolation

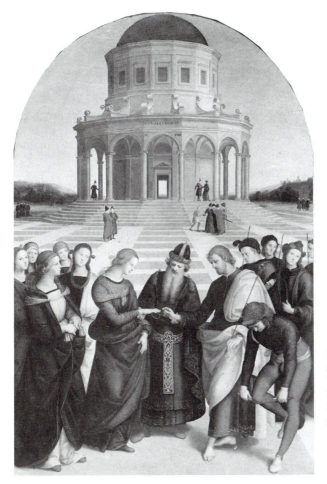

53. Raphael,
*Marriage of the
Virgin* (*Sposalizio*),
1504, Pinacoteca di
Brera, Milan. (Detail
showing signature.)

54. Raphael, *La Fornarina*, c. 1518, Galleria Borghese, Rome. (Detail showing signature.)

by the signature on the back of the chair at the left of *The Potato Eaters* [55]. The young man seated in the chair is about the age of van Gogh when he painted the picture. At this time, the artist was working as a lay preacher among the Belgian miners in the Borinage. He was attempting, without success, to follow his father's path as a minister.

The image of the miner's family, too poor to afford anything but coffee and potatoes, is united by the haloesque light over the table and contains several themes that recur in van Gogh's work. As a young man in his parents' house, in his native Dutch village, and in his relationships with other people, van Gogh never quite fit in. He made an odd, intense impression, as does the young man seated on the chair van Gogh has signed. By signing just there, van Gogh alerts viewers to his identification with the figure, with his isolation and his intensity, with both his wish and his failure to be part of a family.

An entirely different impression is created by Whistler's butterfly signature [56]. It is consistent with the artist's efforts to conform to

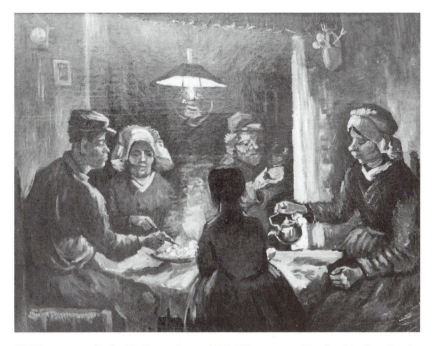

55. Vincent van Gogh, *The Potato Eaters*, 1885, Rijksmuseum Kroeller-Mueller, Otterlo, The Netherlands.

the formalist philosophy of "art for art's sake," and to the nineteenth-century fad for dandyism. Whistler's contemporary reputation as a "social butterfly" is reflected in the choice of his signature. But Whistler was also a biting wit, who gave lectures, engaged in lively social conversation, and wrote letters to the newspapers. When he signed letters, he added a scorpion's tail to the butterfly.

In making a distinction between the way he signed paintings and letters, Whistler personalized the dichotomy between words and images that is part of Magritte's meaning in the *pipe* [1]. It was as if Whistler were trying to reconcile two sides of himself—the pictorial side exemplified by the butterfly, and the verbal side by the sting of the scorpion. This dichotomy conforms to Whistler's stated distinction between color and line, which was also a component of his bisexual identification. In his view, color was feminine and sexual. It needed the control of a masculine line, lest it get out of hand and become a "bold whore."[56] He further distinguished between the artist who paints and the critic who writes. When he sued Ruskin

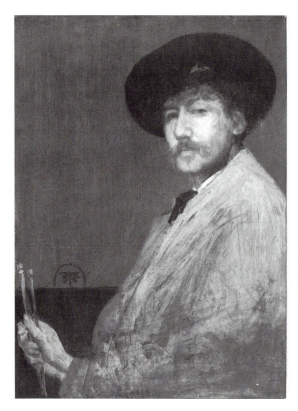

56. James Abbott McNeill Whistler, *Arrangement in Gray: Portrait of the Painter*, 1872, The Detroit Institute of Arts. (Detail showing signature.)

for libel—that is, for the written words that attacked him and his picture—he called the trial a contest between the brush (the painter) and the pen (the critic).

I conclude this discussion of signature and autobiography with a drawing by Saul Steinberg [57]. At the right, a black bottle labeled INK anchors the image. The solid black tip of the pen shows that this self-portrait is drawn with ink from that very bottle. Here the artist is literally in the process of drawing himself; he is at once the author and the subject of the image. A sense of concentration and subdued inner peace is conveyed by the serene facial expression and the deliberate care with which the tip of the pen joins the tip of the chin. Steinberg is at one with his self-image as it is expressed in the drawing. He has also, in a sense, achieved a synthesis of word and image, of line and form. This is a quintessential statement of art as autobiography, of the artist's dual role as creator and created, of his authorship, and of his presence in his own work.

57. Saul Steinberg, *INK*, 1945.

NOTES

1. On Ovid and Pliny as the basis of biographical methodology, see Paul Barolsky, "A Very Brief History of Art from Narcissus to Picasso," *The Classical Journal* 90, no. 3 (1995): 255–59.

2. Pliny, *Natural History*, XXXV, xxxvi, 62. Trans. H. Rackham, Loeb ed. (Cambridge, Mass., 1984), p. 307.

3. Ibid., p. 309.

4. Ibid.

5. V. Golzio, *Raffaello nei documenti* (Rome, 1936), p. 31, and Rudolf and Margot Wittkower, *Born Under Saturn* (London, 1963), p. 153.

6. Arnold Houbraken, in Tancred Borenius, *Rembrandt: Selected Paintings* (London, 1942), p. 28.

7. Pliny, 64, p. 309.

8. Golzio, p. 30.

9. Pliny, 65–72.

10. Ibid., p. 311.

11. Ibid., 67–68, p. 311.

12. Ibid., 69, p. 313.

13. Ibid., 71, pp. 313–15.

14. Ibid.

15. Ibid., 85, pp. 323–25.

16. Ibid., 92, p. 329.

17. Ibid., 94, p. 331.

18. Ibid., 95, p. 331.

19. Ibid., 87, p. 325.

20. M. R. James, *The Apocryphal New Testament* (Oxford, 1924), p. 49; cited by Ernst Kris and Otto Kurz, *Legend, Myth, and Magic in the Image of the Artist* (New Haven and London, 1979), p. 60.

21. Leo Steinberg, in "The Sexuality of Christ in Renaissance Art and in Modern Oblivion," *October* 25 (Summer 1983): 124, Fig. 136, cites a painting by Quentin Massys, in which the infant Christ is shown reading a book. He also reads a book in Jan van Eyck's *Madonna and*

Christ in the National Gallery of Victoria, Melbourne.

22. Cited by Kris and Kurz, pp. 22–23:
 Credette Cimabue nella pittura
 Tener lo campo,
 ed ora ha Giotto il grido
 Si che la fama colui oscura.

23. Giorgio Vasari, *Lives of the Most Eminent Painters, Sculptors, and Architects,* trans. Gaston du C. de Vere (New York, 1979), p. 11.

24. Ibid.

25. Ibid.

26. Ibid., p. 12.

27. Ibid.

28. See Paul Barolsky, *Giotto's Father and the Family of Vasari's Lives* (University Park, Pa., 1992).

29. On matters of biographical fiction, myth, and reality, see Paul Barolsky, *Michelangelo's Nose* (University Park, Pa., and London, 1990) and *The Faun in the Garden* (University Park, Pa., 1994).

30. On Giotto's wit, see Andrew Ladis, "The Legend of Giotto's Wit and the Arena Chapel," *Art Bulletin* LXVIII, no. 4 (December 1986): 581–96.

31. Vasari, p. 119.

32. Ibid., p. 118.

33. Ibid., p. 524.

34. Ibid., p. 1141.

35. Ibid., p. 444.

36. Ibid., p. 382.

37. Ibid., p. 353.

38. Ibid., p. 1140.

39. Ibid., p. 546.

40. Ibid., p. 525.

41. Ibid., p. 543.

42. Ibid., p. 342.

43. Jaime Sabartès, *Picasso: An Intimate Portrait* (New York, 1948), p. ix.

44. Gertrude Stein, in *Camera Work* (New York), August 1912, pp. 29–30.

45. Sabartès, p. x.

46. See Avigdor W. Poseq, "Bernini's Self-Portraits as David," *Source: Notes in the History of Art* IX, no. 4 (Summer 1990): 14–22.

47. Paul Barolsky, "The Artist's Hand," in *The Craft of Art: Originality and Industry in the Italian Renaissance and Baroque Workshop,* ed. Andrew Ladis and Carolyn Wood (Athens, Ga., and London, 1995), p. 14.

48. The above argument is based on Barolsky, "The Artist's Hand," pp. 15–16.

49. See John Gardner, *Gilgamesh,* trans. John Maier (New York, 1984), p. 57.

50. See Lisa Pon, "Michelangelo's First Signature," *Source: Notes in the History of Art* XV, no. 4 (Summer 1996).

51. Jack Flam, *Matisse: The Man and His Art, 1869–1918* (Ithaca, N.Y., and London, 1986), p. 27.

52. Ibid., n. 9.

53. Ibid., p. 28.

54. Personal communication from Jack Flam.

55. For a more detailed discussion of this picture in relation to Raphael's biography, see Laurie Schneider, "Raphael's Personality," *Source: Notes in the History of Art* III, no. 2 (Winter 1984): 9–22.

56. Quoted in Stanley Weintraub, *Whistler* (New York, 1974), p. 124.

7

Semiotics I: Structuralism and Post-Structuralism

Semiotics, from the Greek word *sema* (meaning "sign"), is the application of the science of signs (semiology). It assumes that cultures and cultural expressions such as language, art, music, and film are composed of signs, and that each sign has a meaning beyond, and only beyond, its literal self.[1] "The core of semiotic theory," according to Bal and Bryson in 1991, "is the definition of the factors involved in this permanent process of signmaking and interpreting and the development of conceptual tools that help us to grasp that process as it goes on in various arenas of cultural activity."[2] Although sign theories are not new, their systematic application to the visual arts developed from the work of the American philosopher Charles Sanders Peirce (1834–1914) and the Swiss linguist Ferdinand de Saussure (1857–1913) in the late nineteenth and early twentieth centuries. Semiotics includes Structuralism, Post-Structuralism, and Deconstruction (Chapter Eight), all of which have been applied to art.

Structuralism emerged after 1950 in France, when intellectuals became disillusioned with Marxism and existentialism. It was an effort to identify "universal mental structures as these manifest

themselves in kinship and larger social structures, in literature, philosophy and mathematics, and in the unconscious psychological patterns that motivate human behavior."[3] In their search for universals, Structuralists minimized the role of the individual author in conferring meaning on a text or image. Following the upheavals in Paris of 1968, however, Structuralism lost its central position among French intellectuals, and the various Post-Structuralisms entered the theoretical stage. These deemphasized the "Author" even more than Structuralism had, and extended the effort to cast authorship as a nineteenth-century Romantic myth imbued with patriarchy (the feminists) and elitism (the Marxists). This, in turn, led to the various implications evoked by the so-called death of the Author,[4] which contradicts the biographical methods. Post-Structuralists also dashed Structuralist hopes of identifying universal structures by observation and analysis.

Saussure and Peirce

Structuralism is generally traced to the "structural linguistics" of Ferdinand de Saussure, a Swiss professor of linguistics at the University of Geneva. From 1907 to 1911, Saussure lectured on the structure of language. He foresaw that eventually language would be one of many semiotic, or sign, systems, but for him language was a closed system whose purpose was the communication of ideas. His views were published in 1916, not by himself but from students' lecture notes, as *Cours de linguistique général* (Course in General Linguistics).[5] Saussure identified sets of binary structural elements, such as Language (*langue*) and Speech (*parole*), Signified and Signifier, Syntagm and Associative Relationship, Synchrony and Diachrony.

In the dichotomy *Language-Speech*, language is the grammatical structure of verbal (and written) communication, which has been agreed upon collectively by a given culture. It is social insofar as it is not altered by individual members of the society, and it can be objectively studied. Speech, on the other hand, *is* individual, and variable. It can be loud or soft, clear or slurred, formal or colloquial. Speech and language depend on each other, but because children learn to talk before they learn grammar, speech precedes language

in the history of the individual. In cultural history, on the other hand, language precedes speech.

Signifier and *Signified*, in Saussure's system, constitute the *Sign*— as the two sides of a coin constitute the coin. Saussure compared them to a layer of air superimposed over a layer of water. The signifier is the sounded or written element of the word, and the signified is the word's conceptual element. For example, the word *Snoopy* signifies Charlie Brown's beagle, the mental image of which is the signified. The signifier (sound) is the material aspect of the sign, whose mental content is the signified. Using the example of *Peanuts, Signification* is the process of combining the letters *S-N-O-O-P-Y* with the idea of the dog to make the linguistic sign. For Saussure, there was no logical or natural connection between signifier and signified, between the group of the letters *S-N-O-O-P-Y* and the concept of the dog. Their relation was entirely arbitrary. But the real arbitrariness lies in the fact that language evolves according to its cultural context, rather than according to a priori concepts. In other words, language does not reflect reality; it constitutes reality.

Saussure's insistence on the distinction between signifiers, or word sounds, and their signifieds did not come out of the blue. It was a decisive response to an ancient tradition that linked words and things as if they had an inherent, natural relation to each other.[6] The Old Testament God spoke—"Let there be light"—and the thing (the light) was born. God's word (the *logos*) brought things—the universe—into being. Similarly, God's word, delivered by Gabriel, was believed to have impregnated the Virgin Mary. This concrete view of the *logos* is reflected in Annunciation scenes, where the words of Gabriel's message are painted in raised gold letters across the picture plane. In van Eyck's *Annunciation in a Church* [58], for example, Mary inclines her head to listen as the impregnating words enter her ear.[7]

The creative and procreative power of God's word is consistent with the biographical conventions associating gods with artists, as well as with the utopian belief in an Edenic language. According to this belief, God had taught Adam the original Hebrew language, whose words were perfectly matched with the things they signified. Over time, the original ideal union of words and things became contaminated, and the original, uncontaminated union was sought by philosophers, linguists, and alchemists. It became, in a sense, the

58. Jan van Eyck,
Annunciation in a Church,
c. 1434/6, National Gallery of
Art, Washington, D.C.

philosopher's stone of language, and represented a condition in which—contrary to Saussure—language reflected reality and was in perfect harmony with it.

Charles Sanders Peirce's semiotics differ somewhat from Saussure's in this regard. They allow for *some* natural relation between signifier and signified. His philosophical system is highly complex, and only his concept of the sign—which lends itself to the analysis of imagery—is considered here.[8] Peirce's sign is tripartite; it consists of *icon, index,* and *symbol.* The iconic aspect of his sign is what relates it to something we recognize. There is, for example, an iconic relation between O'Keeffe's *Black Iris III* [42] and the species of iris depicted on the canvas. The painted image of the flower is more naturally related by resemblance to the real iris than are the four letters *i-r-i-s.*

The indexical aspect of Peirce's sign points to, or indicates, something, and the range of indexical possibilities in a work of art is extensive. It includes elements of style, the technique of applying paint, the social, political, and economic contexts of a work, the viewer's response, documents pertaining to the work, and the artist's signature. In *Black Iris III,* the gradual shading and the petals' soft textures index the qualities of a black iris. The enlargement of the iris, which produces a close-up viewpoint, indexes (points to) the influence of photography on O'Keeffe's paintings of flowers. And the inviting quality of the soft petals and dark center, which draw observers into the painted space, combined with the protruding, tonguelike form that seems to push away observers, index the woman's ambivalence toward her own sexuality.

Peirce's symbol depends on conventional, agreed-upon meanings, and as such is related to Saussure's sign. To this extent, the symbol is related to iconography. The symbolic aspect of O'Keeffe's iris, as we saw in Chapter Five, was a subject of some dissension between the artist and her feminist admirers. Drawing on the traditional implications of flowers—in the Annunciation scene, lilies symbolize Mary's passion as well as her purity—the latter read the flower as symbolic of female sexuality. But O'Keeffe denied that such conventions determined the meaning of her picture.

A picture that seems to speak to the semiotics of both Saussure and Peirce is Magritte's *The Betrayal of Images* [1]. It can be read as a

link between their semiological positions—between Saussure's signifier and Peirce's icon. The painting itself is formally divided between word and image. Magritte's veristic style appeals to the iconic quality of the sign. As a result, the painted image enhances artifice—the ability to persuade the viewer that it is what it is not. It is the linguistic message that breaks the illusion by informing viewers of the icon's mendacity. *"Ceci n'est pas une pipe"* is scripted in the lower horizontal plane, which is parallel to that of the icon. The visual claim made by the iconic quality is verbally retracted, and the letters *p-i-p-e* embody the arbitrariness of Saussure's signifier.

Saussure conceived of language as structured along intersecting axes—the horizontal is that of the *Syntagm,* and the vertical that of the *Associative Relationships.* A syntagm is a combination of signs arranged in a linear plane—for example, the spoken or written "chain" of words constituting a sentence—and is related to speech (*parole*). Speech sounds and written words proceed in space and time. They are spoken or written in a sequence, and each unit is distinct from its neighboring unit. For example, the words on this page are printed as they would be spoken—one after another. This circumstance is consistent with the meaning of the Greek word *syntagma,* which is "that which is put together in order." The associative axis consists of words related by having a connection with one another according to some principle beyond its literal content. In the previous sentence, therefore, the word *content* has an association with *subject matter, iconography, meaning, significance, substance,* and so forth.

Saussure compared the relationship of syntagmatic and associative units of language to a Doric column, which is in a syntagmatic relation to other elements of the Doric order—the stylobate and stereobate, architrave, frieze, and cornice. The column in the Doric order is always above the stylobate and below the architrave. But the Doric order has an associative relationship with the Ionic and Corinthian orders, either of which could be substituted for Doric. The syntagm is whatever constitutes the Doric architectural system and exists within it as an ordered arrangement. The associative relationship can move outside the Doric system to Ionic, which is a more Eastern order, or to Corinthian, which is a later Greek order. Associative thus refers to an aspect of linguistics that moves through space and time.

The dichotomy of *Synchrony* and *Diachrony* refers to the static versus the dynamic character of language. Synchrony (from Greek *syn*, meaning "together" or "within time and space," and *chronos*, meaning "time") has to do with whatever is regularly arranged and logical, such as the principles of grammar. It exists as a social system in a time and place, and change occurs only within that basic structure. Diachrony (from Greek *dia*, meaning "through" in the sense of "through space," and *chronos*) refers to language as it exists through time. It takes into account the changes and evolution of words, of their sounds, meanings, and spelling.

From even this cursory account of Saussure's linguistics, it is clear that the organization of language into binary oppositions is within the Western dualistic tradition. It also has affinities with the late-nineteenth- and early-twentieth-century opposition of the formal and iconographic methods of understanding imagery. Saussure's impact on European intellectuals was considerable, and his structural linguistics influenced the various Structuralisms and Post-Structuralisms that have become part of art historical methodology.

Jakobson, Lévi-Strauss, and Merleau-Ponty

The linguist Roman Jakobson[9] was influenced by both Saussure and Peirce. He elaborated Saussure's syntagmatic and associative dichotomy into *Metonymy* and *Metaphor*. Metonymy, according to Jakobson, was related to syntagm, and applied to narratives set in linear time. Metaphor corresponded to associative substitutions—if "the fog is a cat" that "comes on little cat feet," as Carl Sandburg's famous poem asserts, then a cat can substitute for the fog. Taking painting as a semiotic system, metonymy refers to the formal arrangement of its elements, and metaphor to content and its associative allusions to what is outside the painting itself—for example, iconographic conventions, themes, typology. Like Saussure, Jakobson believed that messages were constituted by an axial relation, in which metaphor (like the associative relationship) corresponded to the vertical axis, and metonymy (like syntagm), to the horizontal. Jakobson first presented this elaboration of Saussure's structural linguistics in a lecture in 1956,[10] in which he laid a foundation for Post-Structuralism.

Jakobson believed that semiotic systems were applicable to music, painting, and film, as well as to dreams and language. In this vein, he analyzed the poetry of certain artists, such as William Blake, in relation to the analysis of their paintings. As early as 1919 and 1921, Jakobson had published articles on Futurism (1919) and Dada (1921), in which he described certain "structural" principles.[11] In these artistic movements, he discerned the beginning of a liberation from the conventions of *mimesis* and illusionism, a liberation that had its roots in nineteenth-century Impressionism.

Cézanne and the Cubists, Jakobson argued, had "canonized multiple points of view,"[12] while Futurism destroyed the "mountings of volumes" of Cubism.[13] Dada, according to Jakobson, was a reaction against the fragmentation of World War I Europe. "At the present moment," he wrote in 1919, "when even scientific ties have been severed, Dada is one of the few truly international societies of the bourgeois intelligentsia."[14] Or, one might say, Dada was an international sign system, which was at the same time philosophically anti-system. Thus Jakobson cites the influential Dadaist Tristan Tzara: "I'm against systems; the most acceptable system is to have absolutely no system at all."[15]

More than fifty years later, at the First International Semiotics Conference, held in Milan on June 2, 1974, Jakobson delivered a lecture entitled "A Glance at the Development of Semiotics."[16] Invoking Peirce's triad of signification—icon, index, and symbol—Jakobson called for interdisciplinary semiologies. "Art has long escaped semiotic analysis," he declared. "Still there is no doubt that all of the arts, whether essentially temporal like music or poetry, like theater or circus performances or film showings, are linked to the sign."[17]

In 1958, influenced by Jakobson's elaboration of Saussure's sign, the anthropologist Claude Lévi-Strauss published *Structural Anthropology*,[18] in which he applied Saussure's structural linguistics to the tribal myths of North and South America. He believed that the application of Saussure's linguistics to the speech patterns of the tribes in question could reveal the universal structures of myth. Because myth, like language, shifts dynamically in time and also exists in a particular time and place, Lévi-Strauss intended to break down the components of myths into synchronic and diachronic

groups. His efforts failed, however, because he was unable to account for the multiple complex factors contained in the units of culture.

In 1960, Maurice Merleau-Ponty published *Signs,* in which he applied Saussure's linguistics to philosophy and related the language-speech dichotomy to the phenomenology of perception.[19] Writers and artists were less important for Merleau-Ponty than the texts and images they produced. In this he joined the Marxists and feminists in objecting to the notion of genius, and particularly to André Malraux's "deification" of the artist. "Our conception of the writer," he said, "begins with his work."[20]

At the same time, with those who take a biographical approach to art history, Merleau-Ponty recognized the connection between artists and their work. Whereas some critics believe that "form follows function," Merleau-Ponty believes that the life of an artist "follows" the life of his art. On Cézanne, he writes, "Although it is certain that a man's life does not *explain* his work, it is equally certain that the two are connected. The truth is that *this work to be done called for this life.*"[21]

From the point of view of his semiotic theory of perception, Merleau-Ponty associated language with painting, and discussed their connection historically. In his opinion, "Painters and writers worked for centuries without a suspicion of their relationship."[22] There is also, in his view, a formal similarity between art and speech insofar as both are preceded by concepts of what they express. As art is preceded by an idea of a natural or recognizable form, so speech is preceded by the thought it expresses. And, according to Merleau-Ponty, "this double recourse to an art before art, to a speech before speech, prescribes to the work a certain point of perfection, completeness, or fullness which makes all men assent to it as they assent to the things which fall under their senses."[23]

With modern art, however, there is a complication, because its expression seems not to be assisted by the precedent of nature. Merleau-Ponty was, in 1960, writing of nonfigurative styles, particularly Abstract Expressionism. Whereas artists and writers historically create in response to the world, he said, the modernists abstract from the natural world. They blur forms if they are painters, and they rearrange the words of ordinary language if they are writers. As a result, modern painting does not resemble a recog-

nizable world, and its truth is located beyond resemblance. At the same time, however, Merleau-Ponty recognized that a relationship existed between modern abstraction and the history of art. He noted that the intensity with which modern painting denies the past suggests its continued attachment to it. For newness in painting does not invalidate the old, but challenges it. "All culture," he said, "prolongs the past."[24] It also challenges the past. And this, according to Merleau-Ponty, accounted for the genius of Cézanne—"He [Cézanne] preferred to search for the true meaning of painting, which is continually to question tradition."[25]

These considerations may be applied to the Greek myth of Arachne and Athena. Each contestant used imagery to communicate a specific message to the other, and each image expressed a narrative thought. Both Arachne and Athena "assented" to these messages precisely because of the "fit" between the meanings expressed in the pictures and the concepts that preceded them. The impact of Arachne's art on Athena's aesthetic perceptions is confirmed by the goddess's envy, by her own participation in the contest, and by her rage at her rival's artistic success. But when Arachne becomes a spider, her nonfigurative webs do not contain a "truth located beyond resemblance." Nor are their abstract forms derived from a *concept*— in Merleau-Ponty's sense—about nature. As a spider, Arachne has lost her ability both to prolong the past and to challenge it. She has descended to a point where she can no longer participate in a *human* history of ideas and images.

For Merleau-Ponty, the perception of a work, more than its author or history, was primary because it engaged viewers and readers in their own response to meaning. Like Roger Fry, Merleau-Ponty stressed the importance of looking at what is seen. But he nevertheless opposed formalism on the grounds that it detached form from meaning, and recommended "a good theory of style, or of speech, which puts both above 'technique' or 'device.'"[26] For in every work of art, there are two sides to the act of creating it: the single brushstroke, if it is a painting, and the relation of the single brushstroke to the impression made by the whole composition. But these two sides—the paint element and "its effect in the whole"—become one, because "there is

no choice to be made between the world and art or between 'our senses' and absolute painting, for they pass into one another."[27]

In the history of art as well, according to Merleau-Ponty, styles are not clearly distinct, one from the other. One cannot locate the exact point of transition from one style to another. Brunelleschi's dome, for example, is related to its site—the Piazza del Duomo in Florence—but it is impossible to say just when the closed spaces of the Middle Ages changed into the open spaces of the Renaissance. And similarly in language, it is impossible to say when "Latin becomes French."[28] In other words, history is a dynamic process. And this rather obvious notion informed Merleau-Ponty's understanding of Cézanne as an artist whose aim was to paint the dynamic becoming, or process, of solid form rather than static form.

Merleau-Ponty also connected language with the visual arts through the expressive acts and gestures of the writer and the painter. But underlying the creative acts and gestures, he believed, was a deeper, hidden meaning—a sign structure. "What if," he wrote, "hidden in empirical language, there is a second-order language in which signs once again lead the vague life of colors, and in which significations never free themselves completely from the intercourse of signs?"[29] He spoke, for example, of elements in paintings as signs.[30] The drips of Jackson Pollock would thus be signs of Pollock's presence.

So significant are such signs that by altering a single one, the artist changes the effect of the whole. The integrity of the whole demands the presence of particular elements, or signs—each executed by the creative gesture—and therefore also demands the absence of others. Since the elements of a painting are as "imperiously" governed as "syntax or logic" rules a piece of writing, it is legitimate to treat painting as a language.[31] The consistency of the painting's syntactical structure, according to Merleau-Ponty, accounts for stylistic consistency. A painting is a Vermeer, he says, when it "speaks the language of Vermeer."[32] For Merleau-Ponty, the structural approach implied a "good theory of style."

Schapiro's Semiotic Iconography

Whereas Merleau-Ponty focused on the formal and perceptual aspects of visual signs, the art historian Meyer Schapiro discussed

their iconographic significance.[33] Insofar as iconography analyzes "the symbolic as a code, . . . denaturalizes . . . conventions" and elucidates their "historical changeability," to quote Bal and Bryson, it is "a semiotic approach."[34] But Schapiro's signs are not arbitrary in a Structuralist sense. As applied to art, his semiology differs from that of Merleau-Ponty, Bryson, and Barthes (see below), as well as from the linguistic signs of Saussure.

Schapiro explored the "interplay of text, commentary, symbolism, and style of representation."[35] Taking the image of a ruler or god with raised arms, or arms held up by others, he noted that the metaphorical connotations of an image—and hence its associative power—may not be obvious from its textual source.[36] Schapiro shows that the iconography of such a figure signifies prayer, kingship, and divinity in widely divergent cultures. In Exodus 17: 9–13, Moses raises his hands "to ensure victory" over the Amalekites, and, when he tired, Aaron and Hur supported them. This gesture was read by Christians as an "antitype of salvation through the cross. It was by assuming the posture of Christ on the cross and making of himself the sign of the cross that Moses overcame Amalek."[37] From this basic sign, a figure with upraised arms came to be read as a sign of prayer before battle, of upholding the Church, of the priest officiating at the altar, of blessing, and even of revelation.

The readings of this image belong to the vertical axis of Structuralism—to Saussure's associative relationship and to Jakobson's metaphor. Taking one item from the set of associations to interpret an element of a specific text would contribute to the sequence that proceeds along the horizontal axis.

Schapiro applied his observation that "Meaning and artistic form are not easily separated in representations"[38] to the depiction of frontality and profile views. While there are conventional stylistic determinants motivating either view, the choice of frontal or profile figures can signify a hierarchical rank, a sacred ritual, or a dramatic effect. When we see the image of a frontal face, we have the impression of participating in a direct, one-to-one communication with that image. A profile image, on the other hand, can interact with other depicted figures, leaving us on the outside looking in. Taking the example of Moses with raised arms, Schapiro notes that, when his figure is frontal, it "resembles the symbolized content in

form"—namely, Christ's Crucifixion.[39] "The historical Moses," writes Schapiro, "is not only himself a sign but he makes a sign which is addressed to the Christian viewer. . . ."[40] But when represented in profile, Moses participates in the narrative along with the other players in the scene. In this analysis, Schapiro uses "sign" in the sense of its iconographic function, and not in the arbitrary sense of Structuralism.

In a paper of 1969, "Field and Vehicle in Image-Signs," Schapiro designated the relationship between a painted image and its ground (the "field") as a problem "in the semiotics of visual art."[41] Originally, that is, in the Paleolithic caves, paintings [2] were applied to the natural cave wall "on an unprepared ground," with the result that "the irregularities of earth and rock show through the image."[42] The Paleolithic painters so disregarded the field as a sign in its own right that they often superimposed figures—usually animals—over each other without removing previous ones. In the detail illustrated here, the artist used the natural bulge in the wall to enhance the volume of the image, but there is no evidence of a frame.

From the Neolithic period, according to Schapiro, the smooth, enclosed field emerged, although the date of its appearance cannot be precisely identified. Thus, when Western children of today draw and paint on a piece of paper, their activity reflects a long historical development. Schapiro compares this inheritance to the acquisition of speech, which, "after the phase of lallation shows elements of an already developed phonetic system and syntax."[43]

Perhaps the closest contemporary phenomenon to the Paleolithic approach to the figure-ground relationship is found among graffiti artists. Although graffiti are not new—Schapiro cites their appearance on ancient Roman buildings[44]—they offer a contrast to the drawings of the modern child artist that is relevant to Saussure's linguistics. For Saussure, speech (*parole*) is learned by virtue of difference—that is, preverbal children begin to distinguish words by their difference from other words. From our own experience with unfamiliar, foreign languages, we can identify with the child's early sense of speech as indistinguishable sounds. With attentive listening, and learning the names of objects, the child—like the student of a foreign language—gradually associates a sound (the signifier) with an object or an idea (the signified).

By a similar principle of "difference," children learn the notion of *yes* and *no*. In conscious thought, what is *yes* is not *no*, and what is *no* is not *yes*. In drawing and painting, the average child is told *no* when he scribbles on the walls of his house, on the furniture, or on the floor. When the child does this, he is not drawing on a field intentionally prepared for imagery. He, like the cave painter, is making use of an already available surface. The child's natural impulse, at least in our society, is likely to encounter a *no*, and he is also likely to be told to draw on a piece of paper instead.

The prepared field is thus a social construct—like language—that is derived from inborn potential and developed through a learning process based on difference. This fact no doubt contributes to the controversial nature of graffiti, which do not respect the difference. When the adult makes graffiti, it is no longer the innocent expression of a natural impulse, but an act of defiance. The nature and value of this particular defiant act may vary with individual circumstances, but it nevertheless crosses a conventional social boundary.

When James McNeill Whistler was a child in Lowell, Massachusetts, he drew incessantly and impressed everyone with his talent. When he was a cadet at West Point, Whistler drew on the walls and was expelled. In this case, therefore, the "difference" is endowed with a moral stricture—it is between a *yes* and a *no*, a *do* and a *don't*. Today, the prepared field signifies social, artistic, and emotional order, whereas the unprepared field can signify disorder, lack of control, and rebellion.

The changing nature of the figure-ground relationship is the primary subject of Schapiro's discussion. He notes, for example, that in Assyrian reliefs inscriptions were often carved across the surfaces of the figures, as if the viewer were intended to experience image and language simultaneously.[45] The frame as we know it, according to Schapiro, was preceded by dividing the field into horizontals that served as ground lines,[46] as is common in Egyptian paintings. In fifteenth-century Italy, Alberti conceived of the frame in architectural terms as a window frame. The picture plane—or field—corresponded to the plane of the window, and the painted image, typically governed by the laws of linear perspective, to nature itself. Certain nineteenth-century "frames"—notably among

Impressionists and Post-Impressionists—appear to "crop" the field in the manner of a candid, unposed photograph.

With the emergence of nonfigurative painting in the twentieth century, frames were sometimes reduced to strips of wood around the sides of the canvas. This, in Schapiro's view, happened "when painting ceased to represent deep space and became more concerned with the expressive and formal qualities of the non-mimetic marks than with their elaboration into signs."[47] Instead of presenting a field that seems to recede behind the picture plane, paintings with minimal frames or no frames announced their physical presence with a new assertiveness. These paintings emphasized abstract, formal elements rather than replicating nature, and also confronted viewers with what Merleau-Ponty called "signs" of the artist's material presence.

Schapiro points out that some frames do not entirely enclose the field. This is the case in medieval art and, more rarely, in Classical Greece. Schapiro illustrates a page from the Romanesque *Psalter of Saint Louis*, which is divided horizontally into two scenes: the Annunciation to the Shepherds above and the Three Magi Following the Star below [59]. Except for the angel's right foot and the tip of his wing, the Annunciation scene is inside the painted frame. The heads and right hands of all three Magi, however, break through their frames. The foot of the right horse slightly overlaps the frame, while the left horse seems to both leap into the field and walk calmly within it. The central horse is inside the frame, but seems to tilt forward and out of the field.

Counteracting the predominant left-to-right movement of the two scenes is the effect of the star's placement outside the field. The star becomes the focal point of the glances and gestures of the Magi, who swivel to the left while proceeding to the right. It thus arrests the gaze of the Magi, who, with their horses, are nevertheless engaged in lively motion. In this image, the flexible boundaries of the field signal its very "sign-ness." For it reminds us of the degree to which both frames and fields are significant features of image-making.

Proceeding to certain formal conventions within the field, Schapiro explores their effect on "our sense of the signs."[48] Centrality, for example, is structurally determined when there is a

59. Page from the
*Psalter of Saint
Louis*, Lat. 76A, fol.
16v. Leiden
University Library,
The Netherlands.

defined field. But in the cave paintings, the viewer imposes the cen-
ter according to his location in relation to the image. The artist
working with a set and framed field can manipulate the signs
accordingly. For example, to signal the importance of a figure, the
artist can center it, enlarge it, elevate it, or make it brighter, in rela-
tion to other figures in the same field.

Also "pertinent to semiotics," according to Schapiro, is left and
right positioning.[49] For the right side of a god, and indeed the right
side generally, is the favored side. But, as Schapiro observes, right
and left on the field are reversed from the viewer's standpoint—as
in a mirror reflection. "In both cases," he said, "the parts of the field
are potential signs; but the field is open to reversal in submitting to
an order of values in the context of the represented objects or in the
carrier of the image."[50]

Bryson: Structuralist Semiology

In contrast to Merleau-Ponty's view that perception was involved in semiosis, the literary critic Norman Bryson conceives of the work of art as a visual system of signs. "What is suppressed by the account of painting as the record of a perception," he writes, "is the social character of the image, and its reality as a *sign*."[51] In contrast to Schapiro, he argues against the mimetic emphasis of iconological methods for much the same reasons as Saussure breaks with the tradition of a primordial Edenic Hebrew. The Platonic view of art as mimetic skill that attempts to give form to an idea, or to an essence of a thing, has influenced a strain of traditional art history and aesthetics. Citing Pliny's account of Zeuxis' illusionistic grapes, Bryson denounces such views of an "Essential Copy" as bound by Adamic tradition.[52]

In Bryson's semiology, art is constituted by cultural signs, which, when decoded, identify the breadth of its role in society. He moves beyond the structural limits of Saussure with the intention of avoiding entrapment in a closed linguistic system. His semiology includes cultural signs outside the work of art and their relationship to significations inside the art. By thus opening up the boundaries of one context—in this case, the context of art—Bryson can pull into it signs from another context—namely, the cultural environment. As a result, he argues, semiotic methodology reveals what has been allowed to remain hidden in works of art by previous approaches to imagery. He calls on the discipline of art history to recognize the dynamic nature of viewing art, and the sign systems "circulating" through image, viewer, and culture.[53]

Bryson argues that formalism "denies or brackets out the semantic discussion of the image," whereas iconology "tends to disregard the materiality of painting practice."[54] But by combining these methods and "giving equal consideration to 'signifier' and 'signified' within the painterly sign," he proposes to resurrect art history from its state of paralysis.[55] Further, since recognition implies a social condition—that is, people have to agree on meanings—Bryson believes that "the participation of the painterly sign in the social formation is immanent."[56]

In a comparison of Giotto's *Kiss of Judas* [60] in the Arena Chapel in Padua with Duccio's version from the *Maestà* altarpiece in Siena [61],

60. Giotto, *Kiss of Judas*, c. 1305, Arena Chapel, Padua.

61. Duccio di Buoninsegna, *Kiss of Judas*, 1308–11, Maestà Altarpiece, Museo dell'Opera Metropolitana, Siena.

Bryson demonstrates one facet of his semiology. Although there is no Essential Copy, according to Bryson, he agrees with the consensus that Giotto achieves a more convincing "realism" than Duccio. How Giotto does this is explained by combining formalism with semantics. The "core sentence," or basic iconographic code, which makes the scene recognizable is "Judas—kisses—Christ."[57] Both artists provide additional information, but Giotto provides more than Duccio. And Giotto's information—for example, location of figures in space, pose, gesture, lighting, drapery—enhances the dramatic intensity of the event. Giotto achieves this "effect of the real," in Bryson's view, because *connotation so confirms and substantiates denotation that the latter appears to rise to a level of truth.*[58]

To illustrate this principle, Bryson examines Giotto's profiles of Christ and Judas [62]. Formally, as *line,* the edges of Christ's forehead and nose are straight. This literal denotative element is reinforced by the connotative associations of "rectitude" and "right" conveyed by "straightness." Christ is higher up than Judas; his neck is a strong, expansive form. Judas tilts his head back, constricting his neck under his cloak. Read as signs, these elements point to the

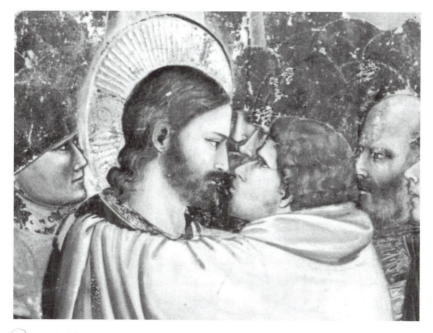

62. Detail of figure 60. Heads of Christ and Judas.

moral superiority of Christ. He "looks down" on Judas, is more open, honest, direct, self-assured, and clear. Because these connotations are more difficult to pin down than conventional codes—halo, cross, and so on—and require more effort on the part of the viewer, they are endowed with a higher value. "The effect of the real," according to Bryson, is thus "less a question of conflict than of symbiosis or covert alliance" between denotation and connotation.[59]

Bryson challenges the concept of art history as a "history of successive visual styles."[60] He favors semiology over formal analysis as a method of characterizing style. The eighteenth-century painter Chardin, for example, does not fit the traditional stylistic category of Rococo even though he worked in the Rococo period. But if considered from the point of view of signs, there are common elements in Chardin and Rococo. Both are what Bryson calls "figural" rather than "discursive" modes of representation. That is, they are constituted independently of language, and bring formal and textural elements to the fore. With the development of the Neoclassical style, and its emphasis on historical narrative, the figural cedes to the discursive.

Chardin's paint [63] is thickly layered, and his brushstrokes are visible. The resulting impasto advances the image so that it comes

63. Jean-Baptiste-Siméon Chardin, *La Fontaine*, c. 1735, The Swedish National Art Museums, Stockholm.

up against the "Albertian eye, used to a window-like canvas."[61] Watteau's *Gilles* [64] is painted in the rich, silky textures of Rococo, which in *La Fontaine* are decidedly plain. But the figure of Gilles, like Chardin's paint, confronts the picture plane with a sense of bulk. The placement of the figures behind and below him tends to "push" him forward and upward. To us, he seems a bit elevated. His frontal pose with arms held at his sides and his expanding torso enhance this impression. Thus, if we take Chardin's paint and Watteau's *Gilles* as indications, or signs, of a changing approach to the picture plane, rather than as formal or iconological elements, they can be read as signs of a particular historical development.

The best Rococo pictures—notably those by Watteau—contain ironic or moralistic undertones that function as counterparts to surface frivolity. *Gilles* evinces the sadness of the performer without a play, which is connoted by his limp arms and idle hands. His immobility

64. Jean-Antoine Watteau, *Gilles*, c. 1719, Louvre, Paris.

and self-absorption contrast with the activated figures—conversing and leering—behind him. In *La Fontaine,* the woman is occupied but still. Like the figure of Gilles, she is solitary, absorbed in her work, as he is in his state of unemployment. And in the room behind her, we are aware of two figures interacting with each other. The older woman seems to be instructing the child, possibly in the virtues of work.

The shifting levels of meaning, which are both disconnected from, and refer to, one another, are related not so much in content as in structure. Like Chardin's paint, the meanings are layered, one behind the other, so that they too disrupt the clear spatial sequences of Alberti's "window." With the advent of Neoclassical discursive painting, the relation of imagery to the picture plane changes once again, and we tend to read pictures horizontally—as narrative— rather than as layered figural messages.

Barthes: Structuralism to Post-Structuralism

In 1969, the year that Schapiro published his article on iconographic signs, the French literary theorist Roland Barthes wrote that "semiology, as a science of signs, has not managed to make inroads into art. . . ." This circumstance presented "an unfortunate obstruction" for Barthes, because it reinforced "the old humanist superstition that artistic creation cannot be 'reduced' to a system: system, as we know, is the declared enemy of man and art."[62]

As a Structuralist, Barthes sought an artistic system of the kind Saussure had applied to language and Lévi-Strauss to tribal myths. He expanded Saussure's Structuralism by extending the relation between the linguistic signifier and signified to different cultural systems—including imagery—"in the form of an equivalence (\neq) but not of an identity (=)."[63] In contrast to the arbitrary sign of Saussure, Barthes's sign *could* be motivated under certain conditions. "We shall say," he wrote, "that a sign is *motivated* when the relation between its signified and its signifier is analogical. . . . It will therefore be possible to have systems which are arbitrary and unmotivated, and others which are non-arbitrary and motivated."[64] The notion of an analogical relation based on similarity between signifier and signified opened the way to Barthes's semiology of images.

Barthes structured the garment and food systems of France into semiologies. In the former, costume was the equivalent of language (Saussure's *langue*) and clothing of speech (*parole*).[65] Since clothing is individually chosen, it can range from high style to low, from neat to messy, clean to dirty, and so forth. It is subject to the same idiosyncratic variations as speech, whereas costume—like language—is an established, cultural syntactical system. In the food system, as it operates in restaurant dining, Barthes read the menu as the basic linguistic structure *(langue)* and one's individual selections as speech.

Both food and clothing constituted semiological systems for Barthes—clothes a sign of protection, and food of nourishment. Such signs also carry specific connotations according to their usage. For example, raincoats protect from the rain and are therefore a sign of wet weather. Whites are a sign of tennis, bathing suits of sun and the sport of swimming, and skis and goggles connote snow. More complex systems structured by Barthes included film, television, and advertising, all of which involve imagery made with a camera.

Although Barthes also wrote about painting, his discussions of photography best exemplify his shift from Structuralism to Post-Structuralism. In "Rhetoric of the Image" (1964),[66] Barthes is a Structuralist, and in *Camera Lucida* (1980) he has become a Post-Structuralist. "Within Structuralism," writes Mary Bittner Wiseman, "the real is the effect of a system of signification, whereas in the post-structural *Camera Lucida* the real is what patterns light and is opposed to the significant and the semiotic."[67] In Barthes's Structuralism, the real and the magical were opposed; in his Post-Structuralism they are aligned.[68]

His structural system is exemplified by his analysis of the Panzani pasta ad.[69] The image shows "pasta in packages, a can, a bag, tomatoes, onions, peppers, a mushroom, everything coming out of a half-open string bag, printed in yellows and greens on a red background."[70] Its "first message" is linguistic—it is conveyed by the caption, which is written. The second message consists of the denotative signs, and the third of the connotated, or "rhetorical," signs. For example, the "half-open string bag" denotes the material reality of itself, but it connotes ingredients recently carried in from a fresh vegetable market. It also connotes a positive value in daily shopping as opposed to "the hasty stocking up ... of a more 'mechanical' civi-

lization."[71] The red (tomato), green (pepper), and yellow colors in the print signify "Italianicity" and connote the Italian flag. This is reinforced by "the Italian assonance of the name Panzani."[72]

Barthes identified a third and fourth sign in the ad. In one, he writes, "the closely packed nature of various objects transmits the idea of a total culinary service, as if, on the one hand, Panzani offered everything necessary to a complicated dish, and as if, on the other, the concentrate in the can equalled the natural products surrounding it, the scene 'bridging' the origin of the products and their final condition. . . ."[73] The signified of the fourth sign is aesthetic. It is the still life, which is a cultural convention among the genres of Western art. Its effectiveness as a sign thus requires that viewers be familiar with that particular context.

For Barthes the linguistic message is a link to the image, and it serves two functions: "*anchoring* and *relaying*."[74] It anchors by denoting—the can of tomato paste is labeled (anchored) as such; it is identified by name. As relayers of messages, words are "rare in the fixed image," but important in comic strips and cinematic dialogue. In the latter instance, according to Barthes, "dialogue does not have a simple elucidative function but actually advances the action by inserting, in the sequence of messages, certain meanings which are not to be found in the image."[75] The relaying function is related to connotation, which constitutes Barthes's notion of the "rhetoric of the image," and it conveys an ideological message. "Rhetoric," he wrote, "appears as the signifying aspect of ideology."[76]

In the 1964 paper, Barthes touched on a point that became central in the Post-Structuralist *Camera Lucida* of 1980—namely, the photograph as a producer of "a new category of space-time."[77] According to Barthes, the myth of the photograph's "naturalness" is reinforced by its apparent lack of a "code." That is, the viewer believes the photograph has registered an actual scene, documented a piece of reality. Its imagery denotes itself, whereas the "human interventions . . . (framing, range, light, focus, speed, etc.)" are the connotative factors that influence the "rhetoric of the image."[78]

Barthes distinguishes between the photograph and other visual images in regard to time, and he expresses the distinction by tense—in linguistic terms. He says that whereas paintings and drawings make viewers conscious that their depicted images represent a

thing "being there" in the present tense, the photograph evokes "the thing's *having-been-there*" in the past tense.[79] As a result, in contrast to certain paintings, "the photograph is never experienced as an illusion, it is in no way a *presence,* and we must deflate the magical character of the photographic image";[80] it is thus more *really* unreal than the painted image. This is clear if one thinks of Magritte's *pipe*—it has an effect of presence, of being-there in the painting. But a photograph of a pipe would record the fact that the pipe had *once* been there and that the eye of the camera had *seen* it—compare Wiseman: "cameras cannot hallucinate."[81]

Cinema, like Magritte's painting, occupies the realm of the magical and participates in the history of fiction. "The cinema," Barthes wrote in 1964, "is not an animated photograph; in it the *having-been-there* vanishes, giving way to a *being-there* of the thing";[82] in other words, viewers experience the still photograph as a *"message without a code,"*[83] or as reportage, but project themselves into cinema, suspend reality, and identify—in the present tense—with the fictional narrative.

This being said, however, Barthes does not ignore the connotative qualities of still photography. Indeed, he linked its rhetorical power to the effectiveness of its denotative mask. The ultimate paradox of the photograph, for Barthes in 1964, was that technology expanded the information transmitted by the image (its denotations), while also disguising "the constructed meaning under the appearance of the given meaning [the connotations]."[84]

The Barthes of 1980, in *Camera Lucida,* according to Wiseman, has been read as having broken with Structuralism and returned to a humanism centered in the self.[85] He has also been criticized for having expounded "an increasingly nihilistic subjective realism."[86] But Wiseman takes a more synthetic approach and reads the late Barthes as combining humanism with Structuralism to arrive at a personal Post-Structural vision.[87] In *Camera Lucida,* Barthes elaborates the signification of photography, but structuralisms yield to the man himself. In view of his previous insistence on the "death of the Author," it is ironic that his own authorship should so dominate *Camera Lucida.* The work is, above all, an autobiography of his response to photography.

At the outset, Barthes is struck by a photograph of Napoleon's youngest brother—"And I realized then," he wrote, "with an amazement I have not been able to lessen since: 'I am looking at eyes that looked at the Emperor.'"[88] This experience presented Barthes with "a choice between regarding the photograph as semiosis or reality," as a system of coded illusions or "as an imprint of the light-rays emanating from the object at the moment the picture was taken. . . ."[89] In fact, the real reality of photography resides in the latter, which is what Barthes termed its *noeme* (from the Greek *noema*, meaning "thought," "purpose," or "design," and which Barthes takes as *essence*). In contrast to painting, the photograph records with light the past existence of what is presently imaged, and thus collapses the time in between. "Time," writes Wiseman, "is the hero of *Camera Lucida:* it insists and is undone in what Barthes calls 'the photographic ecstasy.'"[90]

Seeking the universals of photography, Barthes makes himself "the measure of photographic 'knowledge.'"[91] In so doing, he recovers a focus on the individual that had been absent or minimal in Structuralism. By reference to the Greek maxim in which "*Man* is the measure of all things," Barthes re-finds the humanism of the Classical tradition.

Barthes structures photography into three categories. The Operator who frames a piece of reality and takes the picture, the Spectator who looks at the picture, and the subject of the picture, which is the Spectrum. The latter evoked in Barthes "the rather terrible thing which is there in every photograph: the return of the dead"[92]—again a reference to the collapse of Time. At first, he sees Death in photographs of himself, and later in all photographs: "each photograph always contains this imperious sign of my future death. . . ."[93]

In *Camera Lucida,* Barthes is the Spectator. His spectatorship is structured into *studium* and *punctum.* The former consists of the general effect of the photograph, including its cultural connotations and the intentions of the photographer. The "author" has thus been readmitted, even though the *studium* is also a coded system, roughly equivalent to Jakobson's metaphor. The *punctum,* on the other hand, "will break (or punctuate) the *studium.*"[94] It is the aspect or detail of a photograph that strikes Barthes-as-Spectator—and that

he compared to metonymy. "It is," Barthes wrote, "what I add to the photograph and *what is nonetheless already there.*"[95]

Barthes's most compelling photographic experience occurred after his mother's death. He went through old pictures of her—"gradually moving back in time with her, looking for the truth of the face I had loved. And I found it."[96] The photograph showed his mother in 1898, at the age of five. She stood with her seven-year-old brother "at the end of a little wooden bridge in a glassed-in conservatory, what was called a Winter Garden in those days."[97]

Barthes does not reproduce this photograph, because it existed uniquely for him, "a *punctum* to which others would respond indifferently, as to the *studium.*"[98] The encounter with this picture inspired Barthes's photographic journey, which is the subject of *Camera Lucida.* Citing Nietzsche that "a labyrinthine man never seeks the truth, but only his Ariadne," Barthes calls the photograph of his mother the Ariadne who will identify the thread of his attraction to photography.[99] Through the image of his mother at age five, Barthes confirms the *noeme*—his mother has been there—of photography, and verifies the umbilical connection between her body and his gaze.[100] She is simultaneously dead and resurrected, and her image, configured with light and fixed with a chemical solution, makes of Barthes a prophet "in reverse: like Cassandra, but eyes fixed on the past. . . ."[101]

Finally, Barthes finds his Ariadne, and discovers a new *punctum* more powerful than the "detail." This *punctum* "is no longer of form but of intensity . . ." and time has become "the lacerating emphasis of the *noeme* (*'that-has-been'*), its pure representation."[102] Whereas Cassandra shuddered over *what would occur,* Barthes shudders "*over a catastrophe which has already occurred.*"[103]

These events are consistent with the "puncture," even shattering, of Barthes's Structuralism. His humanity—and his mortality—overwhelmed the abstract search for universal systems. "Once she [his mother] was dead," he wrote, "I no longer had any reason to attune myself to the progress of the Superior Life Force (the race, the species). My *particularity* could never again *universalize* itself. . . . From now on I could do no more than await my total, *undialectical* death." [emphasis mine].[104] Barthes's Structuralism thus became a

Post-Structuralism, to which some measure of humanism is restored, and of which he undeniably lives as the author.

NOTES

1. Cf. Mieke Bal and Norman Bryson, "Semiotics and Art History," *Art Bulletin* 73, no. 2 (June 1991): 174–208.
2. Ibid., p. 174.
3. Edith Kurzweil, *The Age of Structuralism* (New York, 1980), p. 1.
4. Cf., for example, Michel Foucault, "What Is an Author?" in *Language, Counter-Memory, Practice: Selected Essays and Interviews*, ed. D. F. Bouchard (Ithaca, 1977), pp. 113–15; and Roland Barthes, "The Death of the Author," in *Image—Music—Text*, ed. and trans. Stephen Heath (New York, 1977).
5. Ferdinand de Saussure, *Course in General Linguistics*, trans. Wade Baskin (New York, 1966).
6. See Allison Coudert, *Leibniz and the Kabbalah* (International Archives of the History of Ideas, vol. 142) (Dordrecht, Boston, and London, 1995), pp. 145–50.
7. See Ernest Jones, "The Madonna's Conception Through the Ear," in his *Essays in Applied Psychoanalysis*, vol. 2 (New York, 1964), pp. 266–357.
8. Cf. Rosalind Krauss, "Notes on the Index," *October* 1977, III (68–81) and IV (58–67).
9. Roman Jakobson, *Essais de linguistique générale* (Paris, 1963), esp. ch. 2.
10. In his lecture "Two Kinds of Aphasia," delivered at the conference in honor of the 40th anniversary of the publication of Saussure's *Course in General Linguistics*. Published in Roman Jakobson, *Language in Literature*, ed. Krystyna Pomorska and Stephen Rudy (Cambridge, Mass., and London, 1987), ch. 8.
11. Ibid., ch. 2 and 3.
12. Ibid., p. 28.
13. Ibid., p. 32.
14. Ibid., p. 40.
15. Ibid., p. 36.
16. In ibid., ch. 24.
17. Ibid., p. 451.
18. Claude Lévi-Strauss, *Structural Anthropology* (New York, 1963).
19. Maurice Merleau-Ponty, *Signs*, trans. Richard Calverton McLeary (Chicago, 1964).
20. Ibid., p. 58.
21. Maurice Merleau-Ponty, "Cézanne's Doubt," in *Sense and Non-Sense* (Evanston, Ill., 1991), p. 20.
22. Merleau-Ponty, *Signs*, p. 47.
23. Ibid., p. 47.
24. Ibid., p. 79.
25. Merleau-Ponty, "Cézanne's Doubt," p. 13.
26. Merleau-Ponty, *Signs*, p. 77.
27. Ibid., pp. 45–48.
28. Ibid., pp. 41–42.
29. Ibid., p. 45.
30. Ibid., p. 47.
31. Ibid., pp. 55 and 75.
32. Ibid., p. 61.
33. Meyer Schapiro, *Approaches to Semiotics* (The Hague and Paris, 1973).
34. Bal and Bryson, "Semiotics and Art History," p. 191.
35. Schapiro, *Approaches*, p. 17.
36. Ibid., p. 10.
37. Ibid., p. 17.
38. Ibid., p. 37.
39. Ibid., p. 40.
40. Ibid.
41. Meyer Schapiro, "On Some Problems in the Semiotics of Visual Art: Field and Vehicle in Image-Signs" (1969), in *Theory and Philosophy of Art: Style, Artist, and Society*, Selected Papers, vol. IV (New York, 1994). Reprinted from *Semiotica* I, no. 3 (1969): 223–42.
42. Ibid., p. 1.
43. Ibid., p. 3.
44. Ibid., p. 4.
45. Ibid., p. 6.
46. Ibid., p. 7.
47. Ibid., p. 8.

48. Ibid., pp. 12ff.
49. Ibid., p. 20.
50. Ibid.
51. Norman Bryson, *Vision and Painting* (New Haven and London, 1983), p. xii.
52. Ibid., ch. 2.
53. Ibid., p. xiv.
54. Ibid., p. 38.
55. Ibid.
56. Ibid., p. 51.
57. Ibid., p. 58.
58. Ibid., p. 62, and cf. David Carrier, *Artwriting* (Amherst, Mass., 1987), pp. 83–87.
59. Ibid., p. 65.
60. Norman Bryson, *Word and Image* (Cambridge, 1981), p. 239.
61. Ibid., p. 120.
62. Roland Barthes, "Is Painting a Language?" (1969), in *The Responsibility of Forms*, trans. Richard Howard (New York, 1985), p. 149.
63. Roland Barthes, *Elements of Semiology*, trans. Annette Lavers and Colin Smith (London and New York, 1967), pp. 49–50.
64. Ibid., p. 51.
65. Ibid., pp. 26–27.
66. Barthes, "Rhetoric of the Image" (1964), in *The Responsibility of Forms*, pp. 21–40.
67. Mary Bittner Wiseman, *The Ecstasies of Roland Barthes* (London, 1989), p. 5.
68. Ibid., p. 7.
69. Barthes, "Rhetoric of the Image," and cf. Robert E. Innis, *Semiotics* (Bloomington, Ind., 1985), pp. 194ff.
70. Barthes, "Rhetoric of the Image," p. 22.
71. Ibid., p. 23.
72. Ibid.
73. Ibid., p. 24.
74. Ibid., p. 28.
75. Ibid., p. 30.
76. Ibid., p. 38.
77. Ibid., p. 33.
78. Ibid.
79. Ibid.
80. Ibid.
81. Wiseman, *Ecstasies*, 147.
82. Roland Barthes, *Camera Lucida*, trans. Richard Howard (New York, 1981), p. 147.p. 34.
83. Ibid.
84. Ibid., p. 35.
85. Wiseman, *Ecstasies*, p. 133.
86. Ibid.
87. Ibid., p. 134.
88. Barthes, *Camera Lucida*, p. 3.
89. Wiseman, *Ecstasies*, p. 152.
90. Ibid., p. 133.
91. Barthes, *Camera Lucida*, p. 9.
92. Ibid.
93. Ibid., p. 97.
94. Ibid., p. 26.
95. Ibid., p. 55.
96. Ibid., p. 67.
97. Ibid.
98. Ibid., p. 73.
99. Ibid.
100. Ibid., p. 81.
101. Ibid., p. 87.
102. Ibid., p. 96.
103. Ibid.
104. Ibid., p. 72.

8

Semiotics II: Deconstruction

The term *Deconstruction* was first used by the German philosopher Martin Heidegger, and became associated with Jacques Derrida (b. 1930), the French philosopher. Derrida is a Post-Structuralist, who studies the nature of signs and who has "deconstructed" some of the leading structural systems. Whereas the Structuralists tried to *con*struct systems intended to uncover the universal order of cultural expressions, Derrida *de*constructs them. He opposes both Saussure's view of signs as fixed within closed systems, and the logocentric belief in essential meanings.

Like Peirce, Jakobson, and Barthes, respectively, Derrida recognizes the indexical, metaphorical, and connotative qualities of the sign. But he has always accorded a more dynamic flexibility to signifier and signified, and in contrast to Barthes, Derrida had no Structuralist stage in the development of his thought. As a result, it follows that for Derrida meanings are also not fixed. They vary according to contexts, which themselves are continually in flux. The meaning of a word in one context is often different in another. And because we define words in terms of other words, Derrida would say that meaning is always "deferred."

Structuralists and Post-Structuralists typically reject the notion of

an Essential Copy derived from Plato's mimetic view of art. Similarly, Derrida deconstructs assumptions "that texts are mimetic or second-order constructs, referring back always . . . to a first-order realm of empirical reality."[1] On this basis, Derrida argues that there can be no definitive "author"—in the sense that the author confers definitive meaning on the text. In a Deconstructionist reading, the author—and the artist—cannot be God. Nor does the *logos* (his "word")—"Let there be light"—succeed in creating light. Deconstruction, therefore, rejects both the deification of the artist—for example, "the divine Michelangelo"—and the association of this convention with mimetic skill—such as Giotto's illusionism. It also rejects notions—like Plato's—of an essential ideal, that great art gives form to an "idea"—the "beautiful woman" of Zeuxis and Raphael—lodged in the mind and soul of the artist.

The absence of both primordial and ultimate meanings, according to Derrida, opens up the conventional structures and codes of texts. In *Of Grammatology,* he considers whether the preface of a book precedes the text in truth. Is it a preface in time (actually made or written *before* the text), he asks, or only in space (set physically *in front of* the text, but written *after* it)?[2]

Shifting Derrida's method to painting—for example, to van Eyck's *Arnolfini Wedding Portrait* [52]—one could ask a similar question about the signature. Was the artist, in fact, *there,* as he has written (see Chapter Six)? That he painted the picture is certain, and also that he was there when he signed it. But we cannot say for sure that he actually *attended* the wedding ceremony, or that it took place in the painted room. Elements of the picture could be as fictive as a preface written after the text it precedes physically. Such games with time are possible both in painting and in writing, and they are about time and tense as well as presence and absence. Likewise, the figures reflected in van Eyck's mirror may well include the artist himself, but that does not prove he was there for the ceremony as a legitimate witness, as Panofsky claimed.[3] Van Eyck could have put himself there after the fact, just as, in Italy, artists inserted self-portraits and portraits of their contemporaries into biblical events.

In *Las Meninas* [50], we have seen that Velázquez added the red cross of the Order of Santiago *three years* after completing the painting. And yet it is present on his costume *as if* it had been there all

along. Additional manipulations with presence and absence per-
vade *Las Meninas,* and have engendered extensive discussions
among scholars. For example, are the king and queen reflected in a
mirror?—which would imply that they once stood in front of the
infanta watching Velázquez paint her portrait. Or are the king and
queen the subjects of Velázquez's unseen canvas, and is the infanta
watching *them*? Or is it a painting of the king and queen on the back
wall, and not a mirror at all? It is even possible that the entire
arrangement is fictive, that none of the figures were ever actually
where they are in the painting, or at least not at the same time. This
possibility is what distinguished painting from photography for
Barthes (Chapter Seven)—if *Las Meninas* were a photograph, and
the characters in it configured in light rather than in paint, then we
would *know* (or *think* we know) that the figures had once been as we
see them.

The wit of Saul Steinberg's drawing [57] discussed in Chapter Six
is in just this Derridian play of the author's temporal and spatial
relationship to his work. Steinberg literally *delineates* his presence at
the time and in the space of the *act* of drawing. He is *there* in the pres-
ent tense. He also declares with his line that he *was* there, just as a
photograph of Steinberg would declare it for Barthes. With self-por-
traiture, we generally have the impression of the artist's direct pres-
ence. But Steinberg's self-portrait is *about* the artist's presence—it is
what Mitchell calls a "metapicture," a picture about pictures.

For Derrida, all texts are "a play of presence and absence, a place
of the effaced trace."[4] In this view, he engages in a characteristic
Post-Structuralist strategy of recontextualizing concepts by moving
them from one system or discipline to another. For example, by
replacing Derrida's "conscious and unconscious" with "presence
and absence," one transfers the former from a psychoanalytic con-
text to a literary context. By virtue of this transfer, the mind becomes
a text, and the mind-as-text now has a conscious and an uncon-
scious, and the text is invested with a conscious and an uncon-
scious. The conscious is what the reader consciously receives from
the text, and the unconscious is what can potentially be received
from the text. In the mind, as well as in the text, the conscious is
experienced in the present. The unconscious, on the other hand,
spans past, present, and future (there is no time in the unconscious);

it seems to be absent, but contains what *could be* present potentially.

Derrida also deconstructs Saussure's binary pairs of opposites structuring language. He extends the procedure to such binary oppositions of Western thought as male/female, good/evil, order/disorder, right/wrong, in all of which the former is preferred over the latter. Structures of this kind create a sense of existential meaning and of presence. But according to Deconstructionist thinking, the fixity of the opposition—like the boundaries of academic disciplines and philosophical positions—is an illusion, which Derrida systematically disassembles and exposes.

Although Derrida writes mainly about philosophical and literary texts, he has also applied his methods to works of art. In *The Truth in Painting*,[5] he displays the energy with which he goes at traditional assumptions and conventions—in this case, some of the structures of art writing. His style ranges from declarative statements to incessant questions that are reminiscent of a small child determined to find the truth. And just as small children have the disquieting habit of "opening up" the untruth of parental conventions, so Derrida, with the verbal weapons at his disposal, bombards the structures of thinking and writing about art. What can be deceptively childlike—and often witty—is his penchant for wordplay, in which he deconstructs words and opens up meanings within meanings.

The title of Derrida's first chapter—*passe-partout*—is itself a metaphor of opening up boundaries of thought. He begins this process with the book's title: "I owe you the truth in painting," he quotes from Cézanne's letter of October 23, 1905 to Emile Bernard, "and I will tell it to you."[6] Derrida takes off on Cézanne's statement, asking what the *truth* in painting means. Since painting is a visual expression, how does Cézanne *tell* its truth? For *to tell* implies a verbal statement—a "speech-act"—rather than a painterly *action*. And what does it mean that Cézanne *owes* the truth? Where is the debt? And so on. (Note, in this context, that Saul Steinberg has said, "In order to make a good drawing, you have to tell the truth."[7] According to Merleau-Ponty, Cézanne's *truth* in painting was his continual questioning of tradition, and Clement Greenberg wrote, "We cannot be reminded too often of how decisive honesty is in art.")[8]

Soon it emerges that Derrida's real subject is going to be the nature—if there is any—of truth itself in painting. There are, he says, four "pertinent features [*traits*]"[9] to be explored in considering this matter. The first feature pertains to "the power of direct reproduction or restitution."[10] That is, when the image looks like its painted self, without illusion, when it produces or restores the truth itself. This produces itself "twice over, in accordance with the two genitives: truth of truth and truth of truth." It would appear, from this requisite, that Magritte's *pipe* fails to qualify as a painted self, without illusion. Since it is Magritte's words, rather than his image, that tell the truth of the image—that it is not what it seems—the image cannot be called *truthful* in Derrida's sense. Magritte, however, did not promise to pay the debt of painting's truth, and Cézanne did.

The second *trait* "pertains . . . to adequate *representation*, in the order of fiction or in the *relief* of its effigy."[11] On this point, the *pipe might* qualify, whether as an accurate "portrait" of the object or as an allegory. But, as Derrida says, "the model here is truth,"[12] which opens up at least four possibilities: "Presentation of the representation, presentation of the presentation, representation of the representation, representation of the presentation."[13]

"That which pertains to *picturality*" is *trait* number three. By this, Derrida means that the truth of painting is pictorial, and, as such, is consistent with its medium. From this point of view as well, Magritte's *pipe* won't do, even though the words are painted. Picturality is strictly confined here to the art of painting, and no other expressive form—even one having pictorial qualities—for example, theater, film, literary metaphor, dreams—will suffice.

The fourth *trait* is "truth in the order of painting, then, and *on the subject of* painting, not only as regards the pictorial presentation or representation of truth."[14] Addressing the systems of painting and language, Derrida moves into the "parasitizing" of systems, their flowing in and out of one another. By virtue of their dynamic signs, the systems open up and create a "partition of the edge,"[15] which allows writing and events to *se passer partout*, to go everywhere. And that is what the *trait* will do in Derrida's *The Truth in Painting*—it will act "as a passe-partout. It circulates very quickly among its possibilities. With disconcerting agility it displaces its accents or its

hidden punctuation, it potentializes and formalizes and economizes on enormous discourses. . . ."[16] Derrida himself disconcerts, adding that all this only seems to be the case. Because the *passe-partout* in its strict sense must answer by its form "to a finite system of constraints."[17] The *trait,* therefore, moves through systems and is also part of *a* system. But it never actually appears itself, "because it marks the difference between the forms or the contents of the appearing."[18]

In the very structure of *The Truth in Painting,* Derrida demonstrates the mobility of the *trait,* and the hitherto closed character of structures opened up. Adding to the *passe-partout* the metaphor of the frame, he opens up the notion of the frame, while also respecting it. He states his intention to write four times *"around* painting." The frame of the book will, in a sense, be structured in a set of four, like the frame of a painting—even though some paintings are not framed by a quadrilateral. In contrast to Schapiro, who writes of the frame as defining the field of a painting, which is also a sign in its own right, Derrida encircles the frame in order to approach the work of art from different directions.

He plays on the inside and outside of the work, which is the transitional position of the frame. It is, he says, "neither work [*ergon*] nor outside the work [*hors d'oeuvre*]. . . ."[19] Schapiro's discussion of the history of framing assumes a given, once the convention is established. He describes the evolution of the field from unframed to framed, followed by the changing nature of frames through to the absence of a frame in some twentieth-century pictures. But Schapiro's frame—whether present or absent—is a structure and a sign with a history. Derrida's frame is more elusive. It is open to question and the questions open it up.

What Derrida calls the *parergon*—from Greek, meaning "around" (*par*) "the work" (*ergon*)—of the painting frames the book. *Parergon* is also the title of the chapter in which Derrida asks the traditional philosophical and aesthetic questions "What is art?" "What is beauty?" "What is representation?" and "What is the origin of art?" His discussion primarily revolves around—circles—the aesthetics of Kant, with somewhat less attention to Plato, Hegel, Heidegger, and Nietzsche. In the course of his revolution (revolving around), Derrida peels away layer after layer of philosophical tradition, and

conforms to the title of subheading I—*lemmata*—meaning in Greek "that which is peeled away."

Kant remains the central philosopher throughout *Parergon*. Under subheading III, Derrida takes up Kant's "judgment of taste examined as to the relation of finality."[20] He cites Kant's example of the tulip as a paradigm of wild, natural beauty—of "finality without end."[21] Derrida's title of part III, "The *Sans* of the Pure Cut," plays with the homophony in French of *sans* (without), *sens* (sense), and *sang* (blood),[22] while also being related to his own gloss on Kant. Under subsection IV, *The Colossal*, Derrida deals with the issue of size versus dimension, which opposes the *cut* to *continuation—cise*, which is "cut" in French, sounds like "size" in English. "The absolutely large," he says, "is not a dimension,"[23] referring to Kant's "absolutely large" as a definition of the Sublime. Vastness and limitlessness are qualities of the Sublime, which transcends the measure of man. The aesthetic power of the Sublime, therefore, resides in its infinite, measureless character.

Derrida's next two chapters, +R and *Cartouches*, attempt to deconstruct the artist's role as signatory, and the autobiographical implications of the name as sign. In +R, he cites Benjamin's 1936 *The Work of Art in the Age of Mechanical Reproduction*[24] on the disjunction of self from production—the artist "cut" and "not cut" from his work. (In Saul Steinberg's drawing, for example, the artist is *not cut* from the work.) Illustrating +R is a series of graphic—linear—works called *The Journey of the Drawing*, by Valerio Adami. They prompt Derrida's questions on the relation of word sounds to graphic notation, on the self-portrait to the autobiography, on color to line, and so forth.

In *Cartouches*, Derrida uses works from a show at the Pompidou Center in Paris. The artist Gerard Titus-Carmel exhibited *The Pocket Size Tlingit Coffin and the 61 Ensuing Drawings*, which inspired Derrida's play on the cartouche-as-coffin. He illustrates a model in the form of a rectangular box—the "coffin"—which is small enough to fit in his own hand.[25] A cartouche shape, which is a rectangle with curved short ends, is cut out of the box. Derrida relates the coffin to the womb and considers the question how a coffin can give birth. The coffin is also a paternal paradigm—in ancient Egypt the cartouche framed the name of the king. And signing a work "legit-

imizes" it as the "offspring" of the artist. "In short," writes Derrida, "a series which I truncate here: the *paradigmatic coffin*, the pattern [*le patron*; also 'the boss'], the *parricide* to which it gives rise, the *parergon*."[26] Followed shortly by "How to frame a cartouche?" which is, itself, a frame. The circle continues to revolve as Derrida presents frames within frames.

Derrida's final chapter—"Restitutions of the truth in pointing [*pointure*]"—consists of Derrida, in the guise of a panel of questioners, deconstructing what the philosopher Martin Heidegger and the art historian Meyer Schapiro wrote about a painting of shoes by van Gogh [65], and what Schapiro wrote about Heidegger. Derrida repeats Cézanne's "I owe you the truth in painting, and I will tell it to you," and he follows it with a quotation from van Gogh: "But truth is so dear to me, and so is the *seeking* to *make true*, that indeed I believe, I believe I would still rather be a cobbler than a musician with colors."[27] There it is van Gogh who has brought up shoes—via the cobbler.

This leads Derrida to another facet of the shoes—namely, the cobbler's stitching in making the shoes. Playing on words, Derrida notes that *pointure* is *punctura* in Latin, a synonym of "prick." In printing, *pointure* is a pointed black blade "to fix the page" as well as the hole that the blade makes. It is also the "number of stitches in a shoe or glove."[28]

Following this wordplay, Derrida proceeds to a discussion of the ghost story in van Gogh's pictures of shoes. The ghost that haunts Derrida in this chapter lies behind what Heidegger and Schapiro have to say about van Gogh's painting, why they say what they say to their readers and to each other. But before considering Derrida's procedures, I summarize the spectral predecessors of this last chapter. In 1935 and 1936, Heidegger lectured on the origin of the work of art, and the lecture was published in German in 1950. Fourteen years later, it appeared in English.[29] Heidegger took van Gogh's painting entitled *Shoes* [65] to show how art can—as Cézanne promised—tell the truth. For Heidegger, the shoes in question belonged to a lonely peasant woman who trudged through the fields in all kinds of weather.[30]

It was important to Heidegger to identify the purpose of these shoes—as "equipment"—to discover whom they served, and what.

65. Vincent van Gogh, *Shoes*, 1886, Van Gogh Museum, Amsterdam.

Having said that the location of the shoes is not given by the artist, and that van Gogh does not identify the wearer of the shoes, Heidegger filled in the blanks. He "read" the "dark opening of the worn insides of the shoes" as revealing "the toilsome tread of the worker."[31] The stiff, "solid heaviness" of the shoes shows "the accumulated tenacity of her slow trudge through the far-spreading and ever-uniform furrows of the field, swept by a raw wind."[32] The leather of the shoes is dampened and saturated by the soil, and the wearer of the shoes is "uncomplaining" in the face of hunger, of the dangers of birth, and of death. For Heidegger, therefore, the truth of van Gogh's *shoes* resides in their being "equipment" of the earth, and in their belonging to the "*world* of the peasant woman."[33]

In 1968, Schapiro published "The Still Life as a Personal Object— A Note on Heidegger and van Gogh"[34] in a collection of essays in memory of his friend Kurt Goldstein. Schapiro had written to Heidegger, asking which painting of shoes he had referred to—van Gogh painted eight of them—and established that it was the one

illustrated here [65]. But "alas for him," says Schapiro, "the philosopher has indeed deceived himself."[35] For it turns out that the shoes did not belong to a peasant woman at all. They were van Gogh's shoes, according to Schapiro, and they were city shoes, not country shoes.

Schapiro concluded that Heidegger had failed to demonstrate the power of art to disclose the "universal essence of things"[36]—the truth in painting. "I find nothing in Heidegger's fanciful description of the shoes pictured by van Gogh," Schapiro writes, "that could not have been imagined in looking at a real pair of peasants' shoes."[37] In other words, according to Schapiro, painting tells no more of the truth of the shoes than the real shoes would tell. Furthermore, Schapiro notes that Heidegger has missed the import of van Gogh's shoes as portraits in their own right, with physiognomic qualities—"he [van Gogh] has rendered them as if facing us, and so worn and wrinkled in appearance that we can speak of them as veridical portraits of aging shoes."[38]

Heidegger has also missed the autobiographical character of the shoes. On this, Schapiro quotes Gauguin, who lived with van Gogh in Arles in 1888. Gauguin sensed a story behind the still life of the shoes, and asked van Gogh why he kept them. Van Gogh replied that these were the very shoes he had worn when he left his family to preach to the miners in the Borinage, in Belgium. Schapiro allows that Gauguin might have been referring to another painting of shoes, one of which he described as "violet in tone in contrast to the yellow walls of the studio."[39] There is no violet in Figure 65—which is the painting described by Heidegger and illustrated by Schapiro. Nevertheless, in Schapiro's view, the shoes—if not the painting— are the same. They contain another kind of "essence" than the "Essential Copy," and "Gauguin's story confirms the essential fact that for van Gogh the shoes are a memorable piece of his own life, a sacred relic."[40]

At first glance, it appears that Schapiro has found Heidegger out, exposed an art historical error—mainly iconographic—and added a biographical reading to van Gogh's painting of shoes. But that is before Derrida's deconstructive onslaught of questions—over a hundred pages of questions. For example: How do they [Schapiro and Heidegger] *know* the shoes are a pair? And what is a pair? A

pair of shoes? Of gloves? Of feet? Derrida posits "as an axiom that
the desire for attribution is a desire for appropriation."[41] It is a con-
test between country dweller and city dweller, between the peasant
woman and the artist over the ownership of the shoes. And even
more so, it is a contest between who owns the truth of the paint-
ing—Heidegger or Schapiro.

Derrida is not so sure that the shoes *do* form a pair—"where do
they both get the idea that van Gogh painted a pair? Nothing proves
it."[42] By asking this question, Derrida opens up the pairness of the
shoes, their *structure* as a pair—shades of Saussure's binary oppo-
sites—right/left. In fact, a close formal analysis of the shoes *does* call
into question their pairness. It is not at all clear that they are the
same size, for the one on the left seems smaller, narrower, and short-
er than the one on the right, even disregarding the turned-down top
of the left shoe. Derrida finds the pair *gauche*,[43] meaning that identi-
fying the shoes as a pair is a *gaucherie*, a *faux pas*, or clumsiness, and
also that they look like two left shoes. "The more I look at them,"
Derrida says, "the more they look at me, the less they both look like
an old pair. More like an old couple. Is it the same thing?"[44]

Schapiro, according to Derrida, has laid a trap for Heidegger,
who mistakenly assigns the shoes to a peasant. But then Schapiro
falls into his own trap—"And yet," Derrida admits, "He knows all
about traps. He has written most expertly about the trap in paint-
ing,"[45] referring to Joseph's mousetraps in Robert Campin's *Merode
Altarpiece*.[46] Taking off on the "trap," Derrida plays on *lacets*, which
is the French word for both "laces" and "traps" (snares). The laces
are undone, particularly in the shoe on the right. One lace forms a
loop, "an open circle, as though provisionally, ready to close, like
pincers or a key ring."[47] As if ready to trap something, or someone—
maybe a philosopher and an art historian. Shades of Apelles and the
shoemaker: both Heidegger and Schapiro, in Derrida's view, have
fallen into the trap of *hubris*.

There is also a lot of "conversation" between Derrida's voices
about Freud and the psychoanalytic possibilities of van Gogh's
shoes. Although such remarks are more relevant to the following
chapter, I include a few of them here. Derrida considers the shoes
as fetishes, which means as substitutes for the phallus. In this
case, perhaps, it is the phallus for which Heidegger and Schapiro

struggle. But a shoe encloses a foot, which makes it vaginal in form, and these shoes have a dark interior. For Freud, the shoe is bisexual—male/female—another binary opposition that Derrida opens up.

The other "Freudianism" on which Derrida calls is the *fort/da* game described in *Beyond the Pleasure Principle* (1920).[48] Freud observed his grandson repeatedly throwing a toy, which was attached to a reel, away from his crib. When it was out of sight, the child uttered a sound that Freud identified as *fort*, meaning "gone." When the child reeled in the toy, he cried *da*, meaning "there," with evident delight. By this repeated action, the boy controlled the disappearance and reappearance of his toy, thereby illustrating a principal benefit of children's games. In this case, Freud's grandson "played" at mastering his anxiety over the absence of his mother, and reassured himself with the illusion that he was in control of her coming and going.

Derrida takes the *fort/da* game as a metaphor for the shoelaces, and for the arguments of Heidegger and Schapiro. And, of course, he opens it up—like the child, with a sense of play that is as serious as it is delightful. The lace, when the shoe is being laced, passes through the eyelet "from outside to inside, from inside to outside, *on* the external surface and *under* the internal surface . . . it remains the 'same' right through, between right and left, shows itself and disappears (*fort/da*) in its regular traversing of the eyelet. . . ."[49] Like the child's toy—and symbolically the person he "controls"—the lace that goes in is the same as the one that comes out.

Then there is the more complicated matter of the interlacing—of the shoes, and of the Heidegger/Schapiro efforts to control the truth of the shoes. Heidegger's peasant woman is both in and out of the picture—as the lace is in and out of the eyelet. Schapiro takes the shoes from Heidegger—appropriates them—and returns them to the artist. He makes them into a still life—compare his title: "The Still Life as Personal Object"—a dead object, a *"nature morte,"* which is "detachable and coming back to the ghost.'"[50]

Derrida calls in the police, a detective à la Dupin, to assist in discovering the *proof* of the matter, to demystify the assertions—allegations—made by Heidegger and Schapiro. Against the philosopher, Derrida says that *"nothing proves that they are peasant shoes"*[51]

and against the art historian that *"nothing proves or can prove that 'they are the shoes of the artist, by that time a man of the town and city.'"*[52] He attacks Schapiro's insistent use of "clearly" and "evidently"—as if citing *evidence*—to restore the shoes, the *pair* of shoes, to van Gogh. Neither Heidegger nor Schapiro, in Derrida's view, has produced convincing evidence, but both, *Rashomon*-like, have projected their own imaginings onto van Gogh's picture. Derrida finds Heidegger's projection consistent with a larger context of van Gogh's "ideology"—namely, his attachment to peasants who work the land. Van Gogh himself said, "When I say that I am a painter of peasants, it is indeed truly so. . . ."[53] But Schapiro's comments, unlike Heidegger's, assume an "analogy between the painter and the peasant,"[54] and therefore, according to Derrida, the art historian projects even more than the philosopher.

Taking the arguments of Heidegger and Schapiro as oppositions, Derrida opens them up and exposes two more "ghosts." These are Kurt Goldstein, a German-Jewish neurologist, and the Norwegian author Knut Hamsun, who turn out to be essential factors in the readings proposed by Derrida's protagonists. The former was Schapiro's personal friend, who first told him of Heidegger's *Origin of the Work of Art*. In 1933, Kurt Goldstein had been taken prisoner in Germany by the Nazis. He was released, fled to Amsterdam, where he wrote *The Structure of the Organism*,[55] and then went to New York. Schapiro was, at the time, teaching art history at Columbia University. Goldstein taught there as well, from 1936 to 1940, and from 1945 until his death in 1965, when Schapiro "delivered [his] funeral oration."[56] The latter was also the year in which Schapiro and Heidegger corresponded about the shoes.

To Derrida, it seems that Schapiro wanted the shoes for Goldstein. In 1960, Schapiro referred to Goldstein, who had done a lot of trekking himself before arriving safely in the United States, as "a great human physician and human being."[57] Derrida recognizes the hostility in Schapiro's tone when he refers to "Professor Heidegger" and to Heidegger's "kind response" to his inquiry about van Gogh's painting. By dedicating his article to Goldstein, Schapiro, in Derrida's view, acknowledges *his* debt, which is paid by attempting to restore the truth of the painting to his friend. Nor does the underlying political ideology of all this escape Derrida:

more to the point, he saw it from the outset. What angers Schapiro is Heidegger's use of the Nazi-inspired "pathos of the 'call of the earth,' of the *Feldweg* [field path] or the *Holzwege* [timber tracks],"[58] which contributed to Kurt Goldstein's suffering and the extermination of millions of European Jews. Heidegger, in effect, donned van Gogh's shoes to justify—and possibly to disguise—his National Socialist sentiments by aligning them with artistic "truth." He also trespassed—stepped on—Schapiro's art historical territory.

The other ghost is Knut Hamsun, who won the Nobel Prize for Literature and who, like Heidegger, was revealed to have shared the Nazi ideology. Derrida points out that both Schapiro and Heidegger cite Hamsun, although for different purposes. *Growth of the Soil* (1917),[59] which is Hamsun's best-known book, opens with an image similar to Heidegger's peasant woman: a solitary wayfarer, definitely a peasant, trudges northward, through Lapland. He personifies Man in nature—a first Man—an Adam seeking an Eve. "The long, long road over the moors and up into the forest—who *trod* it into being first of all? Man, a human being, the first that came here. There was no path before he came. . . .

"The man comes, *walking* toward the north. He bears a sack, the first sack . . . the figure of a man in this great solitude. He *trudges* on. . . ." [emphasis mine].[60] Shoes and feet are not specified in this passage, but they are in it nonetheless—"haunting" it.

In so doing, they correspond to Derrida's further association to the *pair*. A pair of feet, a pair of shoes, a "Doppelgänger!"[61]—the uncanny Double. One of a pair evokes the other, so that a right shoe implies a left shoe, and vice versa. One might even say that a right shoe that is present is haunted by its absent other half, and vice versa. Presence/absence is another binary opposition opened up and deconstructed by Derrida—Hamsun's first Man, who is very much a presence on the moors, seeks the absent Woman. What is present generally evokes what is absent, and is haunted by the absence. Hence the impulse toward pairing, and the conviction of Heidegger and Schapiro that the shoes of van Gogh necessarily form a pair.

Heidegger, Derrida points out, cites Hamsun in his *Introduction to Metaphysics,* and refers to one of van Gogh's paintings depicting "a pair of rough peasant shoes."[62] But it is not clear if this painting is

the same one Heidegger discussed in *The Origin of the Work of Art*. Schapiro cites Hamsun's *Hunger* (1890) to support his biographical reading of the *shoes*: "As I had never seen my shoes before, I set myself to study their looks, their characteristics, and when I stir my foot, their shapes and their worn uppers . . . their creases and white seams give them expression—impart a physiognomy to them. Something of my own nature had gone over into these shoes; they affected me, *like a ghost of my other I* [emphasis mine]—a breathing portion of my very self."[63] This, in Schapiro's view, resembles van Gogh's feeling about the shoes in his painting. In contrast to Heidegger, who reasons from the painted shoes to a universal "truth," Schapiro reasons from the image to the artist's personality and situation in life. Both Hamsun and van Gogh, according to Schapiro's reading, represent shoes as "standing for" themselves— each is in the shoes of the other.[64]

One of the many ironies of Derrida's deconstruction is the fact that both Heidegger and Schapiro cite Hamsun to prove the truth of their arguments. Hamsun himself is thus doubled—to Heidegger he speaks for a universal peasant ideology, and to Schapiro for the power and dignity of the individual. Also a sub-text of Derrida's deconstruction is the political passions of World War II and its aftermath. The German Heidegger and the Norwegian Hamsun—both Christians—were sympathetic to Hitler and National Socialism, Schapiro and Goldstein to Hitler's actual or potential Jewish victims; binary opposites of a cultural and political nature.

By the time Derrida has completed his undoing of all of this—of which only a cursory account is given here—the entire system has been called into question. The truth in painting seems lost in the shuffle. It is as elusive as the enigmatic Knut Hamsun, who had, in fact, been apprenticed to a shoemaker by his father, and whose brother—a double of a kind—*was* a shoemaker.[65] Derrida concludes: "—It has just left.—It returns to leave.—It has just left once again."[66] And Schapiro comes around again: In 1994, he published "Further Notes on Heidegger and van Gogh,"[67] in which he was at great pains to justify his earlier article.

In the flurry over van Gogh's shoes, no one asks why Titian signed his *Rape of Lucrezia* inside Lucrezia's shoe.

NOTES

1. Christopher Norris, *Deconstruction and the Interests of Theory* (Norman, Okla., and London, 1989), p. 110.
2. See the discussion by Gayatri Chakravorty Spivak in the Preface to Jacques Derrida, *Of Grammatology* (Baltimore and London, 1976).
3. See Erwin Panofsky, "Jan Van Eyck's *Arnolfini* Portrait," *Burlington Magazine* 64 (1934): 117–28; Linda Seidel, "Jan van Eyck's Arnolfini Portrait: Business as Usual?" *Critical Inquiry* 16 (Fall 1989): pp. 55–86; and *Jan Van Eyck's Arnolfini Portrait, Stories of an Icon* (New York, 1993). See also David Carrier, *Principles of Art History Writing* (University Park, Pa., 1993), ch. 4, "Allegory in Flemish Art."
4. Spivak, p. lvii. On presence and absence in self-portraiture, see David Carrier, *Poussin's Paintings* (University Park, Pa., 1993), ch. 1.
5. Jacques Derrida, *The Truth in Painting*, trans. Geoff Bennington and Ian McLeod (Chicago and London, 1987).
6. Ibid., p. 2.
7. Cited in Harold Rosenberg, *Saul Steinberg* (Whitney Museum of American Art, New York, 1978), p. 235.
8. Clement Greenberg (1952), in *Art and Culture* (Boston, 1961), p. 146.
9. Derrida, *The Truth in Painting*, p. 5.
10. Ibid.
11. Ibid.
12. Ibid.
13. Ibid., p. 6.
14. Ibid., p. 7.
15. Ibid.
16. Ibid.
17. Ibid., p. 8.
18. Ibid., p. 11.
19. Ibid., p. 9.
20. Ibid., p. 84.
21. Ibid., p. 85.
22. Ibid., p. 83, n. 21.
23. Ibid., p. 135.
24. Ibid., pp. 177ff., and also ch. 4.
25. Ibid., p. 87.
26. Ibid., pp. 221–22.
27. Ibid., p. 255.
28. Ibid.
29. Martin Heidegger, *The Origin of the Work of Art*, trans. A. Hofstadter, in *Philosophies of Art and Beauty*, ed. A. Hofstadter and Richard Kuhns (New York, 1964), pp. 649–701.
30. Ibid., pp. 662–63.
31. Ibid.
32. Ibid.
33. Ibid.
34. Meyer Schapiro, "The Still Life as a Personal Object—A Note on Heidegger and van Gogh," in *Theory and Philosophy of Art: Style, Artist, and Society*, Selected Papers, vol. IV (New York, 1994), pp. 135–41.
35. Ibid., p. 138.
36. Ibid., p. 139, Schapiro citing Heidegger.
37. Ibid., p. 138.
38. Ibid., p. 139.
39. Ibid., p. 141.
40. Ibid.
41. Derrida, *Truth*, p. 260.
42. Ibid., p. 264.
43. Ibid., p. 278.
44. Ibid.
45. Ibid., p. 275.
46. Derrida is referring to Schapiro's classic article "'Muscipula Diaboli,' The Symbolism of the Merode Altarpiece," *Art Bulletin* XXVII (1945): pp. 182ff.
47. Derrida, *Truth*, p. 277.
48. Sigmund Freud, *Beyond the Pleasure Principle* (1920), S.E. XVIII, pp. 15ff.
49. Derrida, *Truth*, p. 299.
50. Ibid., p. 360.
51. Ibid., p. 364.
52. Ibid., quoting Schapiro.
53. Ibid., p. 367, quoting van Gogh.
54. Ibid., p. 371.
55. The account given here is from Derrida, *Truth*, pp. 271–72.
56. Ibid.
57. Meyer Schapiro, *Mondrian: On the Humanity of Abstract Painting* (New York, 1995), p. 17.
58. Derrida, *Truth*, p. 272.

59. Knut Hamsun, *Growth of the Soil,* trans. W. W. Worster (New York, 1972).
60. Ibid., p. 3.
61. Derrida, *Truth,* p. 376.
62. Ibid., p. 378, quoting Heidegger.
63. Schapiro, *Mondrian,* p. 139, n. 15, quoting Hamsun.
64. Ibid., p. 140.
65. Robert Ferguson, *Enigma: The Life of Knut Hamsun* (New York, 1987), p. 19.
66. In French, "*Ça vient de partir.—Ça revient de partir.—Ça vient de repartir.*" Derrida, *Truth,* p. 382, n. 29.
67. Schapiro, *Theory and Philosophy of Art,* pp. 143–51.

9

Psychoanalysis I: Freud

The psychoanalytic approach to art history deals primarily with the unconscious significance of works of art. This is a complex method, which involves not only the art itself but also the artist, the aesthetic response of the viewer, and the cultural context.[1] It is a method that has been partially integrated with iconographic methods, as well as with feminism, Marxism, and semiotics. Psychobiography, which examines the artist's psychological development in relation to his art, is also a feature of psychoanalytic methodology. Since there are several different schools of psychoanalysis and various psychoanalytic approaches to art within those schools, I will focus on the contributions of three major figures: first Freud, and then Winnicott and Lacan (Chapter Ten).

Although art history and psychoanalysis are distinct disciplines, they have much in common. Both fields are concerned with the power of images and their symbolic meaning, with the process and products of creativity, and with history. Just as works of art involve images, so too do dreams, daydreams, fantasies, jokes, and neurotic symptoms. Interpreting imagery is a significant aspect of both psychoanalysis and art history.

Freud: Some Basic Concepts

When Freud developed psychoanalysis, he was fully aware of its cultural applications. As early as 1896, he compared the clinical process of psychoanalysis with archaeology, and declared that "rocks speak—*Saxa loquuntur!*"[2] Like an archaeologist, the psychoanalyst searches for buried material from the past. The former does so by excavating a physical site, uncovering ancient fragments such as broken pottery and ruined buildings, and clearing away the debris of later periods. The latter takes the artifacts of mental life, such as dreams and memories, which also tend to be fragmentary, and connects them to an earlier time in the life of the individual. Both the archaeologist and the psychoanalyst try to reconstruct fragments and their history. The archaeologist situates the physical ruins within the historical layers of a site, while the psychoanalyst connects mental fragments to a layer of psychosexual development.

The psychosexual stages of development as construed by Freud are the oral, anal, phallic, and genital stages. Each has its own set of conflicts and is located in a specific zone of the body. The oral stage is bound to the sexual excitation of the mouth. During the anal stage, the child learns control of his execretory function. In the phallic stage, both girls and boys focus on the phallus, and fears of castration (in the boy) and a sense of having been castrated (in the girl) predominate. The latency period lasts roughly from five years to the beginning of puberty, which marks the onset of the genital stage. At this point, according to Freud, the genital zones of the body achieve primacy, and operate in "the service of reproduction."[3]

Just as each new archaeological discovery leads to a revision of history, so in psychoanalysis dreams, memories, and fantasies shed new light on one's childhood. When Freud undertook the only known self-analysis, he compared what he found out about his childhood to Heinrich Schliemann's excavation of Troy.[4] Years later, in 1931, he realized that the Oedipus complex (see below) of the girl was not parallel to the boy's—as he had originally thought. He likened this insight to Sir Arthur Evans's discovery of the Minoan civilization, which until the early twentieth century was known only in myths.[5]

Freud's archaeological metaphor of the mind, which assumes a dynamic relationship between past and present, informed many

aspects of his work. His 1910 psychobiography of Leonardo da Vinci, which was the first of its genre, was made possible by his ability to connect the pictures and writings of the artist, as well as his adult behavior, to the developmental stages of childhood. In order to interpret a dream, the mechanisms of which Freud had discovered before 1900,[6] it is necessary to locate its link to childhood. He identified the four mechanisms of dream formation as representability, displacement, condensation, and symbolization, all of which are used to disguise a forbidden wish. When they can be interpreted, according to Freud, dreams are the "royal road to the unconscious."

Rousseau's *The Dream* of 1910 [66] illustrates all four mechanisms, which disguise the dreamer's wish to be charmed (the snake charmer) and seduced (the serpent). The fact that it is a painting means that it is the pictorial representation of an idea, or set of ideas, and thus corresponds to the dream mechanism of representability. The dreamer is the woman, whose pose evokes the reclining nudes of Titian's *Venus of Urbino* [33] and Manet's *Olympia* [20]. Her upholstered divan has been displaced from a French drawing room to a jungle. This condenses the space separating France

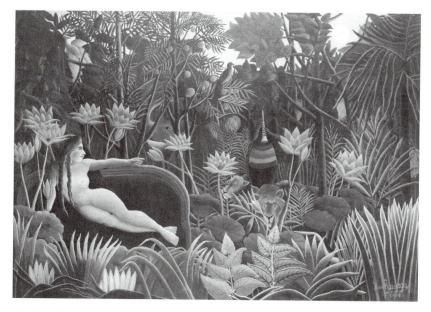

66. Henri Rousseau, *The Dream,* 1910, The Museum of Modern Art, New York.

from the tropics. Day and night are also condensed, for we see the moon in a bright—sunlit—sky. The serpent approaching the dreamer and the flowers are sexual symbols by association with their forms, as well as with their content, and the dark jungle forest symbolizes the instinctual depths of the unconscious mind. Although Rousseau's painting illustrates Freud's account of dream mechanisms, it does not actually replicate a dream. For the dreamer, like the artist in Figure 57, is both the author of, and a participant in, the image. Works of art, in contrast to dreams, must be accessible to a cultural audience and have a cultural style.

Freud believed that creativity was fueled by the instincts, which have an aim (usually sexual or libidinal, and/or aggressive) and an object (the person or thing at which the aim is directed). In the course of development, children begin to redirect their instincts from original (infantile) aims to other aims, which are culturally valued. Freud called this process sublimation.

An example of sublimation would be the redirection of a child's instinct to urinate on fire into firefighting.[7] Instead of indiscriminately extinguishing fires to satisfy an instinct, the firefighter puts out only those fires that are destructive to life and property. By thus sublimating his instinct, the firefighter stands for the rational control of fire and the forces of civilization. Similarly, a child's instinct to play with fire can lead to arson, or it can be sublimated into welding, forging metals, and eventually into creating bronze sculptures. In Greek mythology, it is the smith god Hephaestos who controls fire and forges metals. He was said to have brought crafts—and, with them, civilization—to mankind.[8] Such sublimation of instincts into "higher" cultural pursuits exemplifies Freud's concept of a developmental continuum in time. The original instinct remains buried in the adult's unconscious, which, like the buried city, is the storehouse of past experience.

In the view of Freud and his followers, the process of making art was energized by the instincts but controlled and formed by the synthetic functions of the ego. Freud also discovered the power of the unconscious mind, and the fact that conscious thinking is only a small part of our mental activity. Most of it resides in the unconscious, and is inaccessible except in fragmentary or metaphorical form—for example, in dreams, symptoms, slips of the tongue, and

so forth. When an artist creates a work, therefore, he must be able to tap into his past infantile instincts, which are lodged in the unconscious, and organize them in the present. This procedure, which has been termed "regression in the service of the ego"[9] and "access to childhood"[10] by two prominent Freudian analysts writing on creativity, is possible because there is no time in the unconscious.

In addition to characterizing the process of creative work, Freud identified certain universal fantasies, which are pictorial in nature. Of these, the Oedipus complex and the primal scene are particularly applicable to some of the conventions of artists' biographies and to the interpretation of imagery.

The Oedipus Complex

The Oedipus complex, in Freud's view, is a biologically determined mental construct. It forms the core of child development—beginning (about age three) in the course of the anal stage, and dissolving around the end of the phallic stage (age five to six)—and hence the nucleus of neurosis. Freud's literary "text" for the Oedipus complex was Sophocles' tragedy *Oedipus Rex,* his autobiographical "text" was his self-analysis, and his clinical "text" was the accumulation of more than thirty years of listening to patients. He formulated the theory of the Oedipus complex gradually, and modified it as he collected new data. A schematic account of its operation in boys is as follows: The three- to five-year-old boy wants an exclusive attachment to his mother, which requires the elimination of his father. He is jealous of his father, who possesses his mother, and also fears retaliation from him. In the child's fantasy, his father's retaliation—literally the talion law ("an eye for an eye")—takes the form of castration. Hence, the formation of the castration complex during the phallic stage (see above). This was Freud's first construction, and it is referred to as the "positive" Oedipus complex.

In 1923,[11] Freud published his account of the "negative" Oedipus complex, which is the reverse of the positive. By then, he had discovered the bisexual character of the complex, and the fact that the boy also identifies with his mother and wishes to be the passive love object of his father. The positive and negative constellations operate dynamically, and when the positive predominates, the boy

becomes heterosexual. When the negative predominates, the outcome is a homosexual one. In creative individuals, according to Freud, bisexuality is heightened. This can be seen, for example, when artists experience their work as their children, and themselves as both the mother and father who give birth to the work. Whistler's account of masculine line and feminine color combining to make a picture is a case in point. The twentieth-century painter Josef Albers described a mixed color as the offspring of its component colors. In a well-known anecdote, Giotto compared his paintings to his children, and Michelangelo said he made works instead of children.

The girl's Oedipus complex is more complicated and more difficult than the boy's, because her first love object—like the boy's—is the mother. But, in order to achieve a heterosexual outcome, she has to change from a female to a male love object, with a concomitant change from clitoral to vaginal sexual primacy. The heterosexual boy retains the female object, and thus, according to Freud, makes a smoother and usually more complete transition than the girl.

Artists and the Oedipus Complex

Among artists, the operation of the Oedipus complex is facilitated by the construction of genealogies as described by Pliny and Vasari. In the unconscious, concepts that are distinct in conscious thought can be interchangeable. For example, the male gods, kings, older artists, patrons of art, and even artistic tradition are experienced similarly in unconscious thinking, for they share a kind of traditional, patriarchal authority. When Cimabue recognizes Giotto's genius (Chapter Six), therefore, he asks his *father* for permission to make the boy his student. When Giotto surpasses Cimabue, he symbolically defeats his father by winning fame and outliving him in the cultural memory as well as in reality.

In Pliny's account of Apelles, additional aspects of the Oedipus complex emerge. Because of his skill, the artist has an exclusive relationship with Alexander the Great—Apelles alone is allowed to paint his portrait. He also wins Alexander's mistress. Alexander is thus cast in the paternal role of king and patron, and Pancaspe assumes the mother's role as the king's sexual object. Apelles is the

boy who succeeds in fulfilling his oedipal fantasy, in this case with the blessing of the "father."

The response to an artist's ambition may not always be as accommodating as Alexander's. Prometheus and the builders of the Tower of Babel were not so fortunate. If their actions—the theft of fire and trespassing on God's space—are read on an oedipal level, the nature of the response is psychologically consistent with the challenge. It is a derivative of the talion law that operates in unconscious thinking. The challenges replicate the efforts of the small child to be as big and powerful as the parents, and the response is symbolic castration. When such challenges are unrealistic, as these were, they are referred to as *hubris* by the Greeks, and as grandiosity by the psychoanalyst.

Prometheus and the tower builders challenged gods, but, as we have seen in Chapter Six, it is a biographical convention for artists to identify with the gods. When an artist is challenged by the grandiosity of someone else, therefore, he responds in a manner similar to that of the gods. Like the Old Testament God, Apelles tells the shoemaker not to rise too high—that is, not above the level of the foot. Giotto mocks the peasant who asks for a coat of arms by painting pieces of armor. He not only plays on the homophony of "arms," but he paints a talion image. By dismembering the armor, which stands for the wearer of the armor, Giotto symbolically dismembers (castrates) the upstart peasant. And since a coat of arms is a family crest, the artist also attacks the peasant's social and genealogical ambitions.

The myth of Arachne and Athena exemplifies the oedipal conflict between the girl and her mother. As a mortal, Arachne is destined to lose her contest with the goddess. Reinforcing the oedipal reading of the contest is the content of Arachne's scenes. They depict the male gods—particularly Zeus—pursuing mortal women. In that behavior, Zeus represents the father, and the mortal women—like Arachne—represent the daughters. As such, they usurp the position of Hera, Zeus's wife, and implicitly that of all the goddesses. Since Athena is the motherless daughter of Zeus, as well as a powerful goddess, she is doubly threatened by Arachne's imagery. When Athena, in turn, weaves scenes in which those who challenge the gods are punished, she reminds Arachne that one of the dangers of

father-daughter incest is the mother's wrath. Athena began her dia-
logue with Arachne as the "positive" mother, who warns the girl
and tries to make her see reason. But as Arachne persists, Athena
becomes enraged, and is transformed into the "negative," destruc-
tive mother. By turning Arachne into a spider, Athena destroys her
human capacity to create, and symbolically causes her to regress to
an earlier developmental level.

Regression literally means "a going back," but in psychoanalytic
theory there are different kinds of regression. Freud distinguished
three types—topographical (relating to id, ego, and superego), tem-
poral, and formal. Dreams and hallucinations, which are regres-
sions from ideas expressed verbally to pictures, are examples of
topographical regression. In temporal regression, one returns to a
previous developmental stage.

Arachne's regression takes the form of a descent on the scale of
evolution. Prometheus regresses to a passive, "feminized" position
when he is chained to a rock and tortured. The vulture eating his
liver recapitulates the fantasy of the cannibalistic, castrating father,
for in ancient Greece the liver was believed to be the seat of passion.
When God confounds the language of the tower builders, he ren-
ders them like preverbal children, who cannot understand adult
speech. In all cases, the concept of regression conforms to Freud's
conviction that the past is always present—as much in the individ-
ual psyche as in the buried cities of human history.

David and Goliath: An Oedipal Reading

The story of David and Goliath provided Western artists with a
well-known biblical text that lends itself to a rich variety of oedipal
readings. In I Samuel 17, David, the shepherd boy, plays the harp
for King Saul. They love each other well, and Saul—in the manner
of Cimabue and Giotto—asks David's father, Jesse of Bethlehem, to
"let David stand before me." David overhears the Israelites talking
about Goliath of Gath, the hero of the Philistine army arrayed
against Saul's kingdom. "The man who killeth him," they say, "the
king will enrich him with great riches, and will give him his daugh-
ter, and make his father's house free in Israel." David offers to fight
Goliath in single combat, and Saul accepts the offer. Saul provides

David with armor and weapons, but the young hero takes instead his shepherd's bag, a sling, and a stone.

The Bible is eloquent in describing the giant size and might of Goliath. He stands six cubits and a span tall, is covered in armor made of brass, and the head of his spear is equivalent in weight to six hundred shekels of iron. He taunts David, who uses his sling to hurl a stone at Goliath's forehead. The giant falls, and David, who is without a sword, kills and beheads Goliath with his own sword.

Up to this point in the story, several oedipal ingredients have emerged. David can be read as the young boy who eliminates the father in order to win a woman and become rich. But here there are three paternal figures—the king (Saul), who promises his daughter to the victor; Goliath, who represents the dangerous aspect of the father; and Jesse, David's biological father, who is elevated in stature through his son's success (his house is made "free in Israel"). David's decapitation of Goliath is read by the unconscious as castration.[12] Because David has "split off" the negative father figure (Goliath), he successfully destroys him and retains the more positive facets of the father (Saul and Jesse).

Splitting is an unconscious process of the ego that allows two contradictory thoughts to coexist.[13] Its purpose is to preserve a positive attitude (such as David's love for Jesse and Saul), while also satisfying an instinct (here to destroy the dangerous father in the form of Goliath). An oedipal reading of the biblical text recognizes that Jesse, Saul, and Goliath are split-off facets of the boy's view of his father. That is, they are experienced consciously as three different men—and are represented as such by the text—but they are the same in the unconscious. In consciousness, Jesse is the reality father, Saul is the wished-for royal father, and Goliath is the feared, castrating father.

In I Samuel 18, Saul's son Jonathan and David become close friends. Their souls are "knit" as one, which is evident when Jonathan gives David his clothes and his sword. As David's reputation and popularity grow, Saul becomes envious and makes several attempts to kill him. Saul tries to trick David with his daughters and sends him against powerful armies. Hoping for David's death, Saul asks him for a hundred Philistine foreskins—symbolically a prelude to castration and death. But David succeeds, and Saul finally gives

him his daughter Michal as a wife. By now, Saul's envy toward David is manifest (which is also the father's ambivalence when he experiences his son as a rival). The oedipal quality of this relationship is reinforced by the fact that David has become Saul's *son-in-law*.

In I Samuel 19, Saul tries to enlist Jonathan and all his servants in the effort to have David killed. But Jonathan defends David, and Michal saves him. Eventually (in II Samuel), David becomes a king himself, marries Bathsheba, and is the father of Solomon. In the New Testament Gospels, David is the ancestor of Christ. The biblical emphasis on genealogy, like the genealogical conventions of artists' biographies, facilitates oedipal dynamics.

Aspects of these dynamics are present in the art that depicts the story of David and Goliath. Four works from the Renaissance and Baroque periods will serve to illustrate some of these. The oedipal dynamics operate in relation to the cultural contexts of the works, to the personalities of the artists who made them, and to their iconography.

In fifteenth-century Florence, David's victory over Goliath was imbued with several levels of meaning. Politically it stood for Florentine liberty, which was threatened by the powerful dukes of Milan and other tyrants. David's biblical reputation resonated with the new Renaissance interest in fame as a way of achieving immortality through one's deeds. The Renaissance theme of the adolescent hero, identified with a particular deed that resulted in fame was frequently associated with David. In a Christian context, David as the destroyer of Goliath was paired typologically with Christ's victory over Satan. As a result of these thematic convergences, David became a symbol of Florence itself and the subject of several important artistic commissions.

Donatello's bronze *David* [67] originally stood in the courtyard of the Medici Palace in Florence. In 1495, it was placed in the Palazzo Vecchio courtyard, outside the seat of government. The sculpture reflects the complex, synthetic character of fifteenth-century Florence. In addition to the political and Christian meaning of the statue, Donatello has given his *David* a uniquely effeminate quality compared with other representations of the subject. He included in it Neoplatonic references that correspond to his homosexual repu-

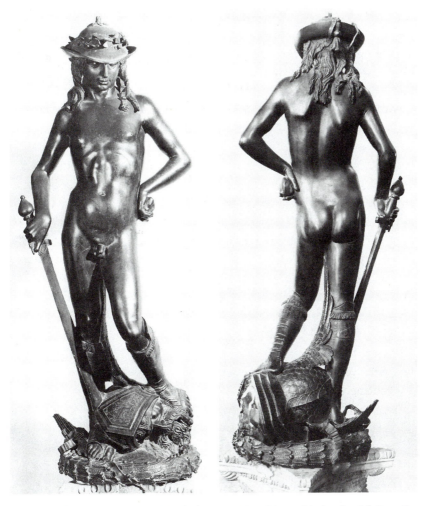

67. Donatello, *David,* front and back view, c. 1440, Museo Nazionale del Bargello, Florence.

tation,[14] and also reveal the erotic quality of the boy's relation to his father in the negative oedipal constellation.[15] In Plato's *Symposium,* Phaedrus says that Eros, the Greek god of love, inspires and protects soldiers when they are Platonic (that is, homosexual) lovers. Pausanias argues in the same Dialogue that tyrannical states discourage homosexuality, whereas republics are more liberal in their tolerance of it. Plato thus provides a model in Classical antiquity for representing a heroic fighter in a homosexual light, especially in the context of a republican state. In the Bible, furthermore, the relation-

ship between David and Jonathan, whose souls are "knit" as one, evokes the homosexually tinged friendships of adolescence.

Not only is Donatello's David effeminate, and somewhat androgynous, but he expresses the narcissism of homosexuality by his self-absorption. The live wing that rises from Goliath's helmet along the inside of David's thigh indicates the erotic interchange between victor and vanquished. David smiles, and allows his toe to play with Goliath's beard and mustache. In the relief represented on Goliath's helmet [68], a group of Cupids enacts a triumph of love between boys.

Michelangelo's marble *David* [12], commissioned in 1501 to adorn a buttress of Florence Cathedral, was placed instead before the Palazzo Vecchio. This work represents a different moment in the story of David and Goliath than Donatello's bronze. Michelangelo's figure has not yet killed his adversary, and anxiously sights him. He holds the sling in his right hand, and the stone in his left. Considered in an oedipal context, Michelangelo's David displays an expression of ambivalence toward the symbolic parricide he is

68. Detail of Figure 67, showing the putti relief on Goliath's helmet.

about to commit. That this *David* also reflects contemporary political and religious tensions in no way minimizes Michelangelo's personal identification with his subject.

Along the lines of identification, it is noteworthy that the original block of marble from which the artist carved the *David* was known as "the Giant." This reinforces the ambivalent character of the finished statue. By the association of giant size with Goliath, Michelangelo defeats his own "Giant"—the father who beat him for his ambition to be a sculptor. He identifies with the shepherd boy, and shapes the marble in his image, thereby literally carving the "Giant" out of existence. The marble "Giant" becomes David, who prepares to kill the biblical giant—as Michelangelo had to "kill" his own father's resistance to his art. The fantasy, and largely unconscious character, of these dynamics is evident in the fact that Michelangelo consciously remained on cordial terms with his father, and supported him financially until the end of his life.

The marble *David* of 1623 [13] by Gian Lorenzo Bernini represents an unambivalent man of action. It reflects the artist's positive oedipal identifications, and his ability to perform without hesitation. David grasps the sling and stone with fierce determination. His entire body twists in violent contrapposto as he concentrates on Goliath and begins his attack. The armor provided by Saul is behind David, as if to show the superiority of his intelligent strategy over brute force.

The predominance of the positive oedipal constellation in Bernini's representation of David is consistent with elements of his biography. His father, Pietro Bernini, was a Mannerist sculptor, who worked for Pope Paul V. As a result of his position, and of his inclinations, Pietro used his connections on behalf of his precocious son. He introduced him to Cardinal Scipione Borghese, the pope's nephew, who became an enthusiastic patron. According to Bernini's biographers, he carved the face of the *David* from his own features, and Cardinal Maffeo Barberini, himself a future pope (elected August 6, 1623), reportedly held up the artist's mirror for this very purpose. In Bernini's biography, therefore, a number of positive paternal figures combined to foster his success—his own father, high-level ecclesiastical patrons, and popes.

In contrast to Michelangelo, who had to fight an abusive father

for the right to be a sculptor (which means for the right to be himself), Bernini was encouraged from the start. His father's enlightened attitude minimized the inhibitory effects of oedipal conflict by allowing his son to "succeed" without guilt and hence without fear of retaliation. The relationship between Pietro and Gian Lorenzo conforms to the psychologically ideal circumstance for a creative child—that his father work in the same field, be less gifted than he, and be willing to concede victory realistically.[16] Such, in fact, was the circumstance of several great and highly productive artists—among them Raphael, Velázquez, and Picasso.

Caravaggio's childhood is little documented, but what is known suggests conflict between himself and his father. He left his home in Milan and went to Rome, where he denied a brother who was a priest. During his early years in Rome, his most prominent patron, Cardinal del Monte, was a well-known homosexual. After leaving del Monte's household, Caravaggio repeatedly ran afoul of the law, and racked up an extensive record of arrests for violence. Eventually he killed a man and was exiled from Rome. Much of Caravaggio's iconography reflects his taste for violence, particularly in the form of decapitation. And it seems that he identified with his beheaded subjects—especially those he represented as simultaneously dead and alive. A case in point is the head of Goliath in his painting *David with the Head of Goliath* [69], in which the David is a portrait of the artist's young lover and Goliath is a self-portrait.

The oedipal character of this iconography is quite complex. For Caravaggio does not identify with David, but with his victim. He is shown as defeated by homosexual love, which has placed him in a precarious dependency on a younger man. His head is literally "in David's hands," thereby depicting the dangers (to himself) of identification with his father (Goliath). He displays his own image not with the vigorous, youthful determination of Bernini's *David*, but as the older, decapitated, symbolically castrated Goliath.

The biblical text resonated with Caravaggio's violent tastes, and he embellished it to suit them. There is no reference in the Bible to David behaving as he does in this painting, and no description of Goliath's severed head. In addition to Goliath, Caravaggio represented the beheading of Holofernes by Judith, and painted a Medusa head on a tournament shield as a wedding present [70].

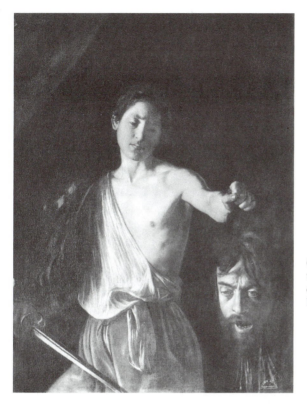

69. Caravaggio, *David with the Head of Goliath*, c. 1605–10, Galleria Borghese, Rome.

70. Caravaggio, *Head of Medusa*, c. 1596–98 (?), Uffizi, Florence.

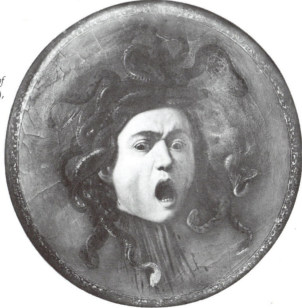

The latter, which was reputed to have contained the features of the artist, has a curiously androgynous quality. As such, it reflects Caravaggio's conflicted bisexual identifications, the terror of castration, and the sense of his psychic existence as a "living death." Whether as the "positive" oedipal boy afraid of his father's retaliation, as the "negative" oedipal boy identifying with his mother— these are combined in the Medusa head—or as the negative father (Goliath) targeted by the boy, Caravaggio depicts a beheaded self. Both heads look down, as if riveted by their decapitated bodies.

The Primal Scene

The primal scene is the child's fantasy of sexual activity between adults, particularly the parents. Freud's classic discussion of the primal scene is contained in the case of the Wolfman,[17] a Russian aristocrat in whom the negative oedipal constellation was prominent. The Wolfman reported a dream, and made a drawing and painting of it, in which "six or seven white wolves" were sitting on a tree outside his window. They were staring at him, with ears pricked up, and the boy was terrified. Freud interpreted the wolves as the dreamer himself, as a child, who was riveted to the sight of the primal scene. The pricked-up ears suggested that the boy was also listening intently to the sounds of the primal scene.

Since this activity produces babies, the primal scene answers the universal question of childhood: "Where did I come from?" As a result, it arouses a natural curiosity in children that is part and parcel of what Freud called the child's sexual research. This he related to the intellectual activity of adults, and noted that trauma in the former could lead to inhibition in the latter. He discussed the fact that children want to see what their parents do at night, and that when they actually encounter adults engaging in sexual activity, children invariably misunderstand it. But whether they see it or not, they infer it, and their "research" gives rise to the so-called sexual theories of children.[18]

The artist's special interest in creativity, and heightened visual sense, has made the primal scene a subject of art. When Arachne wove Zeus's Rape of Europa, for example, she confronted Athena with primal scene material—and also her knowledge of it. She thus

forced the goddess to "see" her own father's primal scene enacted with a lesser being (a mortal) than herself. In Titian's *The Rape of Europa* [23], Europa reclines on the back of the bull in a variation on the traditional pose of the sexually receptive woman. A sense of sexual excitement pervades the scene—in the gestures of Europa's girlfriends on the shore, the agitated sky, and the churned-up sea. The Cupid riding the dolphin stares into the open V-shape formed by Europa's legs, and his pose is a visual echo of hers. He thus stands for the small child who is sexually excited by witnessing the primal scene. Echoing his visual connection with the scene are the prominent eyes of the dolphin and the bull, which stare out of the picture plane at the viewer.

Rousseau's *The Dream* [66] also has primal scene content, although it is somewhat concealed by consciously constructed symbolism. The jungle setting symbolizes the sexual abandon associated with the "wild," while the upholstered divan identifies the "civilized" environment of the dreamer. Her excitement is palpable as the serpent approaches and she points toward the part-human, part-animal flautist. Playing the role of the staring child is the tame lion, whose wide, round eyes seem riveted—like those of the wolves outside the Wolfman's window—to the sight of something. Because children readily identify with animals, they are often represented as such in dreams and in children's stories, a phenomenon to which Freud referred as the totemism of childhood. Rousseau's lion also evokes the tame animals in the Garden of Eden, where the original primal scene occurred.

In Christian art, the canonical primal scene is the Annunciation. Van Eyck's *Annunciation in a Church* [58] represents Mary inclining her head to receive God's impregnating *logos* (cf. Chapter Seven) transmitted to her by Gabriel. This interchange corresponds to a common sexual theory of children—namely, that a woman becomes pregnant when a man kisses her, whispers in her ear, or breathes on her. Another theory, that babies are brought by a stork, derives from the phallic symbolism of birds. Consistent with that theory, Christian artists depicted the Holy Ghost—God's "spirit"—as a white dove.

Van Eyck shows the Holy Ghost approaching Mary on a ray of light. Both the dove and the rays have entered the church without

breaking the glass window, and this image became a Christian metaphor for the Virgin's miraculous conception of Christ. Reading this metaphor psychoanalytically, the rays correspond to the unconscious phallic associations of fire—we speak of the "flames of love," of "inflamed passion," and of "tongues of fire"—and the glass corresponds to the virginal hymen. Finally, Mary's liturgical role as the Church building itself reinforces the miraculous primal scene character of light (and of a bird) entering a window that remains intact.

In 1928, Magritte painted a violent primal scene, in which a fragmentary man terrorizes a woman [71]. The fact that the man is clothed and the woman nude emphasizes her vulnerability. Magritte described the picture as follows: "I've treated this subject, the terror which grips the woman, by means of a subterfuge, a

71. René Magritte, *Titanic Days (Jours gigantesques)*, 1928. Private collection.

reversal of all the laws of space . . . the man seizes the woman; he is in the foreground, so he necessarily conceals a part of the woman, the part where he is in front of her, between her and our vision. But the novelty consists in the fact that the man doesn't overlap the contours of the woman."[19] Magritte's biographer, the art critic David Sylvester, attributes the effect of a collage, or cutout, to the fact that the man does not overlap the edges of the woman.[20] As a result, the man seems literally "stuck" on her so that he can't be repulsed. "It is," writes Sylvester, "a wonderful example of style as content."[21]

Magritte shows the primal scene as an act of violence, which is the way many children imagine it. Typically it is seen, as it is here, as the man inflicting harm on the woman. The child who confronts a primal scene in progress experiences the figures as merged, and has difficulty distinguishing one from the other. What identifies Magritte's painting as an unequivocal primal scene is its title— *Titanic Days*. This combines two tendencies in children—namely, to see their parents as idealized gods, and as fearsome or powerful giants.

In Greek mythology, the parents of the humanized Olympian gods were the Giants, or Titans. They were conceived of as primitive and cannibalistic—Chronos swallowed his children to elude the prophecy that they would take away from him the control of the universe. *Titanic Days* thus refers to a mythic past, when parents seemed to be godlike in their ability to do what children cannot, and gigantic because of their larger size. Magritte's Titans embody the traumatic—because terrifying—image of these primal "parents."

In *The Betrayal of Images* [1], Magritte's thinking appears to be far removed from primal scene content. But the nature of imagery, like verbal associations, is such that it allows for multiple significance. In 1948, Magritte returned, as he had on several occasions, to the *pipe*. This time he produced a drawing of a man's profile, in which the nose is a phallus dipping into the bowl of the pipe [72]. W. J. T. Mitchell describes the pipe as an "instrument of autofellatio," and the drawing itself as a "metapicture."[22] "Metapictures," he writes, "are like all pipes: they are instruments of reverie, provocations to idle conversation, pipedreams, and abstruse speculations. Like pipes, metapictures are 'smoked' or 'smoked out' and then put back in the rack."[23]

72. René Magritte, *Untitled Drawing*, 1948.

Although this drawing is literally an image of "autofellatio," it also denotes the primal scene. It illustrates Freud's notion that masturbatory daydreams are bisexual, for the dreamer must create both the male and female roles.[24] Such daydreams, like the drawing, are autoerotic, but the drawing includes male and female components.

Some time ago, the art historian Carroll Janis wrote me as follows: "I had a dream in which I interpreted the great Magritte canvas, *Ceci n'est pas une pipe*, after I had seen the work in an exhibition at the Sidney Janis Gallery in New York. In my dream, the painting appeared with its words *'Ceci n'est pas une pipe,'* and I replied in the dream, *'Bien sur! C'est une femme.'* Incidentally, I had the dream, I believe, before I knew Magritte's drawing in which the smoker's phallic nose goes into the bowl of the pipe, which appeared to confirm my dream's interpretation [of the painting]."[25]

NOTES

1. See my *Art and Psychoanalysis* (New York, 1993), for a more extensive discussion of this subject.

2. Sigmund Freud, "The Aetiology of Hysteria," S.E. III, 1896, pp. 191–221.

3. For a fuller discussion of these stages see the relevant entries in J. Laplanche and J.-B. Pontalis, *The Language of Psychoanalysis,* trans. Donald Nicholson-Smith (New York, 1973).

4. See Suzanne Cassirer Bernfeld, "Freud and Archeology," *American Imago* 8 (1951): iii.

5. Freud, "Female Sexuality," S.E. XXI, 1931, pp. 225–43.

6. Freud, *The Interpretation of Dreams,* S.E. IV and V, 1900.

7. Freud, "The Acquisition and Control of Fire," S.E. XXII, 1932, pp. 187–93.

8. See "To Hephaestos," in Hesiod, *The Homeric Hymns and Homerica,* trans. H. G. Evelyn White, Loeb ed. (Cambridge, Mass., and London, 1982), p. 374.

9. See Ernst Kris, *Psychoanalytic Explorations in Art* (New York, 1952).

10. See Phyllis Greenacre, "The Childhood of the Artist" (1957), in *Emotional Growth,* vol. 2 (New York, 1971), pp. 505–32.

11. Freud, "The Ego and the Id," S.E. XIX, 1923, pp. 12–66.

12. See Freud, "Medusa's Head (1922)," S.E. XVIII, 1940, pp. 273–74.

13. Freud, "Splitting of the Ego in the Process of Defence," S.E. XXIII, 1940, pp. 273–78.

14. See Laurie Schneider, "Donatello's Bronze *David,*" *Art Bulletin* LV, no. 2 (1973): 213–16, for specific references.

15. See Laurie Schneider, "Donatello and Caravaggio: The Iconography of Decapitation," *American Imago* 33, no. 1 (Spring 1976): 76–91.

16. On this concept see Greenacre.

17. Freud, "From the History of an Infantile Neurosis," S.E. XVII, 1918, pp. 3–123.

18. Freud, "On the Sexual Theories of Children," S.E. IX, 1908, pp. 205–26.

19. Cited in David Sylvester, *Magritte* (New York, 1992), p. 114.

20. Ibid.

21. Ibid.

22. W. J. T. Mitchell, *Picture Theory* (Chicago, 1994), pp. 12–13, n. 36 (see also my Preface, p. xv).

23. Ibid., pp. 12–13.

24. Freud, "Hysterical Fantasies and Their Relation to Bisexuality," S.E. IX, 1908, pp. 157–66.

25. Carroll Janis, letter dated September 18, 1995.

10

Psychoanalysis II: Winnicott and Lacan

There have been many revisions of psychoanalysis since Freud established its foundations in the first half of the twentieth century. Creativity and its products have continued to fascinate psychoanalysts for the very reasons that they appeal to philosophers and mythmakers. The humanist character of the arts and their source in the human imagination make them a natural subject of psychoanalytic inquiry. Two important psychoanalysts who wrote on creativity and the arts from post-Freudian perspectives are D. W. Winnicott in England and Jacques Lacan in France.

Winnicott: Creativity and the Transitional Object

Winnicott, the leading English Object Relations psychoanalyst and a pediatrician, traced the origins of creativity to the early, pre-oedipal mother-infant dyad. Winnicott observed that, between four and twelve months of age, children who are not autistic develop an attachment to a special object, which he called the "transitional object."[1] This can be anything from the corner of a blanket—or an entire blanket, such as that of Linus in the *Peanuts* comic strip—to a pacifier, a teddy bear, or a worn-out rag. Developmentally, the tran-

sitional object is later than the autoerotic attachment to a part of the child's own body—a thumb, a toe, a strand of hair, and so forth.

Winnicott also identified "transitional phenomena," such as playing, singing, babbling, even daydreaming and sleep dreaming. Both the transitional object and transitional phenomena serve the purpose of symbolization. They allow the infant to separate from the mother—typically at bedtime—and stand for her (particularly her breast) in some way. They designate a space, rather than a specific object or activity, and are thus perceived differently by the mother and the child. For the mother, they are distinct from the child, and for the child, they are part of himself. When Linus is separated from his blanket, he experiences the anxiety of an assault on his ego. He shakes with terror until his blanket is returned. For this reason, Winnicott concluded that a "good-enough mother" leaves the transitional object alone, and eventually the child loses interest in it.

The significance of transitional objects and transitional phenomena for Winnicott is their role as a cultural basis for later creative pursuits. Like Freud, therefore, Winnicott saw human development as a continuum in time, and the events of childhood as the foundation of adult character. The transitional object becomes the paradigm of all art, which always has a transitional aspect. Religious art, for example, creates the transition between people and their gods, and every culture expresses this transition in its own way.

The Transitional Character of Religious Art

The widespread notion that gods are up—either in the sky or on mountaintops—calls for a transitional architecture to relate people with their gods. The Mesopotamian ziggurats, for example, functioned as mountains to provide dwelling places for the gods. In the flat terrain of Mesopotamia, these structures brought the gods closer to the human population, especially in the cities. The Egyptian pyramids were capped with gold, which related their highest point to the sun god. Gold that descended the surfaces of the triangular sides was designed to replicate rays of the sun, thereby linking earth with sky, and earthly life with eternal life through the pharaoh's burial place. The builders of the Gothic cathedrals emphasized height through the soaring vertical planes of their towers and

spires. Not only did they literally rise toward God and the heavens, but, like the ziggurats and pyramids, were visual reminders of another level of existence.

Temples and churches express the transition between the material, exterior world of the worshiper and the interior sanctuary housing an image of the god. In Egypt, the hypostyle hall containing hundreds of colossal columns created a sense of mystery as one progressed from the entrance toward the holy of holies. In Greek temples, worship itself took place outdoors, and the god's image in the *naos* was accessible only to priests and priestesses. And Christian churches reserve the innermost enclosures of the choir, the apse, or the side chapels for altars where services are performed. These architectural transitions from exterior to interior are accompanied by an increasing sense of awe, as if one were approaching a hidden source of power. Reversing this architectural "journey" from exterior to interior replicates the child's developmental "journey" from interior to exterior, from the mother's body to the outside world. At every separation from the mother, especially at night when returning to darkness, the child is assisted by the presence of the transitional object.

When religious architecture has a chthonic aspect, it creates a transition between what is above ground and what is below ground. As with the inner sanctuaries of temples, the interior of the earth evokes the prenatal state in the womb. The child's developmental journey is exemplified architecturally in the building stages at Stonehenge. Beginning around 3000 B.C., the site consisted of a circular earth mound containing burials. The slight elevation of the mound announced its presence as simultaneously part of the landscape, and also marked out from it. Later, small stones were arranged along the circle, and, by about 1800 B.C., the central cromlech was in place. This structure is both open and closed, interior and exterior, related to the earth and to the sky. As such, it corresponds to Winnicott's view of the transitional object, which is both outside the child and part of himself.

Children who fear separation at night are often afraid of terrors associated with darkness and death. In Greek mythology, Sleep and Death are twin gods; in the unconscious, they are interchangeable. In death, one returns to earth, and this became the basis of Saint

Augustine's justification for having to die in order to be reborn, as well as for his metaphor in which the Virgin Mary is both the womb and tomb of Christ.

Derivatives of the transitional object recur in funerary art. There, it symbolically prolongs the life of the deceased. Such art reassures the living, because they believe it reassures the dead. Thus, for example, the scenes painted in the tomb chambers of the pyramids depict the daily life of the pharaoh, of his court, and of his family. The Etruscans buried toys in the tombs of their children to keep them company after death.[2] They also built cities of the dead (*necropoleis*), made tombs and cinerary urns that resemble houses, and sarcophagi in the shape of banqueting couches [73]. The lids of the sarcophagi were decorated with the deceased couples represented as asleep in bed or sitting up and participating in a banquet. In either case, those who are buried *in* the sarcophagus are represented as alive on the exterior. Both the Egyptians and the Etruscans created an art specifically intended to bridge the chasm between life and death, just as the child's transitional object bridges the space between the presence and absence of the mother.

Death masks and portraiture also serve the transition between

73. Etruscan Tomb with Banqueting Couple, from Cerveteri, Italy. Louvre, Paris.

life and death, and presence and absence. As early as the Neolithic period in ancient Jordan, human skulls were built up with plaster and the eye sockets were filled with inlay. In this way, the dead seemed to be revived. Actual portraits generally create a dynamic response in the viewer, who automatically connects the person's image with the real person. Imagine the effect if, beneath a likeness of George Washington, the artist had written—as Magritte wrote beneath his "pipe"—"This is not George Washington." The statement would block the connection and interrupt the associative flow from the portrait to the person. In a sense, the portrait "becomes" the person, so that a written statement to the contrary produces a disturbance in the viewer.

Self-portraiture plays a special role in regard to the transitional object. In the case of a straightforward self-portrait, the artist seems to be communicating directly with the audience, bridging the gap between artist and viewer. When the artist inserts his own image into a known narrative, such as the story of David and Goliath (see above), he draws us into his own identification with the events of the depicted text. The rather unusual self-portraits of Caravaggio as Goliath and Medusa can also be read in terms of the transitional object. For the developmental precedent to castration anxiety is the separation anxiety that is allayed by the transitional object.

It is characteristic of the decapitated heads with which Caravaggio identifies—those of Goliath, Medusa, and Holofernes—that they are alive. Translated into words, Caravaggio seems to be saying that, despite the headless circumstance in which he finds himself, he is not dead yet. He essentially survives his own death. But his decapitated heads of John the Baptist, on the other hand, are depicted as very much dead, and thus do not serve as transitional objects. The psychobiographical meaning of this distinction resides in Caravaggio's associations to the name of John the Baptist—Giovanni Battista, in Italian. In Rome, he had denied his brother, who was a priest named Giovanni Battista. The coincidence of names and Caravaggio's hostility to his brother thus converge in the artist's iconography.

Once death has been depicted as a definitive ending, as in Caravaggio's paintings of the saint, the image loses its transitional function. It ceases to imply a future time. In the iconography of mar-

tyrdom, however, death implies salvation, which occurs in the future. To the degree that Caravaggio's John the Baptists are read solely on the level of Christian martyrdom, they evoke the transition to life after death. But if read psychologically, Caravaggio symbolically "kills" his brother through the image of the dead saint.

The Transitional Character of the Materials of Art

Art is a product that is formed from unformed material, or, in some cases, re-formed from formed material. The very notion of "formation" and of becoming through forming is part of the transitional character of art. This is related to what Leonardo meant when he wrote of seeing the chance shapes in a wall (Chapter One), and what he demonstrated when he drew flowing water to resemble a woman's hair. The *Mona Lisa* [9] herself has been interpreted as a metaphor for the rocky, mountainous landscape against which she is set. As such, she conforms to the artist's association of rocks with bones, of earth with flesh, and of the rivers and oceans with the circulatory system.[3]

Traditionally, works of art are formed from the natural materials of the earth. These materials are transitional in their role as intermediaries between the artist's idea and the finished product. In the myth of Athena and Arachne, the material was colored thread woven into scenes. The threads thus formed the transition between the ideas that the contestants wished to convey and the images they created.

Since artists select their materials, it must be assumed that the material has a meaning for the artist. "Love of material," wrote the critic and sculptor Sidney Geist, "is a psychological, not a sculptural affair."[4] With specific reference to Brancusi's love of bronze, Geist interprets *Bird in Space* [Plate 2] as the artist's self-image. It is, according to Geist, a symbolic phallus that stands up to the paternal sun, mirroring Brancusi's wish to confront his abusive, ignorant father.[5] In selecting bronze, and polishing it to a high degree, Brancusi creates a golden, reflective surface whose shine rivals the sun.

The twentieth-century fashion for the "found object" also approximates the child's transitional object.[6] Both have a prior exis-

tence and are selected and given meaning. The child selects the transitional object for its texture, smell, or appearance, and draws it into his creative space.[7] When artists select found objects, they associate something about them to a work of art that they intend to create. This is what Duchamp did with the shovel (Chapter One). By removing it from the hardware store and naming it—*In Advance of a Broken Arm*—Duchamp appropriated the shovel. He transferred it from the mundane space of the store to the creative space of the artist.

When Picasso made the *Bull's Head* [7], he rearranged two objects that are usually attached to a bicycle. To do so required an associative capacity, which, in Picasso, was prodigious. In effect, he fulfilled Leonardo's requirement of creative, transitional seeing. But instead of chance shapes in a wall, Picasso saw the formal potential of manufactured objects. He was thus in full control of his creative space and of the activity that occurred within it. As such, he recapitulated the child's transitional space, into which the good-enough adult does not intrude.

Lacan and the Power of the Gaze

Another important means of psychological and artistic control has been considered in some of Lacan's work on the gaze, and on the role of seeing in child development.[8] Lacan's writing is difficult, and what follows is a brief summary of a few of his concepts explicated by Anthony Wilden.[9]

By 1953, Lacan had identified three levels of mental functioning: the Symbolic (or discursive), the Imaginary (or perceptive), and the Real (by which he meant the inner, psychic reality of the individual, and not what is objectively real). To a considerable degree, these terms replicate Freudian concepts, but they have been influenced by Saussure's structural linguistics. For example, where Freud would say that a dream is a regression from words to pictures, Lacan would say that dreaming is the process by which the Symbolic becomes the Imaginary.[10]

The Symbolic and the Imaginary are, in Saussure's terms, "binary opposites"; the former is based in language, and the latter in the self-image. But Lacan's view of language is more dynamic, and

therefore more psychological, than Saussure's. For Saussure, speech (the signifier) is the expression of a mental concept (the signified), and together they constitute the sign. For both Lacan and Saussure, speech and thought are simultaneous and indistinguishable.[11]

Freud's notion of the symbol was based on connections, or similarities, between the symbol and what it represents. Thus the serpent in Rousseau's *The Dream* symbolizes the phallus by formal analogy (its shape) and also by its behavior in approaching the reclining dreamer. Traditional associations to the serpent as a fertilizer of the earth ("mother earth") and the serpent's role in the Fall of Man reinforce the symbolic connection. Lacan's Symbolic is also unconscious, but it is a system structured like language and legislated by the symbolic father. Lacan calls this the "name of the father"—in French, *le nom du père,* which sounds like *le non* [the *no*] *du père.* Furthermore, following the Structuralism of Lévi-Strauss, Lacan believed that children are born into a symbolic, cultural structure.

Like Derrida, Lacan made much of the *fort/da* game of Freud's grandson. His focus, like Derrida's, was on the issue of presence and absence, but as an expression of the Imaginary (which here refers to the child's fantasy about what he sees and doesn't see). Freud, on the other hand, interpreted the game as an attempt to master the trauma of the mother's absence. For Freud, repeating behavior in order to achieve mastery went "beyond the pleasure principle," because it was not necessarily pleasurable (as in repeated nightmares), and it could lead to self-destruction (in the form of the death instinct). Freud's prior concept of the unconscious was as the repository of instincts that were set in motion by a drive toward pleasure. For Lacan, "desire" is the instinct aroused by a gap, or a perceived absence—that is, by something not seen.[12]

The *fort/da* game is thus predicated on the child's perception of his mother's absence, which has also made him aware of her presence. In Saussurean terms, this approximates (but does not replicate) the notion of language as the perception of difference. What is present is not absent, and vice versa. The *fort/da* toy, in Lacan's view, substitutes for the mother—in a Winnicottian reading, the game itself, which is created by the child, would occupy the transitional space of symbolization. And in language, the absence of a sign's referent is compensated for by the presence of the sign.

Lacan's concept of the mirror phase (the *stade du miroir*) calls on the Imaginary rather than on the Symbolic. This phase occurs between six and eighteen months of age, and is the origin of the ego. The child senses a unified self, but does not objectively comprehend it until he recognizes that the mirror image is his own. Prior to that point, according to Lacan, the ego resides in a perception of the Other (usually the mother); hence the need to control her coming and going, and to create a transitional object.

The child, in Lacan's view, is in a potential state of losing the sense of himself as a totality. In regression, which can occur in a dream, in a hallucination, in schizophrenia, and in Existential literature, according to Lacan, the child's self-image is shattered. When the child's narcissism is thus assaulted, he experiences his *corps morcelé*, or his "body broken up."[13] This is the effect described by Camus in *The Stranger (L'Étranger)* when Meursault's mother dies. His sense of himself in time and place is shattered and his *moi* ("me" or "self") disintegrates on the hot Algerian beach in the glare of the sun. He loses his capacity for appropriate emotional response—he does not cry at his mother's funeral, and he kills a man. He thus becomes a psychic "stranger," alienated from himself and detached from the world around him.

In the Lacanian equivalent of the oedipal stage, the child's castration anxiety is the result of a "lack," or an absence. In regard to the mother, it is a real perception—that is, she does, in fact, lack a phallus. The Imaginary, which is perceptive, notes the lack, while the verbal expression of the conditional—that it *should be present*—is predicated on the linguistic structure of the Symbolic. Castration, on the other hand, is "neither real, nor really potential . . . [but] . . . is part of the child's relationship to the father, that of the 'Symbolic debt.'"[14]

Lacan's theoretical emphasis on what is seen and not seen, what is present and absent, informs his related concepts of the "gaze" and "desire." The gaze rivets the subject to something that is present, whereas desire is the instinct for what is absent. The Lacanian paradigm for these notions is the locked gaze of mother and child, which arouses the envy (from Latin *invidia*, related to *videre*, meaning "to see") of the outsider. Whoever is excluded from the mother-child gaze is, in effect, locked out. The shattering effect of such exclusion replicates the *corps morcelé* of the narcissistic assault.

Giotto's *Nativity* [17], which is described in Chapter Three, can be read as a play on the symbolic power of the gaze. At the far left, Mary and Christ are locked in the riveting gaze of mother and child. Here it is particularly significant, because this is the first time Mary *sees* her infant directly. The midwife and the ox are technically excluded from the mother-child gaze, but they participate in it from the sidelines. Ignoring their gaze by lowering his head is the ass, who looks down. His *ignorance* thus combines not seeing with not knowing, and he is characterized accordingly in Christian tradition.

Joseph, who begins to doze in the foreground, turns his back on Mary and Christ. His eyes are not entirely shut, but his gaze is inward. It is the self-directed, languid gaze of one who hovers between sleep and waking. Joseph's gaze matches his pose, which also denotes an in-between state, as if he were about to drop off to sleep. His transitional character conforms to his position in the Holy Family, for he is simultaneously Christ's father and not Christ's father. At the same time, he is the formal anchor of the painting, and his triangular shape echoes that of the sturdy rock behind the shed. Psychologically, then, Joseph refrains from trying to pierce the mother-child dyad. His "structured," sculptural form corresponds to Lacan's notion of the father as symbolic lawgiver. Lacan's term for this phenomenon, the *nom du père* (or identity), is also the *non*, or *no*—hence his role as the one who structures, or legislates, the unconscious mind.

The Annunciation to the Shepherds, which Giotto merges with the Nativity, plays on the theme of the gaze in different rhythms. Above the shed, five angels direct their gaze in three directions. The two at the left and the fourth from the left gaze upward, toward God, the heavenly father. He is not seen, but his presence is denoted by the angels' gaze. God's absence reinforces Joseph's presence. The central angel arrests the movement of the other four by his foreshortened form and abrupt change of direction. He also links God with Joseph by his placement—in the sky, but gazing directly down at the dozing figure.

The angel at the far right curves downward and locks his gaze with that of the two standing shepherds. Their vertical planes arrest the curvilinear movement of the angels, and they tilt their heads upward to hear the angel's announcement. To the left of the shepherds, separated from Joseph by a spatial void, is a group of six

white sheep and one black goat. These animals vary their gaze in a manner that echoes the human figures. For example, the mother sheep resting her chin on a baby sheep echoes the relationship of Mary and Christ. There are two female sheep and two women— Mary and the midwife; three male sheep and three men—Joseph and the shepherds; one baby sheep and the infant Christ; and one goat, who corresponds theologically to the ass.

In Giotto's *Nativity,* the play of the gaze is contained within the narrative of the picture. In Duchamp's *L.H.O.O.Q.* [46], on the other hand, the gaze operates self-consciously between the viewer and the represented woman. Considered from the perspective of the primal scene, Mona Lisa with a beard and mustache evokes the child's reading of the primal scene as indistinguishable figures who merge into a single, male-female androgyne. Whereas Magritte notifies his viewers that the *pipe* is not a *pipe,* Duchamp registers an instruction in the form of a verbal pun. He tells viewers to *look,* to gaze directly on Mona Lisa's bisexuality, as a child gazes on the primal scene. He also combines the Lacanian Imaginary (because missing) phallus with the Symbolic (because discursive)—*it ought to be there.* He repairs the absence of the phallus by the addition of male attributes, and transforms Leonardo's woman-mountain into a bearded lady.

NOTES

1. D. W. Winnicott, *Playing and Reality* (New York, 1971), ch. 1.

2. For a study of Etruscan funerary art and the transitional object, see Simon A. Grolnick and Alfonz Lengyel, "Etruscan Burial Symbols and the Transitional Process," in *Between Reality and Fantasy,* ed. Simon A. Grolnick and W. Muensterberger (New York and London, 1978), ch. 24.

3. See Laurie Schneider and Jack Flam, "Visual Convention, Simile and Metaphor in the *Mona Lisa,*" *Storia dell'Arte,* no. 29 (1977): 15–24.

4. Sidney Geist, *Brancusi: A Study of the Sculpture* (New York, 1968), p. 158.

5. Sidney Geist, "Brancusi's *Bird in Space:* A Psychological Reading," *Source: Notes in the History of Art* III,

no. 3 (Spring 1984): 24–32.

6. See Susan Deri, "Vicissitudes of Symbolization and Creativity," in Grolnick and Muensterberger, ch. 4.

7. Winnicott, op. cit., p. 2.

8. See Jacques Lacan, *The Language of the Self,* trans. Anthony Wilden (Baltimore, 1968), and Anthony Wilden, "Lacan and the Discourse of the Other," in Lacan, ibid., pp. 59ff.

9. Ibid.

10. Wilden, p. 92.

11. Jacques Lacan, *The Four Fundamental Concepts of Psycho-Analysis,* trans. Jacques-Alain Miller (New York, 1977), ch. 2.

12. Ibid., ch. 3.

13. Wilden, p. 174.

14. Ibid., p. 187.

11

Aesthetics and Psychoanalysis: Roger Fry and Roland Barthes

———————

The aesthetic response to art, even one's philosophy of art, is influenced by psychological factors. To illustrate this notion, I conclude with a brief discussion of the formalism of Roger Fry[1] (Chapter Two) and of Roland Barthes's (Chapter Seven) last work on photography—*Camera Lucida*—from a psychoanalytic perspective.

Roger Fry

In 1866, Roger Fry was born into a devout Quaker family in London. His father, Sir Edward Fry, was a stern disciplinarian whose wife, Mariabella, bore him nine children. Later, because they equated their wealth with virtue and blamed the poverty of others on sinfulness, Roger would describe his parents' values as showing "a want of simple humanity."[2] He was sent to boarding school, where, as head boy, he was required to attend weekly floggings administered by a sadistic headmaster. As a result, he developed a lifelong aversion to violence.[3] He remained attached to his mother,

and corresponded with her until her death. With his father he shared a passion for science.

Fry thought of himself as a painter—a profession that did not entirely please his father. In the end, however, Fry earned distinction on two continents not as an artist but as a critic. He published and lectured widely on formalist aesthetics, worked as Curator of Paintings for the Metropolitan Museum of Art in New York from 1905 to 1910, and was the Slade Lecturer at Cambridge from 1933 to 1934.

The art critic David Cohen has pointed out that Fry had personal reasons for his denigration of content in favor of form.[4] This included a firm resistance to psychoanalysis, despite the fashion for it among the members of the Bloomsbury group. Fry objected to the symbolic interpretations of subject matter as contrary to Classical purity of form in art as well as in literature.

He himself became part of the Bloomsbury circle, and was a friend of Clive Bell (Chapter Two), his wife, Vanessa (who also became Fry's lover), and Vanessa's sister, Virginia Woolf, who wrote a biography of him.[5] The latter was knowledgeable about psychoanalysis, although she had an ambivalent relationship to it. She was disturbed by Freud's concept of the unconscious, for she denied the possibility of not knowing her own mind. Two other members of Bloomsbury, Alix and James Strachey, translated Freud's writings, and James became the editor of the Standard Edition. Nor was Fry himself ignorant of psychoanalysis. In March 1919, he wrote to Vanessa Bell that he was reading the work of Ernest Jones, the English psychoanalyst and Freud's biographer.[6]

Fry's disregard of content in art was consistent with his apparent indifference to psychoanalysis. He never commented, for example, on Freud's 1910 psychobiography of Leonardo da Vinci or his essay of 1914 on Michelangelo's *Moses*. But what *did* ally Fry with psychoanalysis, though he did not acknowledge it, was his conviction that the details of a painting—like handwriting—revealed the artist's character.[7] When it came to his tastes in art, Fry was very clear. He disliked Whistler's philosophy of "art for art's sake," and preferred the "order" of Classical art, of Giotto and the Italians. He also admired the expressiveness of non-Western art, children's art, and modern art. As early as 1906 Fry became interested in Cézanne,

who seemed to him to combine modernism with formal purity. In contrast to the Post-Impressionists, Cézanne, in Fry's view, did not exploit color for emotional effect.

But Cézanne was more to Fry than the most significant artist of the modern period—he was both an object of personal identification and a revered icon. Fry's 1927 study of Cézanne's development appeared with his own imitation of a Cézanne still life on the cover. That work opens with a statement of Cézanne's paternal relationship to the artists of Fry's generation: "Those artists among us whose formation took place before the war [World War I] recognize Cézanne as their *tribal deity, and their totem*" [italics mine].[8] Fry's copy of Cézanne's self-portrait (now in the Courtauld Institute Gallery, in London) leaves no doubt about the degree of his identification, which he confirms in his next two sentences: "They [the artists of his generation] absorb his essence," or would if, "like primitive man," they knew "the efficient magic ritual."[9] And then: "We believe in any case that in our art we incorporate something of his essential quality."[10]

Cézanne's early paintings freely depict sexual and violent subject matter. When he renounced such content, according to the modernist view, he embarked on the formal innovations that would lead to Cubism and revolutionize artists' approach to the picture plane. His work became plastic, constructed, ordered, visibly controlled, and extremely complex. According to Shiff, "Fry conceived the heroic side of Cézanne's enterprise as a struggle to free his art from his obsessions rather than to use his art to explore or master them."[11] Cézanne was also praised by Fry for his commitment to his art, and for his courage in pursuing it. He was, Fry wrote, a "determined explorer, who could not be turned from his purpose by the contempt of the world, the insults of the public, and the utter isolation in which he had to take refuge."[12]

By identification with Cézanne's renunciation of disturbing content, his formal order, and his courage, Roger Fry hoped to restore some measure of control to the insanity that dominated his personal life. On December 3, 1896, Fry married Helen Coombe, one of twelve children, and a painter who designed stained-glass windows. He was thirty, she was thirty-two. His parents objected to the match because Helen had no money, because she was an artist and

not a Quaker, and because she was rumored to have health problems.[13] The latter proved to have been a valid objection, for in June 1892, Helen had the first of a series of psychotic episodes caused by ossified cartilage pressing on her brain. She became incoherent, violent, and paranoid toward her husband. Nine years later, during a period of calm in 1901, their son, Julian, was born, followed by their daughter, Pamela, in 1902. But Helen's mental condition continued to strain Roger Fry's career, and interfered with his travel, especially when he was working for the Metropolitan Museum. Around the time of his dismissal from his curatorship—because of differences with the financier J. P. Morgan—Helen had to be permanently hospitalized. By the following year, 1911, Fry had begun his affair with Vanessa Bell.

In a sense, Fry—like Pygmalion—turned to art in search of the order that was lacking in his private life. His affinity for Cézanne, in whose work formal order had replaced violent iconography, combined a real and accurate assessment of his importance with a need to avoid disturbing content. In one letter to Vanessa Bell, Fry wrote, "I've known since Helen that the world was made of the worst conceivable horrors."[14] Since such "horrors" are the stuff of the unconscious, made manifest and expressed in the psychosis of his wife, Fry tried to protect himself by denying the significance of content. As late as 1933–34, Fry could write that the eroticism of Indian sculptures was a distraction from their aesthetic impact.[15] Helen died in 1913, and eleven years later, Fry reencountered mental disorder. He had made friends with a French woman, who killed herself in a fit of insanity.[16]

Fry's apparent attraction to disturbed women and his efforts to find refuge from emotional content in the formal structure of painting are condensed in what he called his "first conscious impression." He was in the nursery and aware that he was afraid of his strict Calvinist nanny and the jealousy of his twin sisters. In his memory, he detached from the anxiety aroused by his nanny and his sisters, and instead vividly remembered the view from his window—two patches of light with green below.[17]

This kind of memory was identified by Freud as a "screen memory."[18] Such memories refer to a time before the age of seven, and are remembered as vivid, despite seemingly banal content. Often a sex-

ual event is "screened" and disguised as a neutral occurrence. Usually screen memories can be analyzed like dreams, by following the threads of association, and are revealed to contain significant childhood themes. Roger Fry's memory "screens" out the anxiety-provoking material by abstracting from content and focusing on the patches of light over an area of green. Not only does the memory mitigate the perceived dangers of a strict nanny and jealous sisters by redirecting his gaze, it also does so by the vividness of the light and the color, which are structured by the frame of the window. Fry's memory is thus consistent with his aesthetic preference for form over content. In 1902, referring to his experience of a still life by Chardin as a separation of form from content, he declared, "It gave me a very intense and vivid sensation."[19] His aesthetic response to the Chardin thus recapitulated his earliest childhood impression.

The presence of light and green in Fry's view from the nursery can be read as having primal scene content. For light, as in Brancusi's *Bird in Space,* has an unconscious association with the phallus,[20] most likely because of the patriarchal role of the solar deities. The green, in this context, refers to grass and foliage visible from the window, and thus symbolizes the mother's role as the fertile earth. This, of course, is consistent with the fact that Fry's mother produced nine children, two of whom are cast in the drama of his screen memory. In being twins, the siblings in the memory double the impact of their effect on Fry.

When Fry's biography is factored into a consideration of his formalism, his philosophy of art assumes a personal quality and is the more enriched for it. Personal developments also contributed to his greater flexibility in the last decade of his life. In 1924, Fry delivered the lecture entitled "The Artist and Psycho-Analysis." At that point, he publicly admitted the potential of psychoanalysis for art. He cited Freud's view of creativity as giving form to fantasy through the route of sublimation. Two years later, Fry began living with Helen Anrep, who had become the new love of his life. Under her benign influence, he was able to entertain the possibility that content could play a role in one's aesthetic response. He conceded the significance of some content, and differed with Clive Bell's insistence that only "significant form" could evoke an emotional

response to art. By 1933, in his first Slade lecture, Fry spoke openly about the role of the "subconscious" in creativity, and in one's "spiritual life."[21]

Roland Barthes

Barthes was born in 1915, in the French city of Cherbourg, during World War I. The following year, his father, who was a naval officer, was killed in the North Sea. As a result, Barthes wrote in his autobiography, "no father to kill, no family to hate, no milieu to reject: great Oedipal frustration!"[22] But, in fact, Barthes *did* have a go at "killing the father"—and on a grand scale at that. He, like Foucault, "killed" all his literary predecessors, when he championed the death of the Author as part of his Structuralist philosophy.

Barthes was raised in a bourgeois milieu by his mother, and his childhood was characterized by poverty, boredom, recurring bouts of tuberculosis, and other maladies. In 1924, his family moved to Paris, and from then on spent vacations with his grandparents in Bayonne. From 1935 to 1939, he worked on a degree in Classics, and then became a professor at the Biarritz lycée. In 1949, he taught in Bucharest, the following year in Alexandria (in Egypt), and then returned to Paris, where he pursued a career in teaching (at the École Pratique des Hautes Études) and writing.

His fascination with photography, which determined the images he chose to analyze in his Structuralist as well as in his Post-Structuralist phase, is also a central theme in his autobiography. It opens with a series of annotated photographs recording the author's family and life. In one picture of himself as a child, he writes, "I was beginning to walk, Proust was still alive, and finishing *À la Recherche du Temps Perdu*."[23] With that observation, Barthes reveals his sense of psychological and historical time. Proust's famous *déjà vu*, in which, as an adult, he reexperiences the childhood sensation of the *madeleine* (a French biscuit), corresponds to Freud's view that there is no time in the unconscious. It also replicates Barthes's response to the photograph as a collapsing of time (cf. Chapter Seven).

That Barthes cites Proust's childhood recollection as a caption for a picture of his own childhood, especially as he is beginning to

walk, is also significant. He implicitly makes of Proust a literary predecessor, a metaphor for the Author, which he partially reinstated in his Post-Structuralist phase. By the time Barthes wrote his autobiography, in the 1970s, he had proclaimed his own "authorship" and, in a sense, had come to terms with his absent biological father. In so doing, he also proclaimed his sexual identity as a homosexual identity.

The mirror imaging of title and author, of self written by self, *Roland Barthes by Roland Barthes,* reflects the narcissism of homosexuality embodied in the Greek myth of Narcissus. "The opposition of the sexes must not be a law of Nature," Barthes writes; "therefore, the confrontations and paradigms must be dissolved, both the meanings and the sexes be pluralized ... (there will be, for example, only *homosexualities.* . . ."[24] His references to a symbolically castrated body image take many forms. For example, on being left-handed in school: "You had to normalize your body."[25] Under the heading *The rib chop:* in 1945, a piece of one of Barthes's ribs had been removed for surgical reasons. On the grounds that his body belonged to him, the Swiss doctors returned the bone fragment wrapped in gauze. Barthes kept this "fragment of myself in a drawer, a kind of body penis analogous to the end of a rib chop. . . ." And later on, "I flung the rib chop and its gauze from my balcony, as if I were romantically scattering my own ashes, into the rue Servandoni, where some dog would come and sniff them out."[26] Under the heading *Typos:* ". . . (in what I write by hand . . . I write *n* for *m,* amputating one leg—I want letters with two legs, not three) ... through the machine, the unconscious writes much more surely than natural script does, and one can concieve of a *graphanalysis.* . . ."[27]

Barthes's homosexuality, which looms large in both the text and photographs of his autobiography, was certainly related to the circumstances of his childhood—notably the early death of his father and his intense attachment to his mother. His philosophical death of the Author was thus based in his early development. It was later projected onto a broad range of literary studies and became a metaphor for the "frustrated" oedipal parricide of his childhood.

The other main aspect of the oedipal constellation—namely, the son's desire for the mother—informed Barthes's response to photography in *Camera Lucida.* As an adult, he lived with his mother,

and, soon after her death, was hit by a car and killed. Her death led to his discovery of her photograph at age five, which became the occasion for an exploration of photography itself (cf. Chapter Seven). In that photograph, his mother is simultaneously dead and resurrected, because of her *having been there,* and her having been recorded as having been there by the configuration of light on a chemically treated surface.

The frozen time of the Barthian photograph is akin to the buried city of the archaeologist, to the childhood buried in the Freudian unconscious, and to Proust's *madeleine.* The riveting power of Barthes's own gaze comes to the fore when he confronts the photograph of his mother's past. What results is a mother-child dyad of the kind described by Lacan, but it operates *through* time as well as *in* space—that is, both synchronically and diachronically. It is so exclusive of others that Barthes declines to reproduce it, and keeps it for himself. A few years earlier, in his autobiography, Barthes had described his own response to a sense of exclusion under the heading *Exclusion:* he happens to see the end of a wedding in the Church of Saint-Sulpice, and is overcome by a feeling of exclusion. "Chance," he writes, "had produced that rare moment in which the *symbolic* accumulates and forces the body to yield . . . it was the very *being* of exclusion with which he had been bludgeoned: dense and hard . . . he felt more than excluded: *detached:* forever assigned the place of the *witness. . . .*"[28]

Barthes's response to the wedding is a primal scene response, and so is his response to photography. Both require the activation of the gaze and the desire (in Lacan's sense) that accompanies it. But in the case of the wedding he remains outside and excluded, whereas in observing photographs he discovers a solution, a way in, and is no longer excluded. He achieves this through the concepts of *studium* and *punctum.* Into the former, which includes the cultural intentions of the photographer, he readmits the Author, and symbolically resurrects the paternal authority. In the latter, he, Barthes, "punctures" the picture plane with his gaze, and focuses on a particular detail. He takes the "father's" place, not by committing literal incest, but by displacement from the phallus to the eye. He becomes a visual rather than a phallic Oedipus, and need not blind himself for his crimes, because he has sublimated them. He "punc-

tures" ("pricks") the surface of the image rather than the "mother," and thus avoids the dangers of incest and castration.

The sublimatory character of Barthes's oedipal solution is reinforced by his reading of the *punctum* as a transitional phenomenon. He makes of it a transitional space, and he controls it as the child controls his. Replicating Winnicott's characterization of the transitional object, Barthes writes in *Camera Lucida* that the *punctum* is what he adds and what is already there.[29] The photograph of his mother is the ultimate transitional object for Barthes. It binds her to him umbilically despite the finality of her absence, for it records her presence in time and in space. It reassures him that she is alive, even though she is dead, just as the transitional object—and the *fort/da* game—reassures the child that the absent mother is present, or can be made present.

NOTES

1. For information on Roger Fry, in addition to the works cited, I am indebted to a lecture given by the English critic David Cohen, April 6, 1995, at the City University of New York Graduate Center. The psychoanalytic interpretations, however, are entirely my own, and he bears no responsibility for them.
2. Frances Spalding, *Roger Fry* (Berkeley and Los Angeles, 1980), p. 9, n. 9.
3. Ibid., p. 13; and Virginia Woolf, *Roger Fry* (London, 1969), pp. 33–34.
4. Cohen, as above.
5. Woolf, *Fry*.
6. Denys Sutton, ed., *The Letters of Roger Fry*, vol. 2 (New York, 1972), pp. 448–49.
7. Richard Shiff, "'Painting, Writing, Handwriting,' Roger Fry and Paul Cézanne," in Roger Fry, *Cézanne: A Study of His Development* (Chicago and London, 1989), p. xii.
8. Fry, *Cézanne*, p. 1.
9. Ibid.
10. Ibid.
11. Shiff, p. xix.
12. Fry, *Cézanne*, p. 36.
13. Woolf, p. 95.
14. Sutton, p. 381.
15. Roger Fry, *Last Lectures* (New York, 1939), p. 150.
16. Woolf, p. 251.
17. Spalding, p. 1.
18. See Freud, "Screen Memories," S.E. III, 1899, pp. 303–22, and "Child Memories and Screen Memories," S.E. VI, 1901, pp. 43–52.
19. In Spalding, p. 109.
20. See, for example, Gregory Stragnell, "The Golden Phallus," *Psychoanalytic Review* XI (1924): 292–323.
21. Fry, *Last Lectures*, p. 14.
22. Roland Barthes, *Roland Barthes by Roland Barthes*, trans. Richard Howard (New York, 1977), p. 45.
23. Ibid., p. 24.
24. Ibid., p. 69.
25. Ibid., p. 98.
26. Ibid., p. 61.
27. Ibid., p. 97.
28. Ibid., p. 86.
29. Roland Barthes, *Camera Lucida*, trans. Richard Howard (New York, 1981). p. 55.

Bibliography of Works Cited

Books

Adams, Laurie Schneider. *Art and Psychoanalysis*. New York, 1993.

Alpers, Svetlana. *Rembrandt's Enterprise*. Chicago, 1984.

Anacreonta, in *Greek Lyric II*, trans. David A. Campbell, Loeb ed. Cambridge, Mass., and London, 1988.

Antal, Frederick. *Florentine Painting and Its Social Background*. Boston, 1948.

Barolsky, Paul. *Infinite Jest*. Columbia, Mo., and London, 1978.

———. *Michelangelo's Nose*. University Park, Pa., and London, 1990.

———. *Giotto's Father and the Family of Vasari's Lives*. University Park, Pa., 1992.

———. *The Faun in the Garden*. University Park, Pa., 1994.

Barthes, Roland. *Elements of Semiology*, trans. Annette Lavers and Colin Smith. London and New York, 1967.

———. *Roland Barthes by Roland Barthes*, trans. Richard Howard. New York, 1971.

———. *Image—Music—Text*, ed. and trans. Stephen Heath. New York, 1977.

———. *Camera Lucida*, trans. Richard Howard. New York, 1981.

———. *The Responsibility of Forms*, trans. Richard Howard. New York, 1985.

Bashkirtseff, Marie. *Journals*, 2 vols, trans. Matilda Blind. London, 1890.

Baxandall, Michael. *Painting and Experience in Fifteenth-Century Italy*. Oxford, 1974.

Bell, Clive. *Art*. New York, 1958.

Bell, Quentin. *Ruskin*. New York, 1978.

Borenius, Tancred. *Rembrandt: Selected Paintings*. London, 1942.

Brettell, Richard, Françoise Cachin, Claire Frèches-Thory, Charles F. Stuckey, and Peter Zegers. *The Art of Paul Gauguin*. National Gallery, Washington, D.C., 1988.

Broude, Norma, and Mary D. Garrard, eds. *The Expanding Discourse*. New York, 1992.

Bryson, Norman. *Word and Image*. Cambridge, 1981.

———. *Vision and Painting*. New Haven and London, 1983.

Carrier, David. *Artwriting*. Amherst, Mass., 1987.

———. *Principles of Art History Writing*. University Park, Pa., 1993.

———. *Poussin's Paintings*. University Park, Pa., 1993.

Clark, T. J. *Image of the People*. London, 1973.

———. *The Absolute Bourgeois*. London, 1973.

———. *The Painting of Modern Life*. New York, 1985.

Coudert, Allison. *Leibniz and the Kabbalah* (International Archives of the History of Ideas, vol. 142). Dordrecht, Boston, and London, 1995.

Derrida, Jacques. *Of Grammatology*. Preface by Gayatri Chakravorty Spivak. Baltimore and London, 1976.

———. *The Truth in Painting*, trans. Geoff Bennington and Ian McLeod. Chicago and London, 1987.

Ferguson, Robert. *Enigma: The Life of Knut Hamsun*. New York, 1987.

Fine, Elsa Honig. *Women and Art*. London, 1978.

Flam, Jack. *Matisse: The Man and His Art, 1869–1918*. Ithaca and London, 1986.

Foucault, Michel. *This Is Not a Pipe*. Berkeley and Los Angeles, 1983.

Freud, Sigmund. *The Complete Psychological Works of Sigmund Freud*, 24 vols. London, 1953–73.

Fry, Roger. *Vision and Design*. New York, 1956.

———. *Cézanne: A Study of His Development*. Chicago and London, 1989 (originally published London, 1927). Introduction by Richard Shiff, "Painting, Writing, Handwriting, Roger Fry and Paul Cézanne."

———. *Last Lectures*. New York, 1939.

Gardner, John, and John Maier, trans. *Gilgamesh*, New York, 1984.

Garrard, Mary D. *Artemisia Gentileschi*. Princeton, 1989.

Geist, Sidney. *Brancusi: A Study of the Sculpture*. New York, 1968.

Golzio, Vincenzo. *Raffaello nei documenti, nelle testimonianze dei contemporanei e nella letteratura del suo secolo*. Vatican, 1936.

Gombrich, Ernst. *Symbolic Images*. London, 1972.

Greenacre, Phyllis. *Emotional Growth*, 2 vols. New York, 1971.

Greenberg, Clement. *Art and Culture*. Boston, 1961.

Grolnick, Simon A., and W. Muensterberger, eds. *Between Reality and Fantasy*. New York and London, 1978.

Hamsun, Knut. *Growth of the Soil*, trans. W. W. Worster. New York, 1972.

Harris, Ann Sutherland, and Linda Nochlin, eds. *Women Artists: 1550–1950*. New York, 1977.

Heidegger, Martin. *The Origin of the Work of Art*, trans. A. Hofstadter, in A. Hofstadter and Richard Kuhns, *Philosophies of Art and Beauty*. New York, 1964.

Hein, Hilde, and Carolyn K. Korsmeyer, eds. *Aesthetics in Feminist Perspective*. Bloomington, Ind., 1993.

Hesiod. *The Battle of Frogs and Mice*, in *The Homeric Hymns and Homerica*, trans. Hugh G. Evelyn-White, Loeb ed. Cambridge, Mass., and London, 1982.

————. *Catalogues of Women and Eoiae,* in *The Homeric Hymns and Homerica,* trans. Hugh G. Evelyn-White, Loeb ed. Cambridge, Mass., and London, 1982.

————. *The Homeric Hymns and Homerica,* trans. Hugh G. Evelyn-White, Loeb ed. Cambridge, Mass., and London, 1982.

Innis, Robert E. *Semiotics.* Bloomington, Ind., 1985.

Jakobson, Roman. *Essais de linguistique générale.* Paris, 1963.

————. *Language in Literature,* eds. Krystyna Pomorska and Stephen Rudy. Cambridge, Mass., and London, 1987.

James, M. R. *The Apocryphal New Testament.* Oxford, 1924.

Janson, H. W. *History of Art.* Englewood Cliffs, N.J., and New York, 1977.

Jones, Ernest. *Essays in Applied Psychoanalysis,* 2 vols. New York, 1964.

Kant, Immanuel. *Critique of Pure Judgment,* trans. J. H. Bernard. New York, 1951.

Kemp, Martin, ed. *Leonardo on Painting.* New Haven and London, 1989.

Kris, Ernst. *Psychoanalytic Explorations in Art.* New York, 1952.

Kris, Ernst, and Otto Kurz. *Legend, Myth, and Magic in the Image of the Artist.* New Haven and London, 1979.

Kurzweil, Edith. *The Age of Structuralism.* New York, 1980.

Lacan, Jacques. *The Language of the Self,* trans. Anthony Wilden. Baltimore, 1968.

————. *The Four Fundamental Concepts of Psycho-Analysis,* trans. Jacques-Alain Miller. New York, 1977.

Lang, Berel, and Forrest Williams. *Marxism and Art.* New York, 1972.

Laplanche, J., and J.-B. Pontalis. *The Language of Psychoanalysis,* trans. Donald Nicholson-Smith. New York, 1973.

Lévi-Strauss, Claude. *Structural Anthropology,* trans. Claire Jacobson and Brooke Grundfest Schoepf. New York, 1963.

Lucian. *Dialogues of the Sea-Gods,* trans. M. D. MacLeon, Loeb ed., vol. VII. Cambridge, Mass., and London, 1969.

Lucie-Smith, Edward, ed. *The Faber Book of Art Anecdotes.* London, 1992.

Merleau-Ponty, Maurice. *Signs,* trans. Richard Calverton McLeary. Chicago, 1964.

————. *Sense and Non-Sense,* trans. Hubert L. Dreyfus and Patricia Allen Dreyfus. Evanston, Ill., 1991.

Mitchell, W. J. T. *Picture Theory.* Chicago, 1994.

Nochlin, Linda. *Women, Art, and Power and Other Essays.* New York, 1988.

Norris, Christopher. *Deconstruction and the Interests of Theory.* Norman, Okla., and London, 1989.

Ovid. *Fasti,* trans. Sir James George Frazer, Loeb ed. Cambridge, Mass., and London, 1976.

————. *Metamorphoses,* 2 vols., trans. Frank Justus Miller, Loeb ed. Cambridge, Mass., and London, 1984.

Panofsky, Erwin. *Studies in Iconology.* New York, 1962.

Pliny. *Natural History,* 10 vols., Loeb ed. Cambridge, Mass., 1979.

Ridolfi, Carlo. *The Life of Tintoretto and of His Children Domenico and Marietta,* trans. Catherine Enggass and Robert Enggass. University Park, Pa., and London, 1984.

Robins, Gay. *Women in Ancient Egypt*. Cambridge, Mass., 1993.

Rose, Margaret A. *Marx's Lost Aesthetic*. Cambridge, 1984.

Rosenberg, Harold. *Saul Steinberg*. Whitney Museum of American Art, New York, 1978.

Sabartès, Jaime. *Picasso: An Intimate Portrait*. New York, 1948.

Saussure, Ferdinand de. *Course in General Linguistics*, trans. Wade Baskin. New York, 1966.

Schapiro, Meyer. *Aesthetics Today*, ed. Morris Philipson. New York, 1961.

———. *Approaches to Semiotics*. The Hague and Paris, 1973.

———. *Theory and Philosophy of Art: Style, Artist, and Society*, Selected Papers, vol. IV. New York, 1994.

———. *Mondrian: On the Humanity of Abstract Painting*. New York, 1995.

Seidel, Linda. *Jan Van Eyck's Arnolfini Portrait*. New York, 1993.

Spalding, Frances. *Roger Fry*. Berkeley and Los Angeles, 1980.

Steinberg, Leo. *Other Criteria*. New York, 1972.

Sutton, Denys, ed. *The Letters of Roger Fry*, 2 vols. New York, 1972.

Sylvester, David. *Magritte*. New York, 1992.

Vasari, Giorgio. *Lives of the Most Eminent Painters, Sculptors, and Architects*, 3 vols., trans. Gaston Du C. de Vere. New York, 1979.

Verheyen, Egon. *The Paintings in the Studiolo of Isabella d'Este at Mantua*. New York, 1971.

Weintraub, Stanley. *Whistler*. New York, 1974.

Wethey, Harold E. *The Paintings of Titian*, 3 vols. London, 1975.

Wilson, J. J., and Karen Peterson. *Women Artists*. New York, 1976.

Winnicott, D. W. *Playing and Reality*. New York, 1971.

Wiseman, Mary Bittner. *The Ecstasies of Roland Barthes*. London, 1989.

Wittkower, Rudolf, and Margot Wittkower. *Born Under Saturn*. London, 1963.

Wölfflin, Heinrich. *Principles of Art History*, trans. M. D. Hottinger. New York, n.d. First German edition, 1915.

Woolf, Virginia. *Roger Fry*. London, 1969.

Wren, Linnea H. *Perspectives on Western Art*, vol. 2. New York, 1994.

Articles

Alpatov, Michel. "The Parallelism of Giotto's Paduan Frescoes," *Art Bulletin* XXIX, no. 3 (1947): 149–54. Reprinted in *Giotto in Perspective*, ed. Laurie Schneider (Englewood Cliffs, N.J., 1974), pp. 109–21.

Bal, Mieke, and Norman Bryson. "Semiotics and Art History," *Art Bulletin* LXXIII, no. 2 (June 1991): 174–208.

Barolsky, Paul. "A Very Brief History of Art from Narcissus to Picasso," *The Classical Journal* 90, no. 3 (1995): 255–59.

———. "The Artist's Hand," in *The Craft of Art: Originality and Industry in the Italian Renaissance and Baroque Workshop*, ed. Andrew Ladis and Carolyn Wood. Athens, Ga., and London, 1995.

Bernfeld, Suzanne Cassirer. "Freud and Archeology," *American Imago* 8 (1951): iii.

Carrier, David. "Review of Jacques Derrida, *The Truth in Painting,*" *Journal of Philosophy* LXXXV, no. 4 (April 1988): 219–23.

Davis, Howard McP. "Gravity in the Paintings of Giotto" (1971), in *Giotto in Perspective,* ed. Laurie Schneider. Englewood Cliffs, N.J. 1974, pp. 142–59.

Foucault, Michel. "What Is an Author?" In *Language, Counter-Memory, Practice: Selected Essays and Interviews,* ed. D. F. Bouchard. Ithaca, 1977, pp. 113–38.

Garrard, Mary. "Here's Looking at Me: Sofonisba Anguissola and the Problem of the Woman Artist," *Renaissance Quarterly* XLVII, no. 3 (Autumn 1994) pp. 556–622.

Gould, Stephen Jay. "Mickey Mouse Meets Konrad Lorenz," *Natural History,* May 1979, pp. 30–36.

Krauss, Rosalind. "Notes on the Index," *October* III (1977): 68–81, and IV (1977): 58–67.

Ladis, Andrew. "The Legend of Giotto's Wit and the Arena Chapel," *Art Bulletin* LXVIII, no. 4 (December 1986): 581–96.

Lord, Carla. "Jeanne d'Evreux as a Founder of Chapels: Patronage and Public Piety," in *Patrons, Collectors and Connoisseurs: Women and Art 1350–1770,* ed. Cynthia Lawrence. University Park, Pa., and London. Proceedings of the conference on matronage held at Temple University, Philadelphia. In press.

Panofsky, Erwin. "Jan Van Eyck's *Arnolfini* Portrait," *Burlington Magazine* 64 (1934): 117–28.

Pon, Lisa. "Michelangelo's First Signature," *Source: Notes in the History of Art* XV, no. 4. (Summer 1996): pp. 16–21.

Poseq, Avigdor W. "Bernini's Self-Portraits as David," *Source: Notes in the History of Art* IX, no. 4 (Summer 1990): 14–22.

Reeder, Ellen D. "Woman as Other," *Source: Notes in the History of Art* XIV, no. 1 (Fall 1995): 25–31.

Schapiro, Meyer. "'Muscipula Diaboli,' The Symbolism of the Merode Altarpiece," *Art Bulletin* XXVII (1945): 182ff.

Schneider, Laurie. "Donatello's Bronze *David,*" *Art Bulletin* LV, no. 2 (June 1973): 213–16.

———. "Donatello and Caravaggio: The Iconography of Decapitation," *American Imago* 33, no. 1 (Spring 1976): 76–91.

———. "Raphael's Personality," *Source: Notes in the History of Art* III, no. 2 (Winter 1984): 9–22.

Schneider, Laurie, and Jack Flam. "Visual Convention, Simile and Metaphor in the *Mona Lisa,*" *Storia dell'Arte,* no. 29 (1977): 15–24.

Seidel, Linda. "Jan van Eyck's Arnolfini Portrait: Business as Usual?" *Critical Inquiry* 16 (Fall 1989): 55–86.

Stein, Gertrude. *Prose Portraits* (excerpts), in *Camera Work,* August 1912.

Steinberg, Leo. "The Sexuality of Christ in Renaissance Art and in Modern Oblivion," *October* 25 (Summer 1983).

Stragnell, Gregory. "The Golden Phallus," *Psychoanalytic Review* XI (1924): 292–323.

Whistler, James McNeill. "The Ten O'Clock" (1885), in *Whistler: A Retrospective,* ed. Robin Spencer (New York, 1989).

Index

Page numbers in *italics* refer to illustrations.